FUTURE
NOW

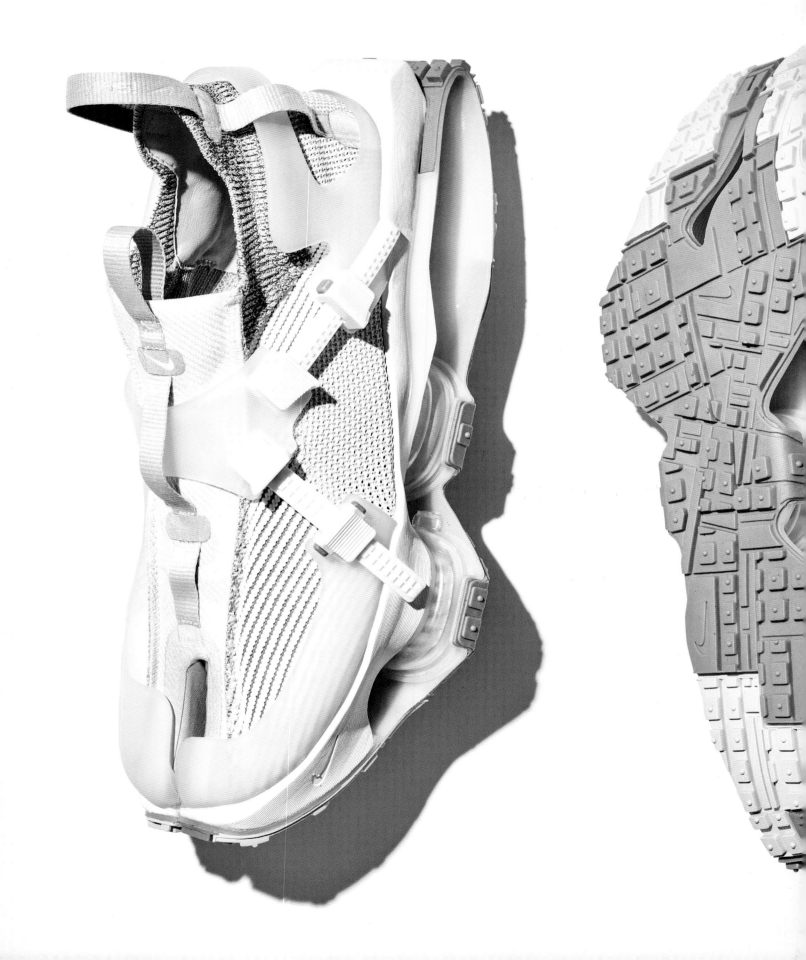

FUTURE
NOW

VIRTUAL SNEAKERS
TO CUTTING-EDGE KICKS

Elizabeth Semmelhack

BATA SHOE MUSEUM *RIZZOLI* **Electa**

CONTENTS

FOREWORD

THE BATA SHOE MUSEUM'S MISSION is to illuminate human history and culture through footwear. As chairman, I am immensely proud of all that the museum team has accomplished since we opened in 1995.

The collection has grown to be one of the world's largest and most comprehensive collections of footwear. We have become an internationally recognized center for material culture research and groundbreaking exhibitions. Field trips have been funded to collect and research the disappearing traditions of shoemaking around the world while keeping up-to-date on the latest innovations. The breadth of the collection has inspired innovative exhibitions bringing out the stories of social and cultural relevance that can be told using footwear as the window. Our publications span topics from sneaker culture and the history of high heels to Inuit boots and Renaissance chopines.

Shoes are so compelling because they transcend time and place, and are both incredibly personal and a reflection of the norms and fashions of the time. Museums traditionally preserve, document, and interpret the past, but this book ambitiously travels beyond the present by looking at the ideas of today that are shaping the footwear of the future.

Elizabeth Semmelhack, the director and senior curator at the Bata Shoe Museum, is certainly one of the most well-known shoe historians today. Through this book, she shares interviews with creatives talking about their innovations, explores mold-breaking ideas on sustainability, dives into the metaverse with its NFT sneakers and virtual footwear, and boldly takes us into a world of cutting-edge thinking that is revolutionizing what we will put on our feet tomorrow.

Christine Bata Schmidt
Chair, Bata Shoe Museum

Detail of Adidas
Futurecraft.Strung
(see page 96)

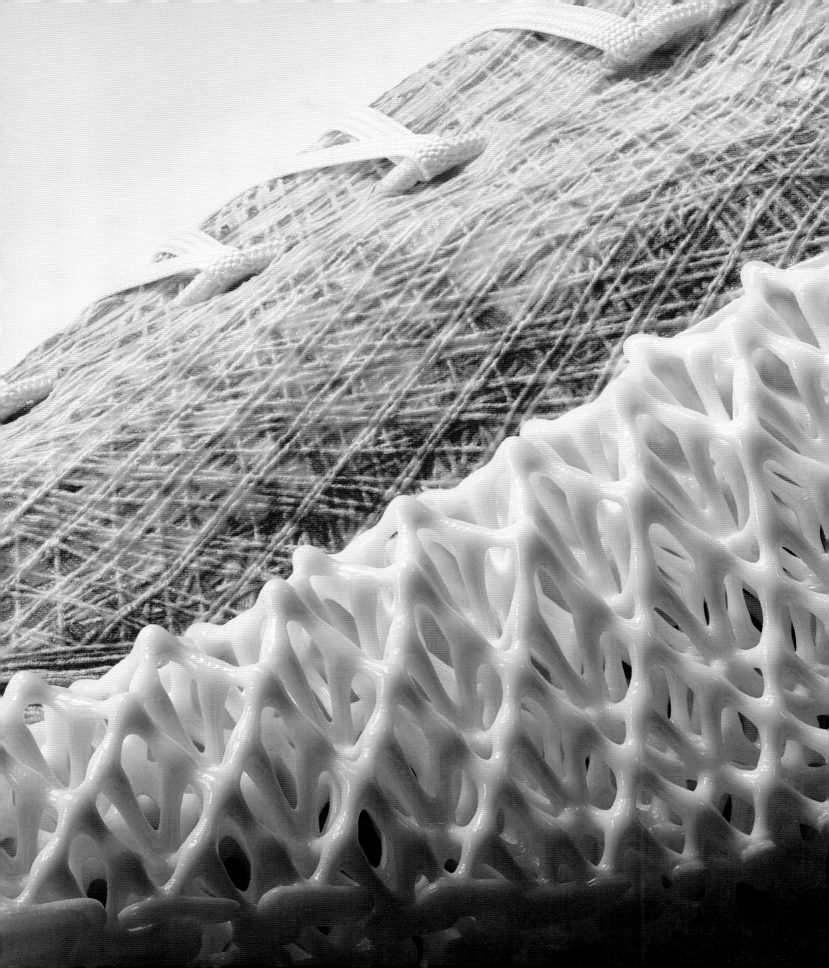

INTRODUCTION
A STEP AHEAD

The innovations of the past shape the possibilities of the future. In the nineteenth century, shoemaking in the West was transformed from an artisanal craft into an industry driven by the invention of new methods and materials that increased output and optimized profitability.

THE ENSUING MASS PRODUCTION of footwear made a wider variety of shoes accessible and affordable to more people, and footwear consumption began to rise. However, industrialization also introduced new limitations. Feet suddenly had to fit into predetermined sizes, and despite the plethora of shoes on offer, consumer choice was limited to the styles and colors determined by manufacturers. Another impact of mass production was ever-increasing levels of exploitation and waste as both production and consumption grew.

Today, many designers and shoe companies are grappling with this history. Innovation remains at the forefront of the industry, but the goals have begun to shift. Some are creating shoes that can be hyper-individualized using smart technologies, while others are finding new ways to make shoes out of sustainable materials, such as mushroom leather. New technologies are also allowing designers to create unprecedented footwear, from remarkably architectural shoes made using 3D printing to collectible sneakers that exist only in the metaverse.[1]

The footwear included in this book is designed to address industrial age problems, as well as to capitalize on postindustrial possibilities. However, rather than representing a break with the past, contemporary designs build upon historical innovations. This brief history provides an overview of some of the most groundbreaking technologies introduced into the Western shoe industry since the start of the Industrial Revolution.

THE GENTLE CRAFT

Prior to the nineteenth century, footwear in the West was often made to the individual specifications of clients. Shoemakers took careful measurements of their customers' feet,

received input as to the type and style of footwear that was desired, and often used material supplied directly by clients (**FIG. 1**). The relationship between maker and consumer was, in effect, collaborative, and the final product was hyper-individualized. It was also expensive. Those who could not afford bespoke shoes could acquire less costly ready-made footwear produced by enterprising shoemakers who had the capacity to produce shoes on spec, or they could try their luck looking for used shoes in the secondhand market.

By the middle of the eighteenth century, European imperialism began to put pressure on shoemakers to increase production for export to colonial territories. The need for footwear also drove domestic production capabilities within the colonies, particularly in America on the eve of the American Revolution.[2] By the late eighteenth century, not only was the newly formed United States able to meet its domestic demand, but it also began exporting footwear, making shoe manufacturing one of the country's most lucrative industries.[3] The strength of this new industry drove innovation and paved the way for the industrialization of shoemaking in the nineteenth century.

MECHANIZATION

The industrialization of footwear manufacturing increased in the United States as the nineteenth century wore on, but European shoemakers viewed many of the labor-saving inventions being promoted with suspicion, such as the use of wooden pegs to secure shoe soles to uppers, the part of the shoe that covers the foot. Pegs had long been used in Western shoemaking to create stacked leather heels but using them to attach soles was unprecedented. The method sped up production, but quality suffered, and most European shoemakers refused to use it (**FIG. 2**). Both European and American shoemakers made the process faster by exploiting the long-standing fashion for shoes without lefts or rights, called straights. The benefit of straights was that they allowed shoemakers to use a single last (the foot-shaped model that shoes are built on) to make pairs of shoes, keeping costs down and output high.

By the middle of the century, shoemaking was no longer the purview of the self-employed craftsmen and their small workshops. Instead, the shoemaking process was splintered in almost innumerable steps completed by factory workers engaged in repetitive labor. The invention of the sewing machine in the 1830s—and the subsequent improvements made to it in the 1860s—profoundly revolutionized shoemaking in the second half of the nineteenth century by increasing production capabilities and bringing women into the factories. Hand-sewing had long been an essential part of shoemaking and traditionally it was the wives and daughters of shoemakers who stitched together fabric uppers, which they then handed over to their husbands or fathers to complete. Shoemakers who had larger workshops employing journeymen and apprentices would sometimes send these uppers to women outside of their households to complete as piecework. The sewing machine changed the scenario by bringing thousands of women out of the domestic space and integrating them into shoemaking factories (**FIG. 3**). Even today, the majority of the sewing required to make footwear is done by female workers.

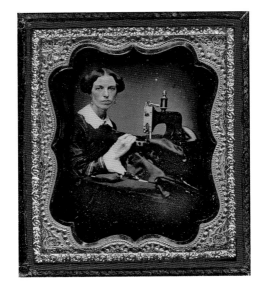

11

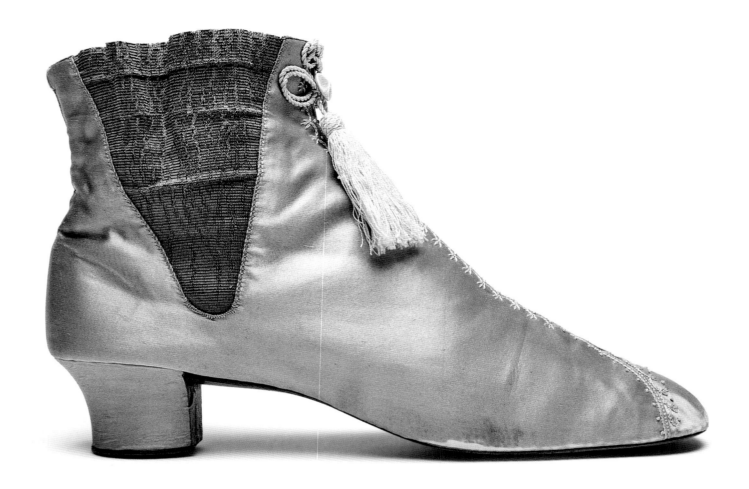

NEW MATERIALS, NEW MODES

In the nineteenth century, the use of innovative materials resulted in entirely new forms of footwear. One of these materials was rubber, the milky white sap of the *Hevea brasiliensis* tree found only in the forests of Central America and Brazil. Rubber's remarkable elasticity and waterproof qualities had long been used by Indigenous people to make everything from balls to waterproof clothing, but Europeans dismissed its usefulness until the early nineteenth century, when a range of Western scientists and inventors began taking it seriously. The challenge with rubber was that it was unstable outside of its natural habitat. A few importers discovered this the hard way in the 1820s, when they began to sell waterproof rubber overshoes made to Western fashion specifications in Brazil. The stretchy overshoes caused a sensation, but they didn't last long; the majority of them either melted in the summer heat or cracked in the winter cold. This, combined with their high cost—roughly five times the cost of leather footwear—left many disillusioned with rubber's potential. [4]

However, Charles Goodyear, a self-taught chemist and inventor, was not swayed. His dedication to the potential of rubber verged on mania—he dreamed of a utopian future in which almost everything, from dishes and jewelry to clothing and footwear, was made of

FIG 4 (*above*)
English, c. 1860s.
Collection of the Bata
Shoe Museum

FIG 5 (*opposite*)
Sneakers, Goodyear
Rubber Manufacturing
Company. American,
1890s. Collection of
the Bata Shoe Museum

12

durable rubber.[5] Finally in 1839, after years of experimentation, he solved the problem of rubber's instability. He added sulphur to boiling latex, a process later dubbed vulcanization, and when the mixture cooled it retained its elasticity regardless of temperature.[6]

The ability to transform raw latex into durable rubber paved the way for many new types of footwear. One of the earliest forms of footwear to incorporate the new material was what is now known as the Chelsea boot. The idea for a boot with an elasticized gusset dates to the 1840s, when shoemaker Joseph Sparkes Hall attempted to create a laceless boot. The novel qualities of the elasticized fabric that he used made Hall's boots easy to remove, as well as providing a close and comfortable fit (**FIG. 4**).[7] The invention of the rubber-soled tennis shoe followed shortly thereafter. In the middle of the nineteenth century, the "ancient" game of tennis was revived, and the privileged added large manicured-lawn tennis courts to their estates. Playing on those courts required specialized footwear—rubber-soled tennis shoes that protected both the wearer's feet from the damp grass and the expensive turf from damage. The first iterations of these tennis shoes were costly, but by the end of the century increased production capabilities and larger social pressures related to exercise meant sneakers, a term used in the vernacular in America since at least the 1870s, had become increasingly popular (**FIG. 5**).[8]

As new forms of footwear were being innovated, each aspect of shoe production continued to be mechanized in the United States. The invention of the McKay stitcher, patented in 1862 at the beginning of the Civil War, allowed soles to be mechanically stitched to uppers. This improved the quality of manufactured footwear and made pegs obsolete. It also proved instrumental to the Union during the war. Shoemaking in the United States was a northern industry, and the advantage of greater expertise coupled with the McKay stitcher's streamlining of the process allowed the Union to supply its army with military footwear of higher quality, a key to military success. The Goodyear welting machine, introduced in 1869, further increased the quality of manufactured shoes by accomplishing complex welted shoe construction in record time.

Each new invention increased production but also destabilized the work environment by creating new jobs while rendering others obsolete. By the 1870s, almost every aspect of shoe production was mechanized. Lasting—stretching a shoe upper over a last and attaching the sole—was the one job considered to require such specialized skills that most believed it could never be done by machine. Yet this, too, became mechanized when inventor Jan Ernst Matzeliger created the lasting machine (**FIG. 6**). After Matzeliger moved to Lynn, Massachusetts, the shoemaking capital of the United States, in 1877, he began working on his design for the world's first lasting machine. By 1883, he had received a patent; his invention increased output from fifty pairs per day per hand laster to up to seven hundred pairs per day per machine operator.[9] Unfortunately, Matzeliger passed away only six years later and did not live to see how profoundly his invention would change the future of shoemaking. His legacy, however, has lived on and he continues to be celebrated as one of America's most important Black inventors.

While innovation was dramatically changing the way shoes were made, increased footwear production was also enfranchising ever-growing numbers of people into the fashion economy. This dismayed many in the privileged classes, and in response they began to

favor dress and accessories decorated with costly detailing that could only be done by hand, such as beading and detailed embroidery. French shoemaker François Pinet understood his high-end customers, and he paired machine-made heels with high-quality silk uppers lavishly hand-embroidered with flowers stitched in stunningly accurate botanical detail (FIG. 7). Although Pinet prided himself on the modern aspects of his factories, of the over eight hundred workers he employed, only a fraction actually worked onsite. Instead, the expensive embroidery prized by his customers was done by seven hundred women who worked at home doing piecework for nominal pay. Pinet's skillful blending of modern production and artisan detailing made his shoes objects of desire for many of the wealthiest women in Europe, and his name became synonymous with high-end exclusivity, paving the way for the designer footwear of the twentieth century.

BOGGED DOWN

Innovations in materials and production methods only increased in the twentieth century. The outbreak of war in 1914 plunged the world into conflict and brought with it a new type of warfare. The unprecedented firepower of the newly invented machine gun forced combatants to literally dig in where they languished, mired in mud and trenches. In these perpetually damp conditions, soldiers on the Western Front began to develop serious and disabling sores and infections on their feet, a condition called trench foot. Leather footwear offered little protection, but rubber boots held promise. Allied manufacturers rushed to meet the overwhelming demand—the United States ordered 5.5 million pairs in 1918 alone. In the end, the Allies' manufacturing capabilities for rubber footwear aided their victory.[10] After the war, the rubber Wellington was introduced into civilian wardrobes.

CELLULOID DREAMS

The Roaring Twenties saw a greater emphasis on women's footwear, as hemlines inched higher and Hollywood increasingly influenced fashion. New innovations also gave shoemakers novel materials with which to experiment. Strides in air-conditioning suddenly gave shoemakers access to "exotic" skins, such as snake from India, lizard from Java, and alligator from Brazil, which could now be shipped unprocessed to tanners in the West. The heels of women's shoes also became a site for experimentation. There are tantalizing reports of the popularity of glass heels, some of which were said to be illuminated. However, the majority of dazzling heels created in the 1920s were embellished with glossy sheets of celluloid, one of the very first plastics.

Celluloid, a mixture of camphor and nitrocellulose, was invented in 1869 by John Wesley Hyatt to replicate ivory for billiard balls. Given the negative impact plastics have gone on to have on the environment, it is somewhat ironic that Hyatt was compelled to create celluloid due to the lack of ivory because of overhunting.[11] Celluloid was also used to mimic tortoiseshell—another material that became rare due to over-hunting—mother-of-pearl, and lacquer. It could also be embellished with rhinestones and other decorations. Celluloid had been applied to women's heels since the late nineteenth century, but it was not until the 1920s that its enormous range of visual effects began to be exploited to their fullest (FIG. 8). There was one problem: celluloid

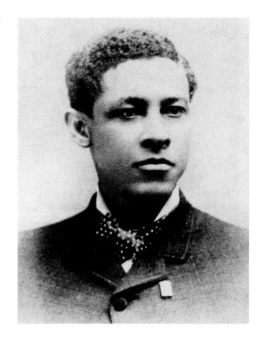

FIG 6 (above)
Jan Ernst Matzeliger,
1885

FIG 7 (opposite)
Embroidered boot,
Jean-Louis François
Pinet. French, 1880s.
Collection of the Bata
Shoe Museum

14

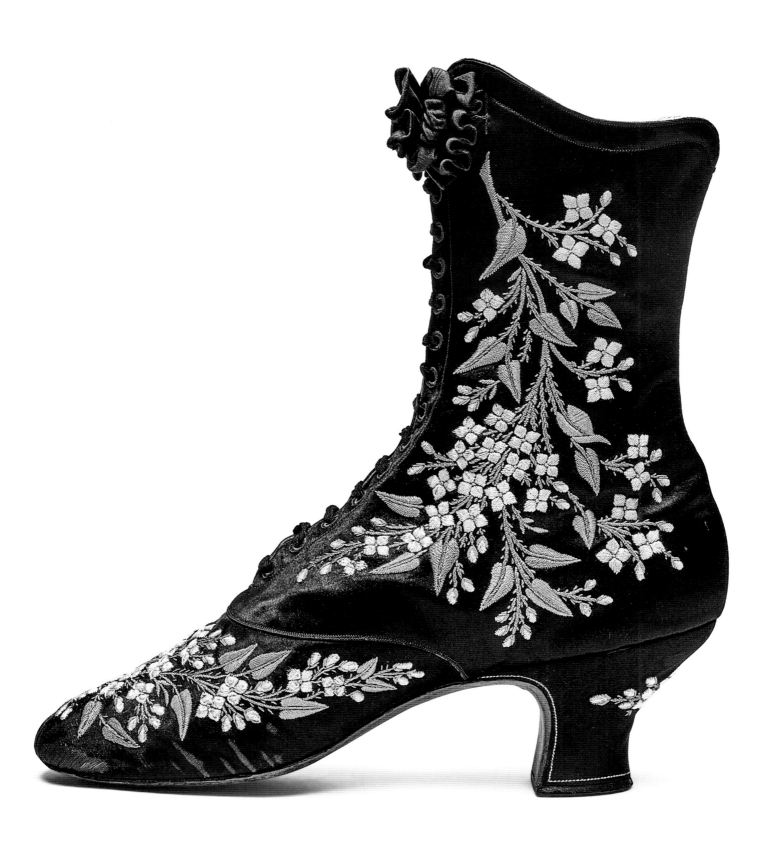

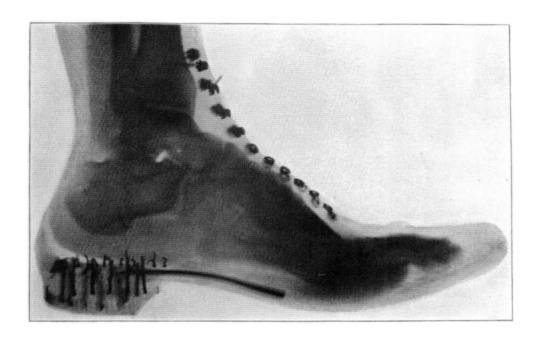

was highly flammable. Hyatt's billiard balls had a tendency to explode, and when celluloid began to be used in women's heels some feared their combustibility.[12] One promising substitute for celluloid was polyvinyl chloride (PVC), also known as vinyl. B. F. Goodrich and Waldo Semon invented it expressly as a substitute for celluloid heel covers, but this new material found utility way beyond footwear and became the second most used plastic in the world.

Another potentially harmful invention, the X-ray, was also pressed into service by the shoe industry in the 1920s. Wilhelm Röntgen discovered a form of light that could pass through objects and reveal internal structures in 1895. He called this light X-rays. Soon it became possible to create images using X-rays, and as early as 1896, feet inside of shoes became a subject of interest (FIG. 9). X-rays were used to aid in the design and fit of military footwear during World War I, but in the postwar period the fluoroscope machine became a promotional tool that gave shoe stores a futuristic aura and promised service grounded in science. Little concern was given to the radiation exposure of customers and clerks, and fluoroscopes continued to be used for decades.[13] A less dangerous way of measuring for fit was also invented in the 1920s: the Brannock Device. It allowed for the measurements of length and width to be taken simultaneously. It remains in use today.

The belief that science was the means to a brighter future only increased in the 1930s, and investments in research led to some of the most innovative materials, manufacturing processes, and shoe designs of the twentieth century. Chemistry was at the center of this work, and companies such as Dow and DuPont began to pour money into research. One of the first creations to come from these investments was polychloroprene, a successful but expensive synthetic rubber innovated by Arnold Collins at the DuPont research lab led by Wallace Hume Carothers and trademarked as neoprene. It would not be used in footwear until later in the century. Acrylic "glass," trademarked Lucite, was also developed at DuPont

FIG 8 (opposite)
Detail of celluloid heel embellished with rhinestones, Hanan & Sons. American, 1920s. Collection of the Bata Shoe Museum

FIG 9 (above)
X-ray of woman's foot in boot in *The X-ray: or, Photography of the invisible and its value in surgery* by William James Morton. American, 1896

FIG 10 *(left)*
Rainbow Platforms,
Salvatore Ferragamo.
Italian, 1938.
Collection of the
Ferragamo Museum

FIG 11 *(following)*
Stilted shoe, Steven
Arpad for Balenciaga.
American and French,
1939. Collection
of the Metropolitan
Museum of Art. Gift of
the Brooklyn Museum,
2009; Brooklyn
Museum Costume
Collection, 1947

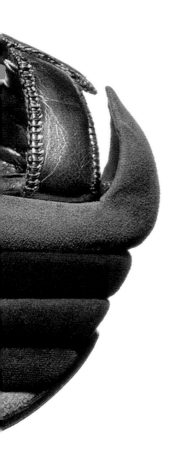

and would be exploited for both fairy-tale inspired and futuristic footwear immediately after World War II. Lucite was followed by nylon, another Carothers lab invention. DuPont experimented with nylon for over ten years before revealing it to the public in 1938.

What made nylon exceptional was that it was wholly synthetic and could be spun to a thinner fineness than silk. Nylon stockings also proved to be more run resistant. Women's fashion in the 1930s demanded sheer stockings, but those made of silk or rayon were delicate and prone to damage. Outside of recreational places such as the beach, women in the West were required to wear stockings when in public. However, a pair of silk or rayon stockings could only withstand about one week of wear. For women in the workforce this expense was not trivial, and many spent an average of 10 to 20 percent of their weekly earnings on new stockings.[14]

Not only materials and processes were being innovated in the 1930s. The decade was also a boom time for visionary shoe designers. Salvatore Ferragamo, André Perugia, and Roger Vivier all played with the architecture of women's footwear, creating never-before-seen platforms and wedges, as well as futuristic novelty heels and revealing peep toes to showcase the new fashion for polished toenails. Ferragamo's famous Rainbow platform, designed for Judy Garland in 1938, was the embodiment of Streamline Modernism (FIG. 10), while Steven Arpad's late 1930s designs for the French couture house Balenciaga seem as radical today as they did when they were first created (FIG. 11).

With the exception of flashy spectators, men's footwear fashions in the 1930s paled in comparison with women's. There were, however, important innovations in the way men's shoes were marketed. In the early 1930s, B. F. Goodrich decided to collaborate with the famous Canadian badminton player Jack Purcell. Purcell offered advice on the design of his namesake sneaker and Goodrich promoted his participation as a means of creating marketing differentiation. The sneaker itself was not revolutionary, but the idea of collaborating with a sports hero was, and it opened the door to collaborations later in the century. The addition of Chuck Taylor's name to the Converse All Star in 1934 was in the same vein and presaged the use of celebrities to promote athletic footwear.

RUBBER RATIONS

At the end of the nineteenth century, Western colonial powers forcibly shifted rubber production from Brazil to what was then known as the "Belgian" Congo and across Asia, and rubber footwear production went global. By the 1920s, Japan had become one of the world's most prolific producers of low-cost rubber-soled sneakers. It also produced rubber versions of the traditional Japanese rice-straw zori, later known as the flip-flop, for export across Asia. In the 1930s, the Czech company Bata sought to compete with Japanese producers with its CENEL press, which dramatically sped up sneaker production, allowing the company to be one of the largest exporters of shoes in the world. When World War II broke out, Japan sided with Germany and Italy, and one of the country's first military actions was to quickly seize the largest rubber producing regions in Asia, thereby taking control of a material essential to the war effort. Without access to rubber supplies, many countries began to focus their attention on innovating effective and affordable rubber substitutes.

19

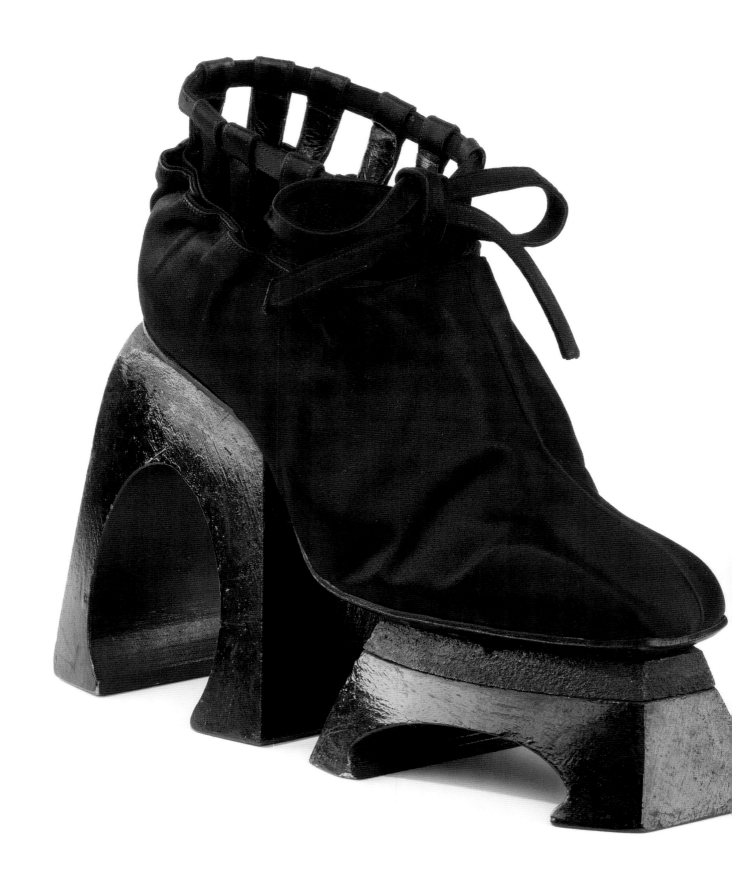

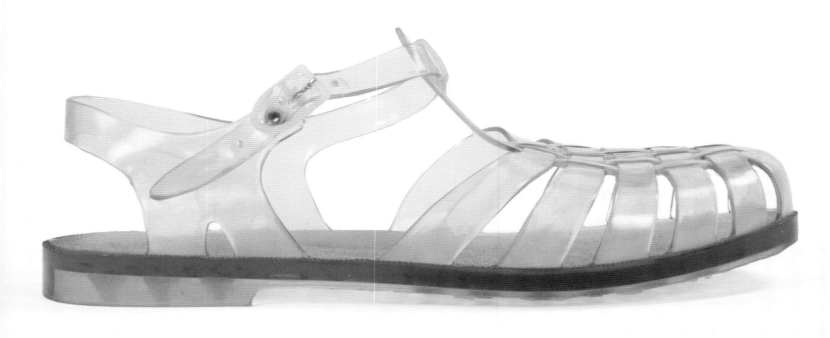

The desperate need for rubber led to rubber rationing in all the Allied countries. In the United States, sneaker production was halted and some companies, such as Keds, shifted to wartime research and the development of military footwear, including the jungle boot. These innovations were touted in advertisements aimed at young boys in an effort to keep the brand at the forefront of the postwar consumer's mind.[15] Other shoe companies, likewise, began to focus on the teen demographic, seeing it as an important postwar customer base. As one manufacturer in the States put it in 1944: "Contrary to past notions that plugs should be slanted to parents who fork over the dough for their children's commodities and necessities, it is really the teen-agers who have the final say as to what they buy and wear. With this realization, Hanover is starting out to build a wartime under-19 public and a potential postwar adult consumer market for their dog covers."[16] This focus on the youth market would become central to the growth of the sneaker market in the coming decades, as new materials and styles tempted young consumers and allowed sneakers to be integrated into the daily wardrobes of teenagers.

INJECTION MOLDING AND AIR CUSHIONING

The immediate postwar period saw quite a few advances in footwear production, some driven by need, others driven by a desire to find peacetime uses for wartime innovations. In France, it was the lack of available leather immediately after the war that inspired plastics manufacturer Jean Dauphant to create the first injection-molded footwear in 1946. The PVC sandals, called *la méduse,* or the jellyfish, were based on the design of traditional French fisherman sandals (**FIG. 12**).[17] Injection molding dated back to 1872, when John Wesley Hyatt, the inventor of celluloid, patented the method, but Dauphant's "jellies" marked the first time that it was used in the footwear industry. Injection molding uses heat-softened plastic that is poured into a closed mold where it is then allowed to cool and solidify. Today it is the principal means of fabricating footwear and footwear parts.[18]

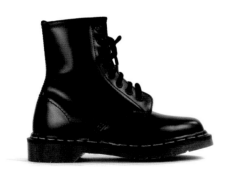

The invention of the famous Dr. Martens boot also dates to the immediate postwar moment. In 1945, while recovering from a skiing accident, German Army physician Klaus Märtens was inspired to create a pair of boots that could ease his recovery. With the assistance of his friend Dr. Herbert Funk, he created a boot with a rubber sole composed of two separate pieces with hollow compartments that when heat sealed together formed air pockets to cushion the feet. Their innovative use of air presaged the use of air cushioning in soles that would take the sneaker industry by storm decades later. Their soles also caught the interest of the British shoe manufacturer R. Griggs in the late 1950s. R. Griggs had been exploring ways to make work boots more comfortable, so it struck a deal with Märtens and licensed the right to produce his boots, while also independently trademarking the term AirWair.[19] On April 1, 1960, R. Griggs issued its first eight-eyelet Dr. Martens, christened the 1460 after the date of its manufacture (**FIG. 13**). Although these boots were originally designed to be orthopedic, they went on to become cultural icons and remain staples of counterculture fashion used by a vast array of groups, from British nationalists to punk rock bands to vegan activists.

One of the most innovative postwar developments in footwear came from inventor and entrepreneur Florence Zacks Melton, who went to the Firestone Tire and Rubber

23

Co. in Akron, Ohio, in 1947 to inspect its wartime invention—foam latex, which had been used for cushioning in helmets. Initially she wanted to use the washable material for shoulder pads, but instead she decided to create bedroom slippers with foam latex soles. The Dearfoams brand continues to be one of the largest producers of slippers to this day.

INVISIBLE SHOES

A popular trend in women's fashion in the 1940s and early 1950s that relied on the recent innovations in materials was transparent footwear. The first pair was created by Ferragamo in 1947. Inspired by a fisherman using a nylon fishing line, Ferragamo created his award-winning Invisible Sandal (FIG. 14). The desire for glasslike footwear only increased in the early 1950s after the release of Disney's animated feature film *Cinderella*.

Another postwar fashion made possible by wartime technology was the invention of the high, thin stiletto heel. Wood had long been used to make women's heels, but it was not strong enough for exceptionally slim heels, so shoemakers began to seek out alternatives. Hard plastics would ultimately be the answer, but the earliest attempts relied on steel. The first thin steel heel was created by visionary shoemaker André Perugia when he made a minimalist evening sandal for Christian Dior in 1951.[20] His design was revolutionary, and soon many others began to create their own stiletto heels (FIG. 15).

Another visionary shoe designer of the postwar period was Beth Levine. She was one of only a handful of women shoe designers in the twentieth century, and she saw potential, rather than limitation, in nontraditional shoemaking materials and forms. Modern materials, such as nylon, vinyl, and Astroturf, as well as everyday materials like paper, were used by Levine in her creative process. She was the first to use Lycra—an elasticized material invented at DuPont in 1958 and intended for use in girdles—to make formfitting boots, presaging its widespread use in the shoe industry later in the century. Her 1957 No Shoe design—a pair of high-heeled soles with surgical adhesive pads made for her by Johnson & Johnson to adhere directly to the wearer's feet—was ahead of its time. She revisited the idea in 1965, making the heel lower and edging the sole with plastic leaves to create a pair of shoes suitable for the Garden of Eden (FIG. 16).

FAUX FLOP

While designers such as Levine were pushing the envelope of shoe design, even conservative shoe companies were eager to try out new materials, albeit in more conventional ways. Faux leather had long been a dream of shoe manufacturers, but every attempt had resulted in material that lacked breathability, making it unwearable. DuPont's debut of poromeric Corfam in 1963 presented one promising solution. Thousands of pairs of Corfam shoes were made and sold, but complaints poured in. The shoes were uncomfortable, they never felt "broken in," and they did not effectively dissipate moisture. Despite all of DuPont's efforts, and the estimated eighty to one hundred million dollars spent on development, Corfam was discontinued in 1971, and comfortable faux leather remained out of reach.[21]

FIG 14 *(opposite)*
Invisible Sandal,
Salvatore Ferragamo.
Italian, 1947.
Collection of the Bata
Shoe Museum

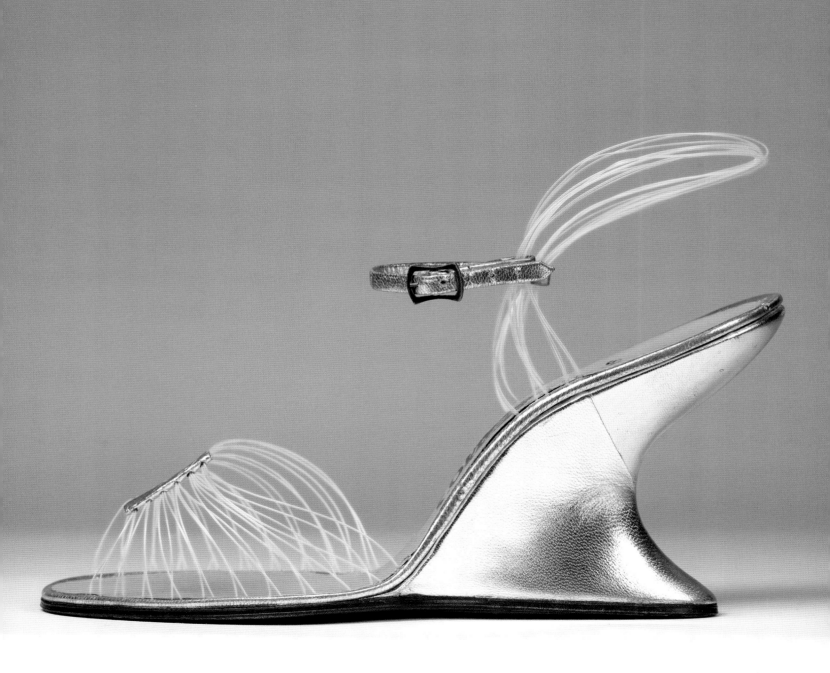

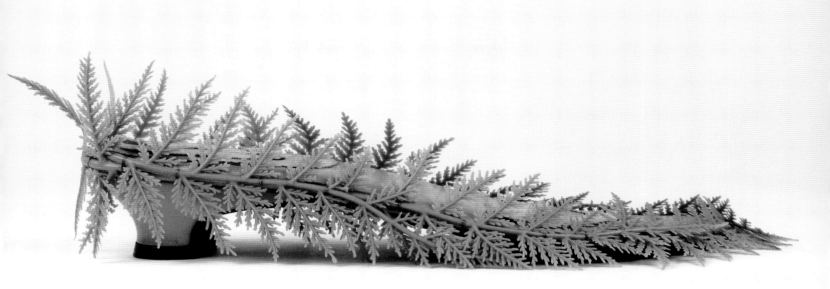

Despite the failure of some innovations, the belief that science and technology, especially the race to space, would shape the future in positive ways dominated the footwear industry and energized inventors and designers. French designer André Courrèges's space-age designs, including boots, helped define fashion in the early 1960s. The boots worn by Apollo 11 astronauts Neil Armstrong and Edwin E. "Buzz" Aldrin Jr. in 1969, when they became the first humans to step onto the surface of the moon, were conceived with safety in mind. They relied on cutting-edge materials, including woven chromium steel and silicone rubber, and incorporated thoughtful design, such as a sole patterned with ridges shaped to fit the rungs of the lunar module ladder.[22]

OFF AND RUNNING

Beyond lunar exploration, the greatest frontier for shoemaking in the 1960s was in athletic footwear. The rubber-soled, canvas American sneaker had changed only subtly over the decades. German and Japanese companies, however, began to ramp up their research and development efforts to create lighter, better fitting running shoes as jogging grew in popularity and the stakes in competitive running were rising. In 1968, Puma tried Velcro—invented in 1941—as a lace replacement on its controversial Brush Spike running shoes. Velcro allowed a more customizable fit (**FIG. 17**). Adidas experimented with lightweight knit nylon in 1971 when it debuted the Americana.[23] Bill Bowerman, American coach and cofounder of Blue Ribbon Sports, later named Nike,

FIG 15 (*opposite*) Silk-covered steel heel, Roger Vivier for Christian Dior. French, 1956. Collection of the Bata Shoe Museum

FIG 16 (*above*) No Shoes, Beth Levine, Herbert Levine. American, 1965. Collection of the Bata Shoe Museum

27

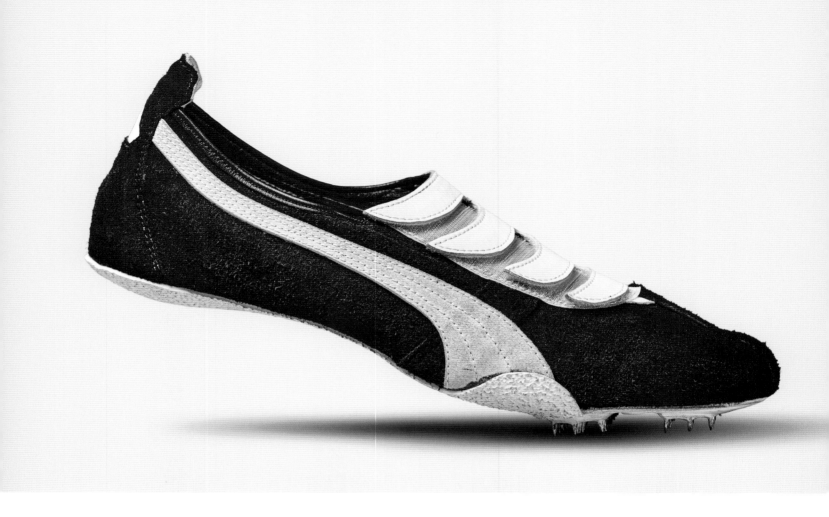

was experimenting with nylon in an effort to create exceptionally lightweight running shoes. He was also experimenting with ways to reduce the weight of sneaker soles. Nike's 1974 Waffle Trainer married a lightweight nylon upper with a low-weight, high-tread sole famously inspired by experiments Bowerman carried out by pouring melted urethane into his family's waffle iron. The shoe also owed no small part of its success to the fact that it was eye-catching, and it easily began to cross over from fitness to fashion (**FIG. 18**).

As the running craze grew in North America, so did the pressure to create lightweight sneakers, and many companies began to experiment with various sole materials. Thermoplastics, such as ethylene-vinyl acetate (EVA), began to be used to make lightweight foam that was flexible, provided great cushioning, and had excellent rebound. Nike used a version of this in its 1971 Nike Cortez, and it quickly became a standard feature in sneaker production. However, the most revolutionary idea that emerged in the 1970s came from innovator and former aerospace engineer Frank Rudy, who suggested that Nike try encapsulated air in its soles.

The use of air as a means of providing cushioning was already a central feature of the Dr. Martens AirWair, and the idea of incorporating an air bladder into the sole of a shoe goes back at least as far as 1931, when Adolf Schaffer received a United States patent for

FIG 17 (below)
Brush Spikes, Puma.
German, 1968.
Collection of Puma
Archives

FIG 18 (opposite)
Waffle Trainers, Bill
Bowerman, Nike.
American late 1970s.
Collection of the Bata
Shoe Museum

28

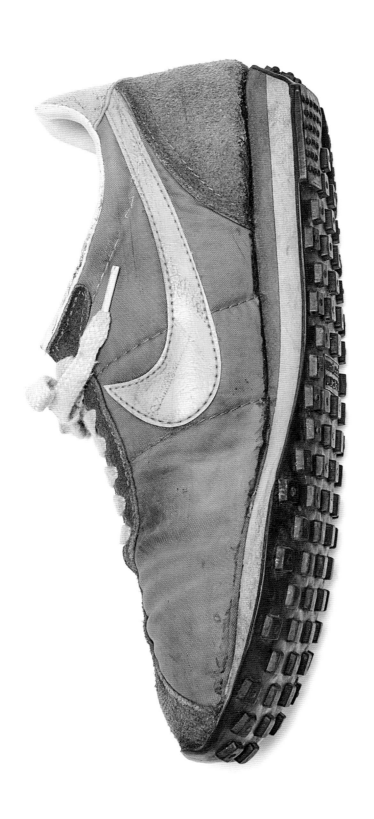
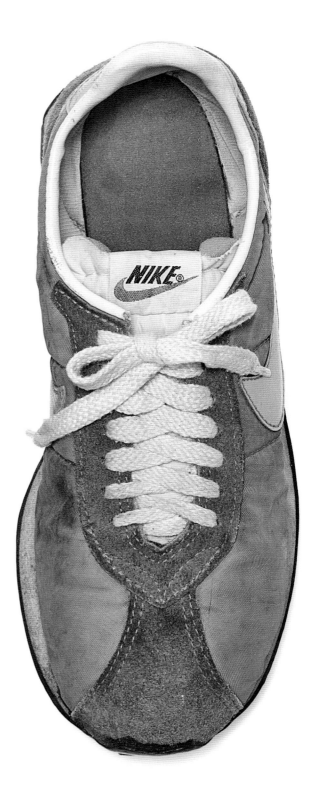

"Pneumatic soles filled with a compressible fluid, e.g., air, gas." However, its use in athletic footwear only started in the 1980s. The first Nike sneaker to feature Rudy's invention was the Tailwind, which came out in 1978. It was followed by the Air Force 1 in 1982, and then in 1987 the Air Trainer 1 and Air Max 1, both designed by Tinker Hatfield. While the Air Trainer 1 was revolutionary because it was the first cross-training shoe, it was the Air Max 1 that spoke to the future. Inspired by the architecture of the Centre Pompidou in Paris, Hatfield decided to reveal the air bladder hidden inside the sole of the Air Max 1 by incorporating a small "window" in the outsole (FIG. 19).

Hatfield had a way of capturing the zeitgeist and transforming it into footwear. He took over the design of Air Jordans in 1987 and created the Air Jordan III, and it was Hatfield, along with Mark Parker, who designed the futuristic self-lacing sneakers with light-up soles that the main character Marty McFly wore in the 1989 movie *Back to the Future Part II* when he travels into the then distant future year 2015. Although auto-lacing was years in the future, the dream of laceless sneakers was already being pursued in the 1980s. Nike's Air Pressure, designed by Bruce Kilgore in 1989, featured an air pump for customizable fit, but it was the Reebok Pump that captured the market.

The Pump was designed by Paul Litchfield, a key innovator and a member of Reebok's Advanced Concepts team. Inspired by the use of inflated air bladders in ski boots to create a firm, customizable fit, Litchfield began developing a mechanism that would allow a pump integrated into the tongue of a sneaker to be manually inflated by a concealed

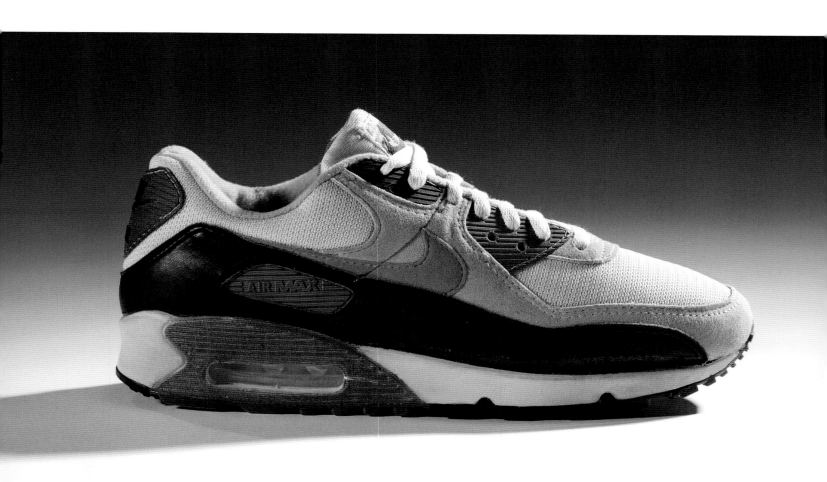

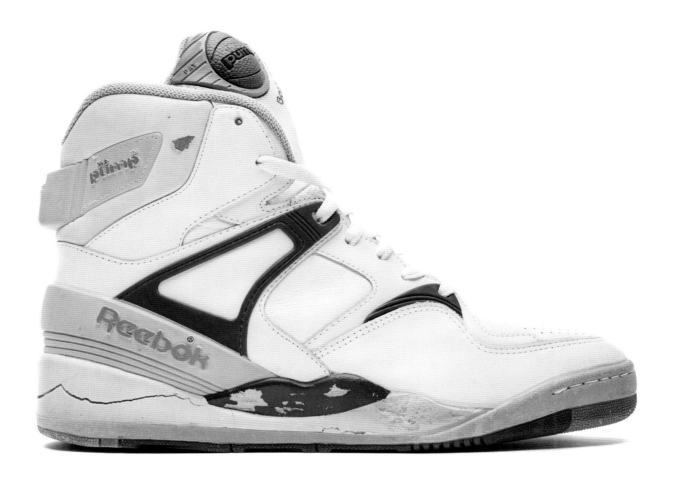

bladder. The Pump's cutting-edge technology combined with its cheeky basketball-shaped pump, bold marketing campaign, and an unprecedented price tag of $170 made it one of the most sought-after sneakers of the period (**FIG. 20**). Puma was also interested in the potential of laceless sneakers, but it went in a different direction. In 1991 Puma released the Puma Disc XS 7000, the first sneaker to replace laces with an internal wire system that could be tightened or released with the aid of a disc at the tongue.

SMART SHOES

All of the laceless innovations were groundbreaking, but they still did not rival the technology imagined in *Back to the Future Part II*. Yet technological strides were being made and computers were beginning to be pressed into service to improve both athletic performance and sneaker production. Adidas was at the forefront of this technology wave with its revolutionary Micropacer, released in 1984 (**FIG. 21**). It featured a microsensor in the left toe that could record distance, running pace, and caloric output, and the information was readable on a screen found on the lace cover of the left shoe. Puma's RS-Computer shoe, designed by inventor Peter Cavanagh a few years later, not only had a computer chip in the heel that could record distance and time, but also came with a software package, program disc, and connector cable so that the shoes could be linked to a home computer for analysis.

FIG 19 (*opposite*)
Air Max 1, Tinker Hatfield, Nike. American, 1987. Department of Nike Archives

FIG 20 (*above*)
Pump Prototype, Paul Litchfield, Reebok. American, 1989. Reebok Archives

31

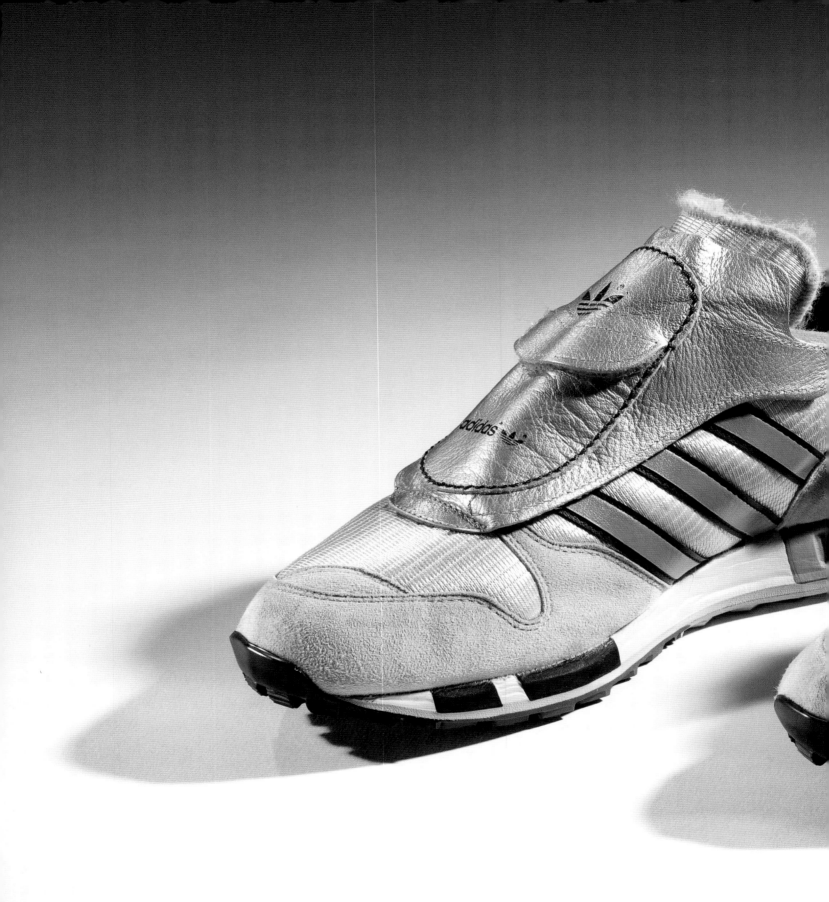

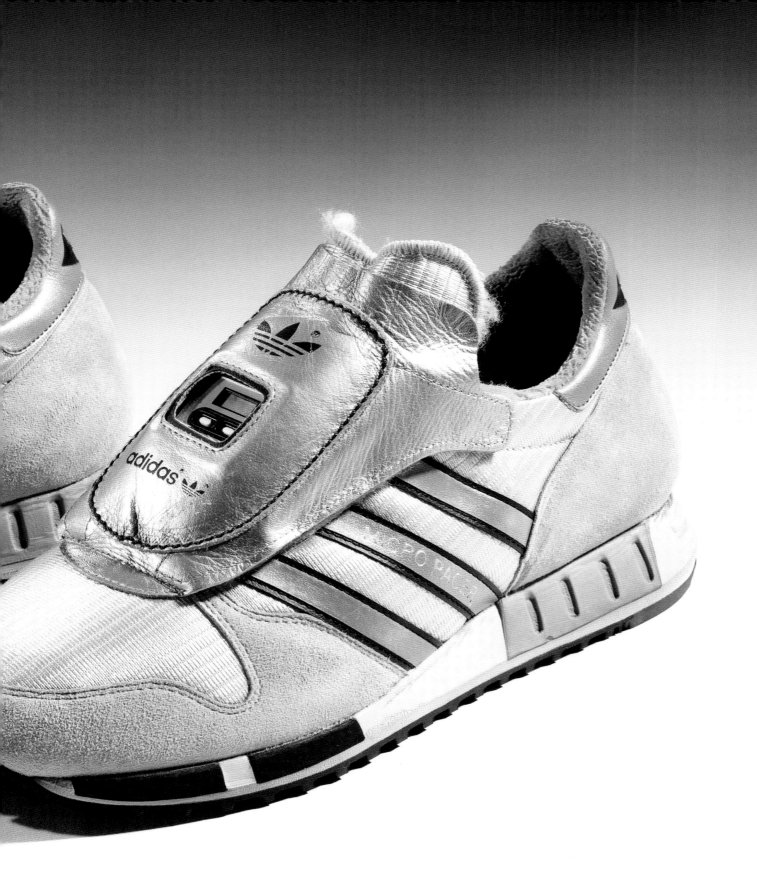

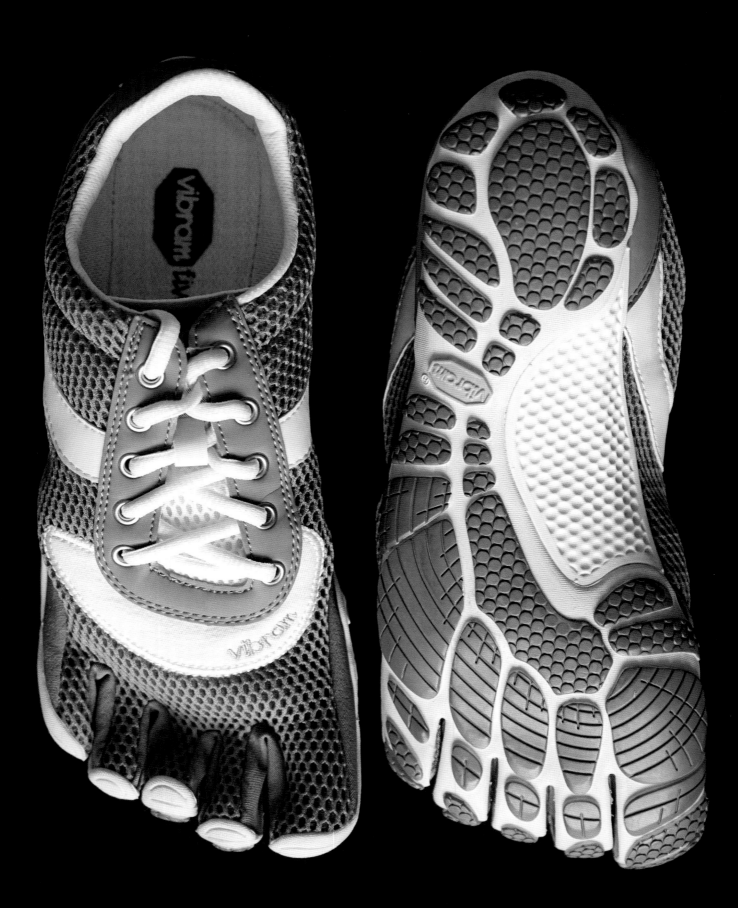

Computers were also changing the way that footwear was being designed and manufactured. In the 1950s, computers began to be used for drafting, but it was not until the late 1960s that 3D CAD/CAM (Computer Aided Design/Computer Aided Manufacturing) was invented. Pierre Bézier, an engineer at Renault, created the system for automotive design, but it had much broader utility. When the desktop computer entered the workplace in the 1980s, a range of CAD/CAM options came on the market, and their use became standard in many industries, including footwear design and manufacturing. The technology was precise. It optimized the manufacturing process, provided clear visualization of the designed product, and both shortened turnaround times and decreased material wastage.[24]

3D printing, an innovation that is only now revolutionizing footwear production, was also invented in the 1980s. Charles Hull developed the idea when he was creating lamps that could be used to UV-cure resin. He believed that if polymer resin could be used to build objects one layer at a time, using UV light to cure and bond each layer, a new production process could be created.[25] What was so revolutionary about this approach was that it allowed extremely intricate and complicated designs to be built in ways that did not require the time-consuming and wasteful carving of physical materials or expensive mold-making.

BACK TO NATURE

Although technology was revolutionizing athletic footwear, by the 1990s many began calling for running shoes that allowed feet to be more "natural." Many companies introduced pared down footwear, including Nike's 1991 Air Huarache, with a foot-hugging neoprene inner sock, and Reebok's 1994 Instapump Fury, a sneaker stripped of unnecessary components[26] (see page 54). But in the early 2000s, the biomechanics of barefoot running were grabbing both industry and public attention. Harvard professor Daniel Lieberman and his team had been studying the role of running in human evolution, and their work, published in *Nature* magazine in 2004, posited that the human body had evolved to perform endurance running and that supportive athletic footwear was potentially unnecessary.[27] Tobie Hatfield, brother of Tinker and designer of running shoes at Nike, had long been a proponent of minimalist shoe design. After watching Stanford athletes practice barefoot on grass in 2001, he worked with designer Eric Avar to create the lightweight Nike Free Runner. Released in 2004, it launched a new, hugely successful line for the brand. Vibram also began to offer barefoot runners. Introduced in 2006, Vibram FiveFingers were gloves for the feet, designed to fit like a skin, separating each toe in a way that many onlookers found unsettling (FIG. 22).

LIT

This desire for a back-to-nature approach in running shoes at the turn of the twenty-first century stood in stark contrast with the chunky platforms favored by club kids and the craze for soles that lit up with each step. Shoes with lights had been tried before—newspaper reports from the 1920s mention women's heels with little lightbulbs, the 1970s saw novelty shoes such as the Arthur Murray brand of disco shoes that incorporated lights, and in 1983 the Italian company Lotto offered lights that could be attached to the heels

FIG 21 *(previous)*
Micropacer, Adidas,
German, 1984.
Collection of the Bata
Shoe Museum

FIG 22 *(opposite)*
Vibram FiveFingers.
Italian, 2015

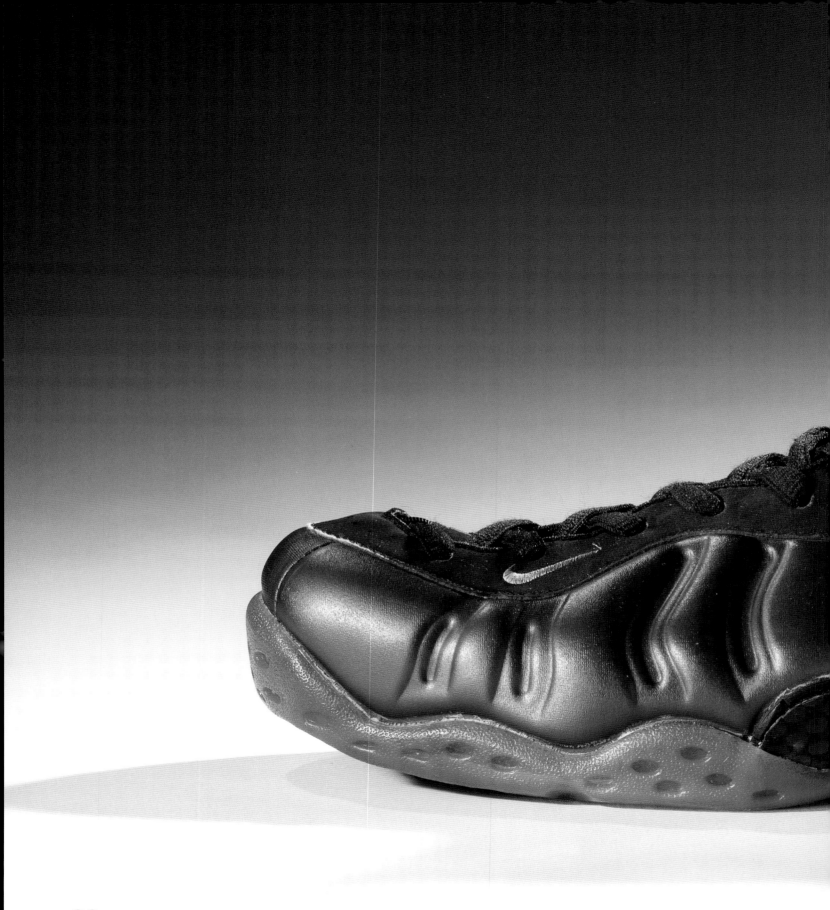

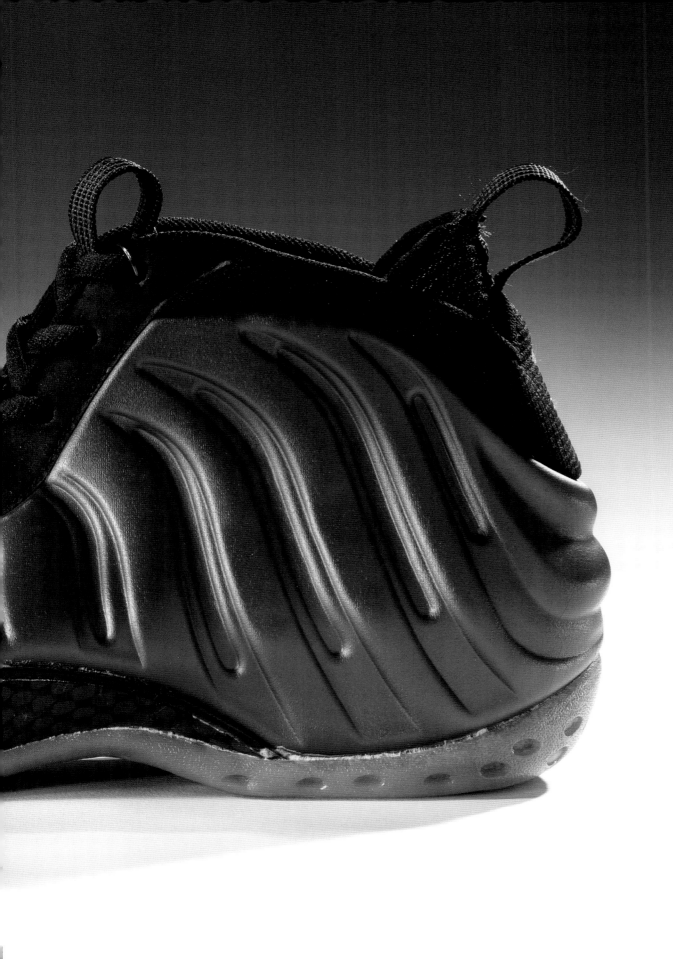

of running shoes to ensure safety at night—but it was not until 1992 that the fashion took off with LA Gear offering Light Gear for adults and Kids Lights for children. These shoes used light-emitting diodes (LEDs) that lit up with each step, and soon this technology was being used by many different brands, especially those focused on children's footwear. The novelty of twinkling shoes made them extremely popular, but there was growing concern about the levels of mercury in the batteries used to power the lights. Their prevalence in children's footwear and reports that discarded shoes were leaching mercury into landfills resulted in boycotts of the company. LA Gear began to accept returns, discontinued the use of the batteries, and paid for environmental cleanup, but the stigma remained. The headline-grabbing coverage also reflected the growing concern about the impact that the footwear industry was having on the environment.

FOAM FITTING

The soles of many trendy shoes rose to great heights in the mid-1990s. For example, the Buffalo boots made famous by the Spice Girls rivaled the platforms of the 1970s in height. Rather than being made of ponderous wood or light cork, however, many of the descendants of those earlier platforms featured sneaker-inspired soles made of molded foam rubber. It was also in this period that the head of Nike's advanced product engineering group, Eric Avar, began exploring the possibility of making uppers, not just soles, with foam. The radical Foamposite One, followed by the Foamposite Pro, both released in 1997, achieved just that, but not without effort (**FIG. 23**). Avar began by imagining a foot dipped in a liquid that would mold itself seamlessly to the foot. From there he began to think about the material that would be required to achieve this vision. This led to an unexpected partnership between the South Korean company Daewoo and Nike, which led to creation of the polyurethane-based materials that would compose the shoe. Although the royal blue color and the undulating design were in part inspired by nature—Avar had been studying the exoskeletons of beetles—the shoe looked so futuristic that it received a very mixed reception when it was released. The design seemed doomed, so the costly molds used to create it were destroyed.[28] However, it went on to become one of the most iconic designs of all time and its innovative technology was incorporated into numerous sneakers.

The idea of an entire shoe made of foam was also behind the Croc, a form of footwear that elicited even stronger reactions. Crocs began with the development of Croslite, an injection-molded EVA-based foam invented by the Canadian company Foam Creations. In 2001, the company debuted a Croslite sandal designed for boating that caught the eye of three friends, Scott Seamans, Lyndon Hanson, and George Boedbecker Jr.[29] The trio bought the rights to the Croslite technology and created Crocs. The clog-inspired shoes were durable, comfortable, gender neutral, made for all ages, and available in a rainbow of colors. The demand was unprecedented, and when Crocs went public in 2006, its initial public offering was the largest in footwear history. However, the popularity of Crocs plummeted with the recession in 2008. For a return to popularity, Crocs would have to wait until 2017, when fashion designers, influencers, and Gen Zers catapulted them back into the limelight (**FIG. 24**).

FIG 23 (previous) Foamposite, Eric Avar, Nike. American, 1997. Department of Nike Archives

FIG 24 (opposite) Rainbow Crocs. American, 2019. Collection of the Bata Shoe Museum

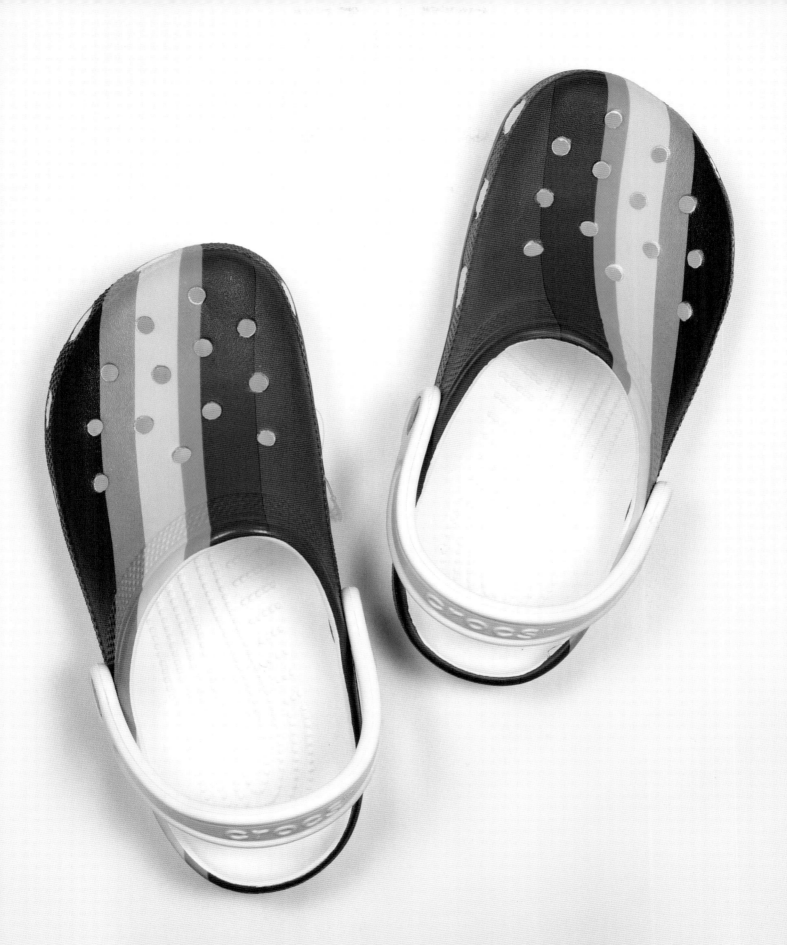

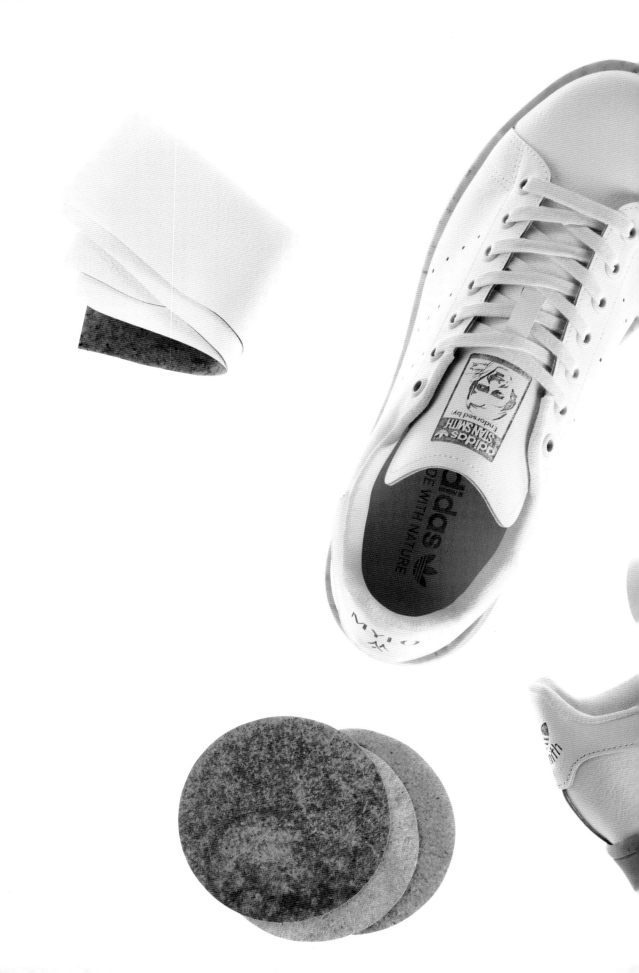

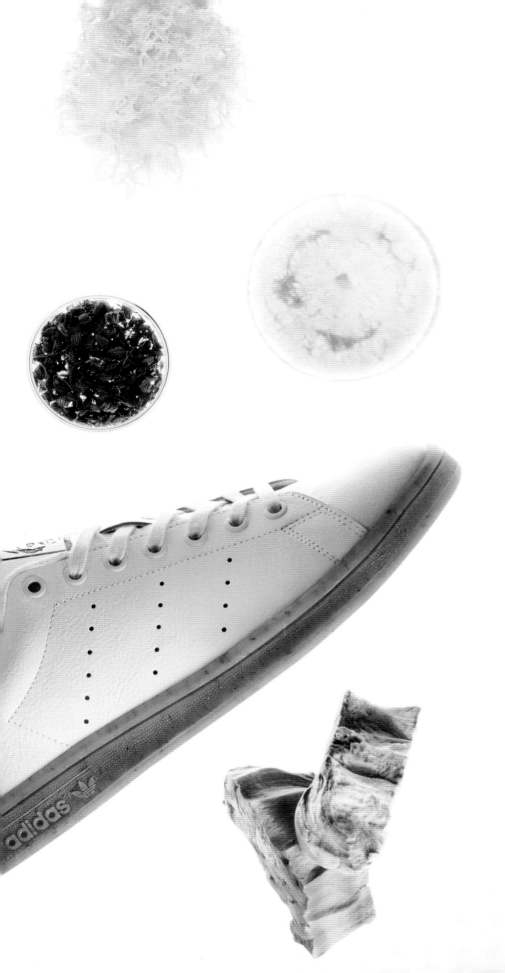

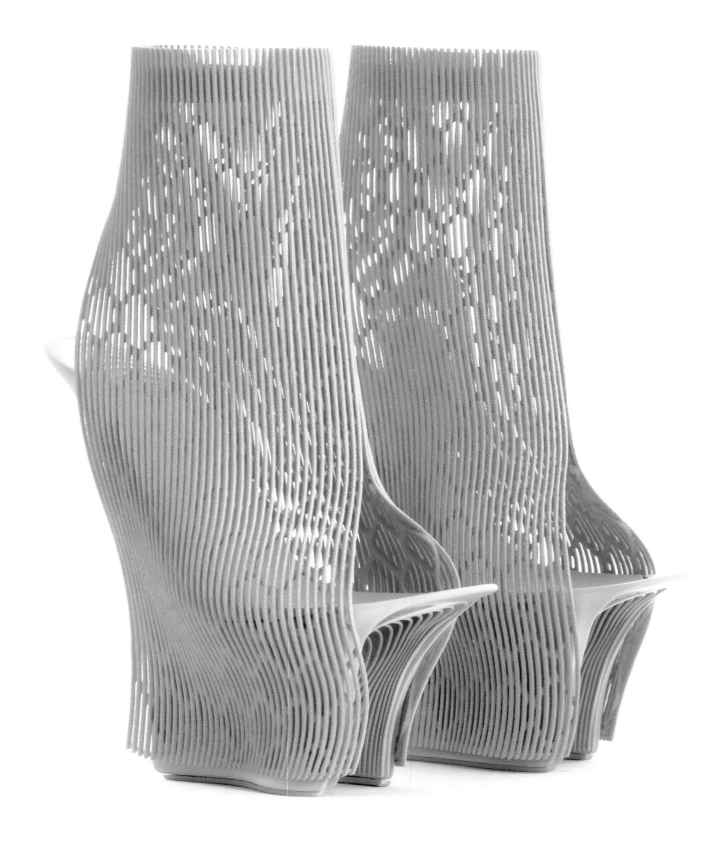

FIG 25 (*previous*)
Mushroom leather Stan
Smith, Adidas. German,
2021. Adidas ag

FIG 26 (*opposite*)
Ilabo, Ross Lovegrove
x Arturo Tedeschi x
United Nude. Trans-
national, 2015

WASTED

One of the most common criticisms of Crocs when they debuted in 2002 was that, similar to other footwear crafted from synthetic materials, they did not naturally degrade in landfills. In fact, the huge amount of physical waste produced by the manufacturing processes of the wider footwear industry, as well as the frequently deplorable conditions for factory workers, was starting to receive widespread public attention in the West in the early 2000s. In response to the increased scrutiny, some companies began to address conditions in their offshore factories and to seek out ways to become more environmentally responsible.[30] Many companies developed codes of conduct and began to publish yearly reports on their factories and suppliers, but of all the attempts to address these issues while sustaining profitability, the most futuristic was Adidas's automated Speedfactory. In 2015 Adidas announced that it would open an experimental, nearly fully automated factory in Ansbach, Germany. By decentralizing and automating production using high-tech methods, labor, manufacturing, and distribution costs could be kept low, as could environmentally damaging waste and emissions caused by shipping products across the globe. In 2016, the new factory opened with a small number of workers overseeing the robotic machines fabricating the 3D printed soles and knit uppers of the Futurecraft MFG (Made for Germany). Hopes were high: if the venture was successful, Adidas planned to build Speedfactories around the world, meeting and responding to the needs of consumers on a local level. In 2017 a second Speedfactory opened in Atlanta, but by 2020 the two factories had been shuttered.[31] In the end, it became clear that human workers were nimbler and more capable of adapting to change. Robots simply were not flexible enough to meet the ever-changing demands of the sneaker business.

GILL NETS AND MUSHROOMS

The Speedfactory was not the only innovation that Adidas experimented with in an effort to change. The company also sought out new materials and partnerships. Adidas's collaboration with Stella McCartney, a fashion designer long dedicated to the use of cruelty-free materials, began in 2002, and over the years, she and Adidas have experimented with a wide range of materials, the most recent being mushroom leather. First available in 2015, mushroom leather is beneficial from both an environmental and an efficiency perspective, as it is formed using the root-structure of fungi and can be processed and ready to use in only a matter of weeks (**FIG. 25**). Mushrooms are not the only plants being used in this way. The explosion of toxic algae worldwide has encouraged experimentation with algae in the creation of pliable foam similar to EVA yet biodegradable. The 2021 Yeezy Foam Runner was made using this algae-derived foam. Adidas also partnered with Parley for the Oceans to find a way to recycle ocean plastics (see page 102). This resulted in the groundbreaking Parley for the Oceans x Adidas x Alexander Taylor sneakers that incorporated recycled gill nets. More importantly, Adidas has pledged to be virgin-plastics-free by 2024.[32]

A number of new sneaker companies, such as Veja and Allbirds, that are specifically dedicated to sustainability emerged in the 2000s. Many also pledged to be transparent about their factories, ethics, and materials and sought certification as B Corps, which meant that

they meet the "highest standards of verified social and environmental performance, public transparency, and legal accountability to balance profit and purpose."[33]

Efforts to reduce waste have pushed improvements in the technology used to create footwear, resulting in some startling new designs. Improvements in 3D printing are allowing designers to create unprecedented forms, such as the architectural works by Rem D. Koolhaas with the late architect Zaha Hadid and fashion designer Iris van Herpen (FIG. 26). The printing of these complex designs results in no material waste, as nothing needs to be cut away, carved out, or molded in physical form. Similarly, knit technology—both Nike and Adidas released knit sneakers in 2012—allows shoe uppers to be created with up to 80 percent less material waste.[34]

The recycling of footwear has also grown in importance. In 2003, Nike offered to take back old sneakers and recycle them into a material that is used to make playground surfaces (FIG. 27). The early 2000s saw numerous community efforts to collect worn footwear and redistribute it to populations in need. The popularity of the Internet and the creation of eBay also allowed for the redistribution of older models and deadstock to an ever-growing group of sneaker collectors. This trend has only grown over the years and now online platforms exist that allow the constant reselling of increasingly valuable sneakers. These include StockX, "the stock market of things," and Goat, a "global platform for the greatest products from the past, present, and future," both established in 2015.

UNREAL

Blurring the line between the real and virtual worlds has led to some intriguing footwear developments, from the boots donned by avatars to the launch of collectible non-fungible token (NFT) sneakers and the limitless potential in virtual reality (VR). The ability to dress virtual dolls was created in the early 1990s, when a Japanese programmer known only as MIO.H created the Kisekae Set System (KiSS) that enabled computer users to drag and position items of clothing, including footwear, onto figures in a manner similar to the dressing of traditional paper dolls.[35] This pastime became hugely popular in Japan, and by the mid-1990s it went global. Computer-based role playing games (RPGs) began in the 1980s with very rudimentary character development capabilities, but by the early 2000s games featured programs with robust character creation capabilities, allowing players to customize the clothing and footwear, among many other aspects, of their avatars. Massively multiplayer online games (MMOGs), such as City of Heroes, which released in 2004, allowed players to customize their characters through clothing choices, including footwear—style, color, materials, and details could all be selected. Many of these games also made some styles or outfits attainable only through the completion of missions or by spending earned in-game currency as a means of allowing players to flaunt their success.

Dress options in MMOGs, including all of the customizable items, were assets specifically built into each game. Second Life by Linden Lab, released in 2003, diverged from this model by allowing players to design, create, and sell original items. Second Life was an MMOG, but it wasn't actually a game, as it had no other objective than allowing people to inhabit an alternative, virtual reality.[36] When Second Life began, players arrived

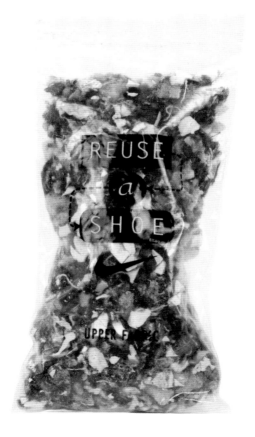

FIG 27 (below)
Reuse-a-Shoe, Nike. American, 1996. Collection of the Bata Shoe Museum

on an uninhabited wooded island and, with tools they were given, were able to build the infrastructure in any way they chose. What quickly developed was a retail economy in which players could create anything that could be found in real life. Second Life users were allowed to own the "intellectual property" of their "in-world" creations, but legal disputes over the rights of creators began to spill over into the real world.[37] One of the first lawsuits between avatars was a claim for damages over the theft of two boot designs. The plaintiff, Second Life player and in-game designer Teasa Copprue (avatar name: Asri Falcone) accused fellow player Thomas Simon (avatar name: Rase Kenzo) of stealing her designs, including her bestselling Cum F**k Me (CFM) Boots and her Celine Boots, and flooding the in-world virtual market with lower priced copies, resulting in real financial loss.[38] Copprue was joined by five other Second Life designers with similar claims against Simon, and the case went to court in 2007. Using existing copyright laws, attorney Francis Taney won the case by arguing that the plaintiffs' virtual designs were protected as pictorial, audiovisual, or literary (code) works. Although the amount awarded in damages was nominal, it was a groundbreaking case.

The porousness between the real and virtual worlds became an increasingly important part of other game franchises, especially sports games. EA Sports and 2K Sports both rose to fame by creating games that sought to replicate the experience of playing on actual sports teams, such as the NBA and NFL, but as famous players. Sneakers grew increasingly important in these games as more players wore signature shoes, and the graphic capabilities in the games evolved to become sophisticated enough to allow high-fidelity details, such as individualized sneaker design. In 1999 2K was the first to introduce a real-life player in a signature shoe when it depicted Allen Iverson wearing his Reebok Answer IV. In 2012, 2K worked with Nike on a Shoe Creator mode that allowed players to customize sneakers for in-game athletes; the most successful players were able to unlock in-game virtual "consultations" with Tinker Hatfield.[39] Epic Games brought the Jordan brand into Fortnite in 2019 with a Jordan "skin" pack drop that included the in-game exclusive Air Jordan I. The popularity of the sneakers in Fortnite had older sneakerheads complaining online that when they wore their Air Jordan Is in public they now feared hearing an "annoying little kid" say, "Mommy, look, he's wearing shoes from Fortnite."[40] Aggravation aside, the success of this collaboration pointed to the continued relevance of the Jordan brand at a time when many of the children playing the game didn't even know of basketball legend Michael Jordan.[41]

Technology has also impacted how footwear is marketed and consumed. Shopping online for footwear was commonplace by the early 2000s but being able to virtually try on a shoe from home before buying is a more recent development. In 2010 Converse worked with the Sampler app, which allowed customers to try on shoes from its online catalog virtually using their own phones.[42] More recently the company Wannaby, established in 2017, created technology that allows potential consumers to try on shoes virtually. Gucci was first to use Wannaby's in-app augmented reality (AR) feature to "ARket" its shoes and introduced the app in conjunction with the release of its Ace sneaker in 2019.[43] The COVID-19 pandemic that swept across the globe starting in late 2019 made virtual try-on technology even more enticing as social isolation severely restricted, and in some places

eliminated, in-store purchasing. The multimedia messaging app Snapchat partnered with Wannaby in 2020 to leverage the potential of "shoppable AR."[44] Although the use of shoppable AR is in its infancy as this book goes to press, it is reported that companies that have started using it are seeing higher numbers of purchases and lower numbers of returns.[45] In addition, users are widely sharing images of virtual shoes on their feet across social media, providing companies with another means of "free" advertising. These uses of AR suggest that the design of a shoe is of principal importance, but AR is also being used to assist in the fit and feel of footwear. In 2019 Nike introduced the Nike Fit app, which uses AR to scan customers' feet using their smartphone cameras and then, using a thirteen-point measuring system, maps each foot to assess appropriate shoe size.[46] A challenge with AR, however, is that it is powered by artificial intelligence (AI), and while this allows for dynamic interactions, AI often has built-in biases that can result in inaccurate tracking for many non-white and gender nonconforming users.[47]

One of the most interesting recent footwear-related developments is the rise of collectible NFT sneakers that exist only in the metaverse. In early 2020, an image of Elon Musk wearing a remarkable pair of sneakers inspired by Tesla's controversial Cybertruck went viral (FIG. 28 and FIG. 29). While over one million people saw and shared the image, neither the sneakers nor the image was "real." They were both digital and had been made by a collective of three friends called RTFKT. The company was flooded with inquiries about the sneakers. Collectors wanted to know how the sneakers could be acquired, but few understood that they were NFT sneakers, meaning that they existed only virtually and that the winning bidder would have to pay using cryptocurrency and in return would receive the virtual sneakers and proof of ownership via a section of a blockchain, an imputable virtual ledger. When the OG Cybersneaker went up for auction on October 13, 2020, the collector LandBaron offered 65 ETH (Ether, the cryptocurrency of the Ethereum network), equal to $24,592 at the time but withdrew the bid when he found out that the sneakers did not exist physically. They were ultimately sold to EricwithAC for 30 ETH ($11,357).[48] In March 2021, RTFKT auctioned off six hundred NFT sneakers, incorporating the artwork of eighteen-year-old digital artist FEWOCiOUS. They were all sold within seven minutes and the auction earned $3.1 million.[49]

Of central importance to the collectibility of NFT sneakers is that the use of the blockchain authenticates proof of ownership. Indeed, authenticity has long been central to the wider appeal of sneaker collecting. StockX, Goat, and eBay all guarantee the authenticity of the sneakers they sell. Those sold by eBay have a scannable tag that provides detailed information about the assessed pair's authenticity.[50] Authentication apps are growing in popularity as increasing numbers of people buy and resell high-value sneakers on their own. The Legit app, started in 2019 by two brothers then in their teens, offers free educational information so that customers can decide for themselves, as well as expert authentication for which there is a charge.

One factor that is taken into account in the assessment of high-value sneakers is whether or not they have been worn, and to wear or not to wear a pair of sneakers is a hotly debated topic. Virtual footwear sidesteps this controversial issue as it can only be "worn" by avatars in games or used in metaverse spaces, such as Decentraland, the

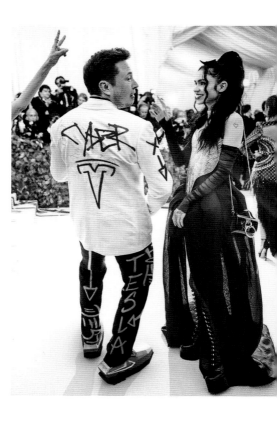

FIG 28 (above)
RTFKT-altered image of Elon Musk wearing Cyber Sneakers, RTFKT. Tans-national, 2020. Collection of RTFKT

FIG 29 (opposite)
Cyber Sneaker, 2020. RTFKT

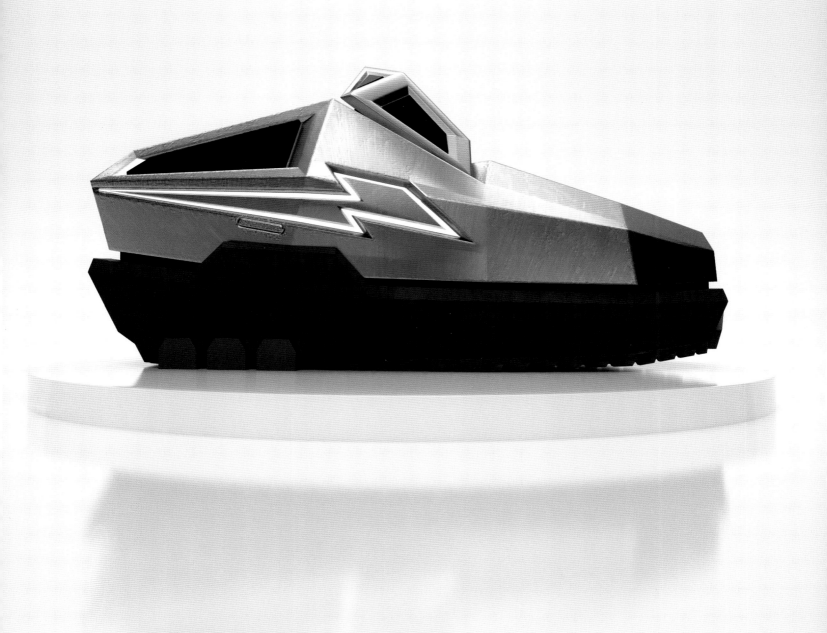

Sandbox, and Nike's new Nikeland. This means that while individuals may own exclusive footwear, they are currently limited to seeing only representations of themselves shod in these desirable shoes. In VR the ability to *feel* like you are wearing footwear is an exciting possibility for the future. Since virtual footwear is not constrained by practical purpose, it has the potential to offer unprecedented sensory experiences. Full-body trackers that are worn by users so that their movements can be tracked in VR already exist and progress is being made concerning locomotion—EKTO VR has devised a form of wearable robotic footwear that matches the wearer's motion in headset while keeping them in the center of the room (see page 238)—but haptics, the sensation of touch, remain a challenge (FIG. 30). Once this is resolved, footwear in VR will further enhance the immersive experience.

FUTURE FOOTWEAR

As the history of shoemaking shows, since the beginning of the industrial age, footwear and footwear production have been constantly propelled forward by innovation and reflective of shifting needs and desires. The footwear of the future will surely continue to be shaped by those who can imagine new possibilities and see potential in novel methods and materials, but it will also require creators who are willing to be thoughtful and responsive to social change and environmental concerns. The following pages explore some of the most extraordinary shoes currently being made and offer insight into the minds of visionaries who are imagining today what we will be wearing tomorrow. ✱

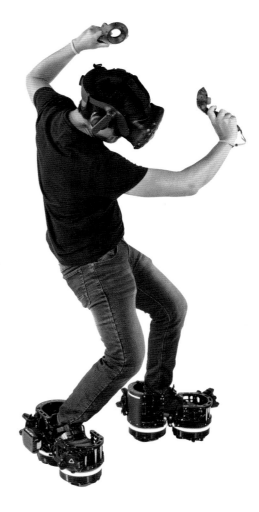

FIG 30 (*right*)
EKTO One, EKTO
VR. American, 2020.
Collection of EKTO VR

ENDNOTES

1 The metaverse can be loosely defined as online worlds where individuals can interact via avatars in virtual spaces.

2 For more information on early American shoemaking and consumption, see Kimberly S. Alexander, *Treasures Afoot: Shoe Stories from the Georgian Era* (Baltimore: John Hopkins University Press, 2018).

3 For more information, see "The History of Shoemaking in North America," in *Berg Encyclopedia of World Dress and Fashion*, ed. Phyllis G. Tortora (London/New York: Berg Publishers/Oxford University Press, 2010), 128–34.

4 Salo Vinocur Coslovsky, "The Rise and Decline of the Amazonian Rubber Shoe Industry: A Tale of Technology, International Trade, and Industrialization in the Early 19th Century" working paper (Cambridge, 2006): 11–12.

5 "The Charles Goodyear Story," Goodyear, accessed November 2, 2016, https://corporate.goodyear.com/us/en/about/history.html

6 Thomas Hancock, *Personal Narrative of the Origin and Progress of the Caoutchouc or India-Rubber Manufacture in England* (Cambridge: Cambridge University Press, 2014), 107.

7 Joseph Sparkes Hall, *The Book of the Feet: A History of Boots and Shoes* (London: Simpkin, Marshall & Company, 1847), 131.

8 Elizabeth Semmelhack, *Shoes: The Meaning of Style* (London: Reaktion Press, 2017), 227–40.

9 Frederick J. Allen, *The Shoe Industry* (Boston: The Vocation Bureau of Boston, 1916), 61.

10 Semmelhack, *Shoes*, 122–23.

11 See Nazim Mustafaev, *Celluloid Heel* (Moscow: Shoe Icons Publishing, 2018).

12 "Protest Celluloid Heels: British Women Fear Blaze May Endanger Wearers," *Washington Post*, June 17, 1917.

13 Allison Marsh, "When X-Rays Were All the Rage, a Trip to the Shoe Store Was Dangerously Illuminating," *IEEE Spectrum*, October 30, 2020, https://spectrum.ieee.org/tech-history/heroic-failures/when-xrays-were-all-the-rage-a-trip-to-the-shoe-store-was-dangerously-illuminating.

14 *WANT: Desire, Design and Depression Era Footwear*. Bata Shoe Museum (January 30, 2019–March 30, 2020)

15 Elizabeth Semmelhack, *Collab: Sneakers x Culture* (New York: Rizzoli, 2019), 15.

16 "Radio: High School Sports Sell Shoes." *The Billboard*, February 26, 1944, 6.

17 "The Jelly Shoe by Jean Dauphant AKA La Méduse," TheHistorialist, October, 30, 1955, http://www.thehistorialist.com/2015/10/1955-jelly-shoe-by-jean-dauphant-aka-la.html

18 Douglas M. Bryce, *Plastic Injection Molding: Manufacturing Startup and Management* (Dearborn, MI: Society of Manufacturing Engineers, 1999), 1.

19 "Dr Martens' Sigh of Relief Over Copyright in AirWair Logo," *Pinsent Masons Out-Law News*, December 8, 2003, https://www.pinsentmasons.com/out-law/news/dr-martens-sigh-of-relief-over-copyright-in-airwair-logo.

20 Frances Walker, "Steel Heel Holds Up New Shoe," *Pittsburgh Post-Gazette*, November 8, 1951.

21 Gerd Wilcke, "E.I. du Pont Plans a Halt to Production of Corfam," *New York Times*, March 17, 1971.

22 The astronauts actually wore two types of footwear: pressure garment assembly (PGA) boots, which were integrated into their pressurized spacesuits, and lunar boots that they wore over their PGA boots for walking on the moon. The lunar boots featured fabric made of woven chromium steel and silicone rubber soles with ridges shaped to fit the rungs of the lunar module's ladder. See "Apollo Operations Handbook Extra Vehicular Mobility Unit," March 1971, https://www.lpi.usra.edu/lunar/documents/NASA%20TM-X-69516.pdf

23 Adam Jane, "Material Matters: How Nylon Changed the (Sneaker) World," *Sneakerfreaker*, January 24, 2018, https://www.sneakerfreaker.com/features/material-matters/material-matters-how-nylon-changed-the-sneaker-world

24 "The History—and Future—of CAD/CAM Technology," *Thomas Insights*, November 6, 2019, https://www.thomasnet.com/insights/the-history-and-future-of-cad-cam-technology/

25 "Charles Hull," National Inventors Hall of Fame, https://www.invent.org/inductees/charles-hull

26 Bill Bowerman had had a long-standing dream of creating a running shoe with a seamless socklike upper. This was realized by Bruce Kilgore when he designed the Sock Racer, released in 1985.

27 Daniel E. Lieberman, Madhusudhan Venkadesan, Adam I. Daoud, and William A. Werbel, Biomechanics of Foot Strikes and Applications of Running Barefoot or in Minimal Footwear (website), https://barefootrunning.fas.harvard.edu/index.html

28 Russ Bengtson and Nick Engvall, "20 Things You Didn't Know About the Nike Foamposite," *Complex*, May 7, 2020, https://www.complex.com/sneakers/20-things-you-didnt-know-about-nike-foamposites/

29 Meghan O'Rourke, "The Croc Epidemic," *Slate*, July 13, 2007, https://slate.com/news-and-politics/2007/07/how-crocs-conquered-the-world.html

30 "Nike Chronology," Center for Communication and Civic Engagement. https://depts.washington.edu/ccce/polcommcampaigns/NikeChronology.html

31 Devin Coldewey, "Adidas Backpedals on Robotic Shoe Production with Speedfactory Closures," *Tech Crunch*, November 11, 2019, https://techcrunch.com/2019/11/11/adidas-backpedals-on-robotic-factories/?ncid=txtlnkusaolp00000616 /

32 Michelle Lou, "Adidas Pledges to Only Use Recycled Plastic by 2024," *Huffington Post*, July 16, 2018, https://www.huffpost.com/entry/adidas-plastic-usage_n_5b4c9849e4b0e7c958fd6484

33 "About B Corps." Certified B Corporation. https://bcorporation.net/about-b-corps

34 Traditional uppers are cut out of flat material, such as leather or textile, leaving behind unusable scraps. Bonnie Tsui, "The Extraordinary Future of Shoes," *Bloomberg CityLab*, July 22, 2014, https://www.bloomberg.com/news/articles/2014-07-22/the-extraordinary-future-of-shoes.

35 Kisekae is a reference to kisekae ningyou, paper dolls that can be dressed in various paper outfits. "A slightly left-of-center history of KiSS," Left of Center, https://embyquinn.tripod.com/history.html

36 V3image, *A Beginner's Guide to Second Life* (Las Vegas: ArcheBooks, 2007), 10

37 V3image, *A Beginner's Guide*, 11.

38 Ian Harvey, "Virtual Worlds Generate Real Litigation," *Law Times*, February 11, 2008, https://www.lawtimesnews.com/news/general/virtual-worlds-generate-real-litigation/259438

39 Aaron Hope, "NBA 2K13 'Shoe Creator,'" *Sneaker News*, September 27, 2012, https://sneakernews.com/2012/09/27/nba-2k13-shoe-creator/

40 Mo Garba, 2019 comment on Hollow, "The New JORDAN Skin FREE REWARDS in Fortnite," YouTube, May 22, 2019. https://www.youtube.com/watch?v=UXEVOEITGKc&t=466s

41 Dan Carson, "Teacher Has to Explain Who Michael Jordan Is to Grade School Class," *Bleacher Report*, June 4, 2015, https://bleacherreport.com/articles/2486173-teacher-has-to-explain-who-michael-jordan-is-to-grade-school-class

42 Samantha McDonald, "These 10 Retailers Are Leading the Way in Augmented Reality," *Footwear News*, May 14, 2018, https://footwearnews.com/2018/business/technology/augmented-reality-retail-shopping-shoes-fashion-1202561189/

43 Nia Groce, "Gucci Beefs Up Tech with Augmented Reality App for Shoes," *Hypebeast*, June 26, 2019, https://hypebeast.com/2019/6/gucci-augmented-reality-shoe-app-launch

44 Maghan McDowell, "Snapchat Bets on Augmented Reality to Win at Social Commerce," *Vogue Business*, June 16, 2020, https://www.voguebusiness.com/technology/snapchat-bets-on-augmented-reality-to-win-at-social-commerce

45 McDowell, "Snapchat."

46 Gunseli Yalcinkaya, "Nike App Uses AR and AI to Scan Feet for Perfect Fit," *Dezeen*, May 9, 2019, https://www.dezeen.com/2019/05/09/nike-fit-app-ar-ai-trainers/

47 Lauren Thomas, "Lines Between Men's and Women's Fashion Are Blurring as More Retailers Embrace Gender-Fluid Style," CNBC, June 9, 2021, https://www.cnbc.com/2021/06/09/gender-fluid-fashion-booms-retailers-take-cues-from-streetwear-gen-z.html

48 RTFKT (@RTFKTstudios), "Just sold the CYBERSNEAKER to EricwithAC," Twitter, October 13, 2020, https://twitter.com/rtfktstudios/status/1316110555938254851

49 Rob Nowill, "A Sale of Virtual Sneakers Raised $3.1 Million USD in Seven Minutes," *Hypebeast*, March 3, 2021, https://hypebeast.com/2021/3/rtfkt-studios-fewocious-sale-nfts

50 "Authenticity Guarantee," eBay, https://pages.ebay.com/authenticity-guarantee-sneakers-seller/

PART 1
INNOVATIVE

Innovation has long driven footwear design, with each new material and production method meeting shifting needs and stoking desires. Today, innovation continues unabated. Cutting-edge technologies are being used by forward-thinking creators in startling ways, from responsive smart shoes to 3D-printed heels.

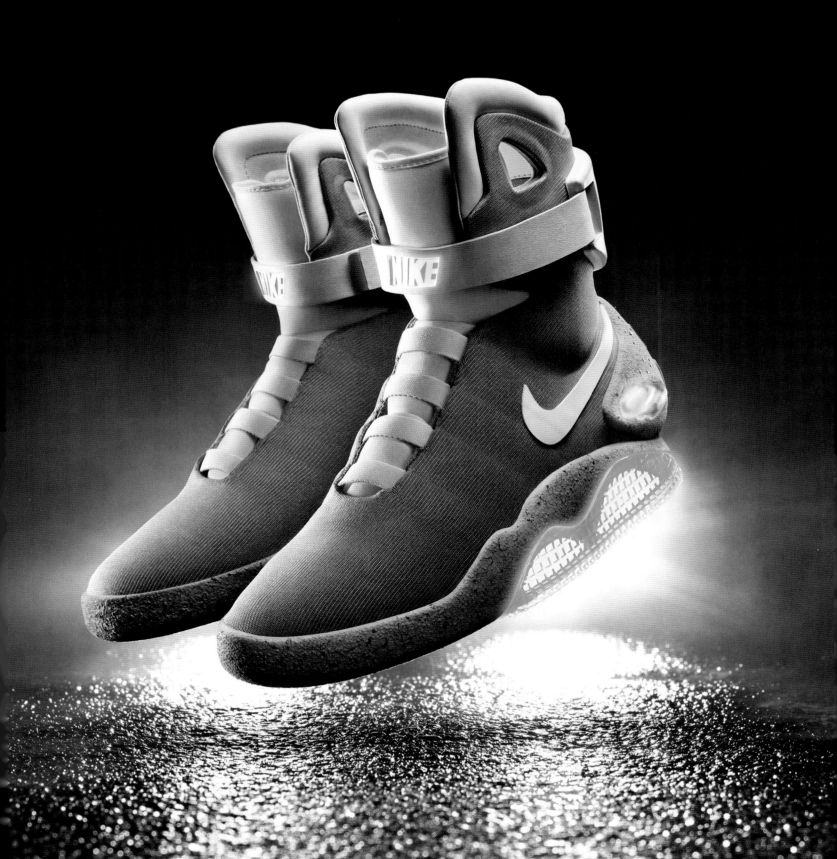

NIKE MAG

NO OTHER SHOE is more linked to dreams of future footwear than the Nike MAG worn by the character Marty McFly when he time-travels to the year 2015 in the 1989 film *Back to the Future Part II*. The movie shoes were designed by Nike's Tinker Hatfield and Mark Parker and when they began working on the concept, Hatfield imagined a pair of shoes that could "come alive" when put on—instantly lighting up and auto-lacing. The desire for these sneakers to be made available in real life was almost instantaneous, but the technology to create auto-laced footwear was still decades away.

Serious work to make this dream come true began in 2005, when Hatfield turned to Tiffany Beers, then a young engineer at Nike, and asked her to work on making the concept shoe a reality. The first replica of the MAG was released in 2011, when 1,500 pairs were made and auctioned off on eBay to raise funds for the Michael J. Fox Foundation for Parkinson's Research. The shoes featured the same styling as those worn in the movie, including electroluminescent areas in the ankle straps, back quarters, and outsoles. However, they were not self-lacing.

Aside from the desire to replicate the technology highlighted in the movie, Hatfield and Beers were convinced that auto-lacing had utility and could significantly help both athletes and people with mobility issues.

In 2012 batteries strong enough yet small enough to power auto-lacing became available, and after years of research Beers was able to achieve the long-awaited goal. On October 21, 2015, the day that Marty McFly arrived in the future, Nike announced that it was releasing eighty-nine pairs of self-lacing Air Mags, again to raise money for Fox's foundation. More importantly, the invention of Electro Adaptive Reactive Lacing (E.A.R.L.) has gone on to change sneaker history. ✳

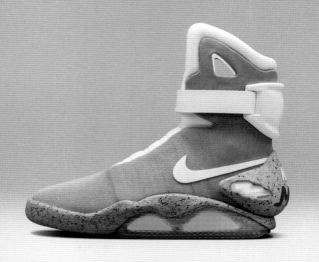
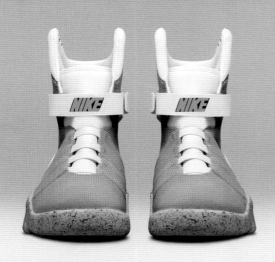
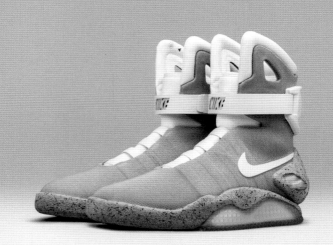
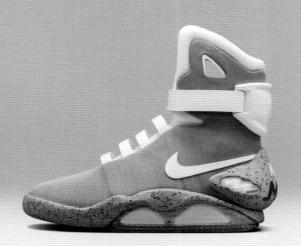
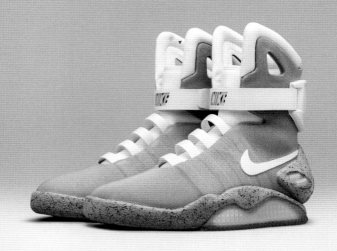
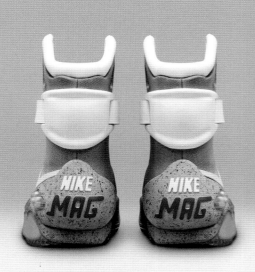

INTERVIEW WITH
STEVEN SMITH

ELIZABETH SEMMELHACK: Many designers find inspiration in the past, but you always seem to have your eye on the future. Is that true? And if so, why?

STEVEN SMITH: In some ways I feel like Nikola Tesla: you can see the future but no one else is with you yet. You have these visions and these ideas; you want to bring everybody else to the future that you can see.

ES: What does that future look like?

SS: Just new and better objects of desire. Having a futurist mindset is hard, because you have to envision what it could be. What would it be? What would I want it to be? How do I combine these things? What new materials and processes are out there? It ends up being a combination of those things—that's just how my brain is wired.

ES: It seems to me that you have a drive to strip away the superfluous, that you are very devoted to form follows function.

SS: Yeah, absolutely. There is an honesty to a lot of the stuff I do and its purpose. The Instapump Fury was lightweight, it was minimalist, but it also required trade-offs. It was meant to be, at the time, the lightest weight running shoe possible. People had this perception that it was going to be outrageously expensive. But the parts reduction and simplification allowed us to reinvest that money in higher quality components, so we had fewer components but higher value.

If you look at that hybridization of the end goal of things, it was to make the shoe in America, make it innovative, and use new materials that nobody else would take the risk on.

Instapump Fury, 1993. Gift of Reebok, collection of the Bata Shoe Museum

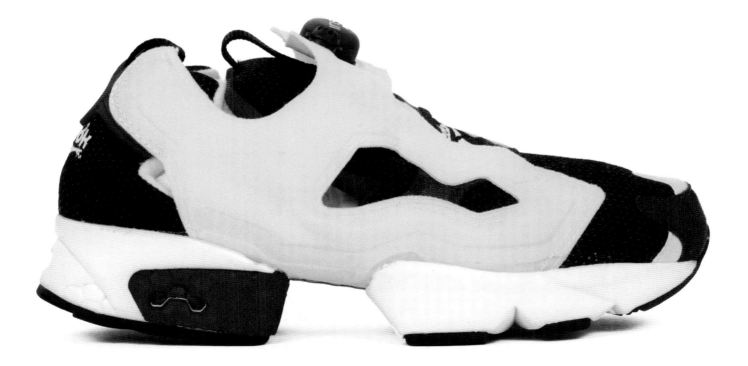

This kind of work involves throwing caution to the wind because there are so many people who ask "why?" when you are asking "why not?" It's difficult. That's why a lot of people don't want to do them—they get scared of it. You think about being a futurist and you're finally seeing things like electronics finding their way into the sneakers. This smart-pump shoe back at Reebok in 1994 had a computer control module in it and an automatic pump. It was so far out that some of the things that we had envisioned and that I'd sketched up were not able to be made. Things like MEMS (Micro-Electronic Machines) didn't exist, so we had Dean Kamen, who invented the Segway, make these electric valves for us to control the air within the little computer module we built into this shoe. We made one pair and Paul Fireman had them. People thought we were like aliens creating this thing. Now we're in 2020, 2021, and electronics are starting to come in and do all the things that we were envisioning and fabricating back then. Again, it's that vision of the future, what it is, what it could be. I did a thing on the future of footwear for the *New York Times Magazine* in 1996. The final concept that I came up with, I did all these sketches, and they hired this model maker to do it. The clay model of

Tyvek Racer Reebok, 1996. Collection of Steven Smith

this concept—it was an intuitive, self-morphing second skin—ended up in the Smithsonian in an exhibition. Some of what I was envisioning back then is still not happening.

ES: If I remember correctly, one of your ideas was a sole that changed its tread depending on the surface being walked on. It was connected to sensors that crept across the foot, providing feedback to a microchip in the sole that also was to aid in performance. Does that remain too far in the future?

SS: Yeah, absolutely. I designed this intuitive, self-morphing running shoe, and I had done two different versions of that. One of them had a holographically projected Reebok logo out of a micro-LED that shone onto your foot. Just total future visions of things that, again, still aren't out there yet, but would be pretty amazing to make. I designed a single-piece molded shoe. You look at the aesthetic now, and it still looks futuristic. I was drawing these things and people were like, "Are you on drugs?" I was like, "No, I can just see it."

ES: Let's talk a bit more about materials. For the Foam RNNR, you used algae foam. How did you even come to consider that material, and are there other unorthodox materials that you want to work with?

SS: There are always cool materials out there. Part of it is having your eyes wide open as to what is available and seeing something and envisioning what it could be. How could I use this? How could I apply it? At Reebok, in 2014, I designed a 100 percent multi-material 3D printed shoe with a fractal structure—forms that you can only get with 3D printing. It's a little bit of a cop-out to say 3D printing, but 3D printing will evolve. We've all been lied to about it; it's not production-ready, but I think it's going to be the thing—production-ready 3D printing. People are saying, "You can design your own shoes and then the company will 3D print it for you." but I don't think that is going to work. Why would a company take on that liability?

ES: You see production staying in the hands of the producers, the companies?

SS: I would say so, because there's good design and bad design. If you allow that kind of open sourcing, some bad designs could get out there, and you don't really want your brand on them.

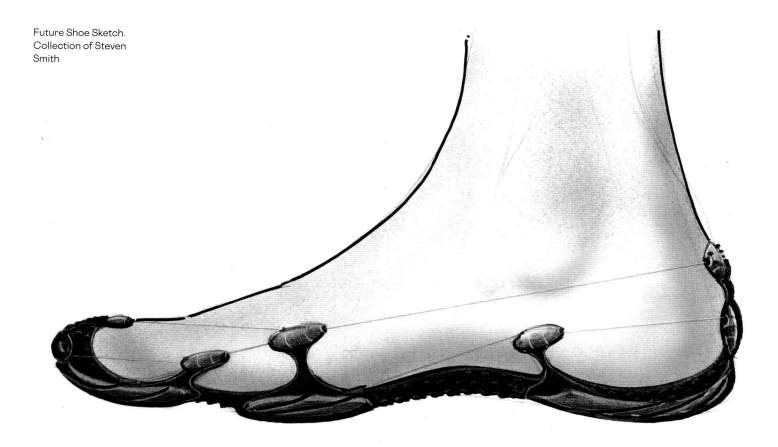

Future Shoe Sketch.
Collection of Steven
Smith

ES: You don't see us all having our own 3D printers making our shoes on the daily?

SS: You could if you could afford it. That's the other thing: the tech all sounds really cool but who can really afford to have their own 3D printer at home? I would go hang out with Syd Mead because we're both in the same mindset of visions of the future, and he was talking about 3D-printed food, like the *Star Trek* food machine. Which is a really cool vision, and once you put those out there, it's like a stake in the ground for scientists and engineers to discover and make it happen. But I've never been one for innovation for innovation's sake. Just because you can do it doesn't necessarily mean you should do it. What's the end goal of it? Is it just to prove that you can do something, or is it to make life better or make a better product? That's how I look at futurism. It might be futuristic looking, but can it work? There are lots of people who are doing all these really cool virtual sneaker designs, but what is it? Is it a beautiful sculpture, or is it made for an end user? I'm sure seeing lots of crazy 3D modeling by people, but what is it?

ES: That's why I think the virtual space is going to be a very interesting place where people can collect and where people can live and embody different shapes, skins— different identities. I think that's also emergent, right?

SS: Again, if your brand's attached to something that is bad or it fails, that's where you still need control as a brand. You end up with the Homer from that *Simpsons* episode. It embodies everything we're talking about. Danny DeVito is Homer's relative, and he's a multimillionaire. He decides to use Homer as his muse for his new car company, and he lets Homer design a car—the Homer.

ES: Did you always trust yourself?

SS: The hardest thing to learn is that you need to enroll other people because otherwise you can't get it done. That's the hardest thing for me: you have to enlist other people. You need a team. Whether they're like-minded or not, you need to have a goal and establish that we're creating a product that nobody's seen before. You have to ask them, are you with

Yeezy MXT Moon Gray,
Foam RNNR, 2021.
Collection of the Bata
Shoe Museum

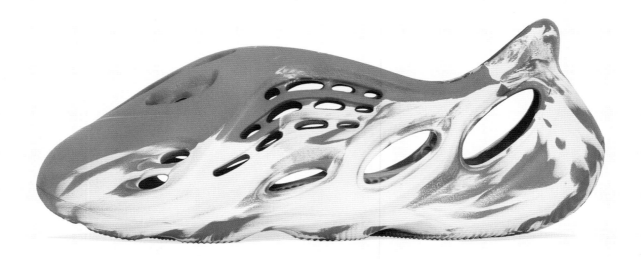

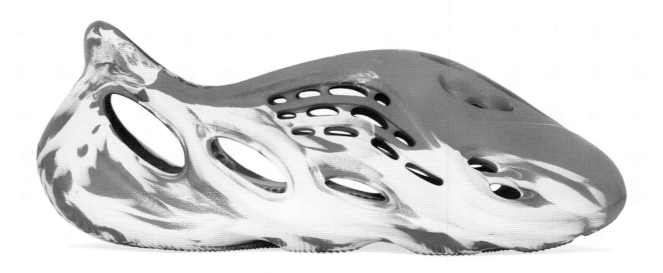

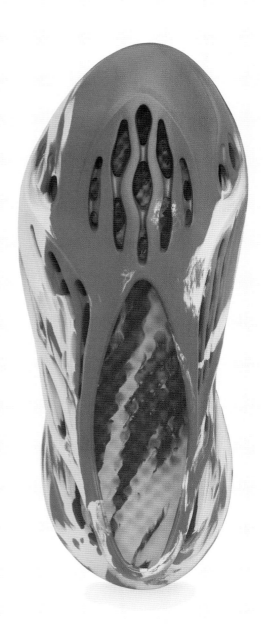

me? Let's go. And so they have to be up for that challenge. They may not necessarily be the visionary or the artist, but they'll support you, and you can show them. That's the beauty of what we do as designers, I can draw it and then go, "Look, this is what it could be." Oh, yeah, now I see. I understand what you're saying now. I understand how we can use that or bring that thing to life. But it really takes risk, and most corporations aren't willing to take the risk and roll the dice. That's the beauty of my current situation, I'm collaborating with a visionary who's on the same plane. It's the why nots versus the whys.

ES: Are you okay with failure?

SS: Yeah. As much as I love Tesla, and value him much higher than Edison, Edison said, "I never failed. I just found a thousand different ways *not* to do it," and he's right. But if you've never taken the risk, you don't know anything.

ES: What's next? What are you working on? Can you say?

SS: I think innovation in manufacturing is one of the key things. It's always a continuum. As new materials are developed on the bio side or eco side, I think that those are the opportunities. There are two different camps: you make something that degrades, or you make something that lasts forever so you don't need another pair of shoes. I think there's a happy medium where maybe it can evolve into modularity designed for disassembly.

Sometimes you create something like the Fury or 574 that becomes an icon. Do those become things that you adapt to become a renewable product, or do you create the next icon that happens to be a renewable product? That is part of figuring out being a visionary. I would want it to be something else, something that's dictated, an object where the aesthetic is dictated by that process.

That's the way I've always viewed it. There needs to be a holistic solution to the problem. Then if it trickles down into new styles and you can integrate that tech into those new designs, all the better. This is the thing that I'm always agonizing over: things can coexist. But that's the problem we run into. People are always like it's either-or, but I say, why can't it be both? I want the stuff I'm designing today to be able to coexist with things I did thirty-seven years ago and be just as relevant in the same marketplace on the same shelf and at the same retailer. Kind of mind blowing in a lot of ways.

ES: The first Instapump from 1994 has become such an icon. It was so futuristic then, but it still looks futuristic today. However, at the same time, it's also now historic.

SS: Yeah, that's what's cool about icons. You ask, when are they from? It's like, there's no past or future. It's in the now. It's not about dreaming of the future. We're living in the future that we created every day. It's steep thinking, but when you step back and you look at it, when is it from? Same with the Wave Runner. When is that from? It could be from the 1990s, it could be from now. We created it in 2016, but you see it and it's almost like it's always been there. Do you know what I'm saying?

It's hard for people to wrap their heads around thinking like that. But the Fury is another one of those iconic things that could be from the future, but it's from the past, and it's here now.

ES: How is it that you ended up in shoes, given that you could have designed anything? Why shoes?

SS: I wanted to design cars. I love cars, but I also love machines. I never played team sports, per se, but I loved to run. I loved individual sports. I had a skateboard, but it wasn't a very East Coast thing so I wasn't very good at it. I had BMX bikes because I loved to ride bicycles and ride off-road. I have motorcycles, too. I love stuff. Did you ever watch *Married with Children* with Al Bundy?

ES: I have seen it.

SS: Al Bundy's big claim to fame was he scored the winning touchdown for Polk High School. That was the pinnacle of his life. I ran high school track and qualified for the team, but I was a middle-of-the-pack runner. I always ran in New Balances. That's what I wanted. They were the objects I desired. I wanted a pair of SuperComps, but my parents couldn't afford them. If you look at the tail on the SuperComp, it's very much Pump Fury. It's fire: red, orange, yellow.

ES: Yes, I see the similarity.

SS: You were on fire when you ran in them. These shoes made such an impact on me as a teenager. When I graduated, nobody taught shoe design or sneaker design, it didn't exist as a career, per se. We were the vanguard that made it into a career and made it a desirable career. But I did learn how to

design products. Then I found out about car design, that you go into that field and you'd be the guy who designs nothing but hubcaps for your entire life. That didn't appeal to me.

The curriculum at MassArt geared you to work for local companies like high-tech Wang, digital Data General, Corning medical, or Hasbro. So, I heard about this job at New Balance, and I was like, I could go design something that I use myself. Because these other guys that I went to school with ended up at those other companies. They were designing computers; they were designing medical equipment for operating theaters that maybe thirty doctors in the whole world ever touched or saw. They weren't going to use the things they were designing because they weren't surgeons. I'm like, I'm going to go design running shoes for me, that I can run in, and it was really cool. So, I went to New Balance. It was in this ratty old mill, but it was also the Reagan and Wall Street era with three-piece suits and ties on the corporate side, but I was in jeans and a T-shirt. I'm like, yes, this is it. I was the user of that brand, and I believed in that brand, so everything was connected, and I was only the second full-time designer they had hired. Me and the other guy, Kevin Brown, who was the senior designer, the two of us were the entire design department. I interviewed, and they were like, "It's 11:30. Interview's over. We're all going running. We'll get back to you." I'm like, "What, you guys run every day?" They're like, "Yeah everybody." They called me the next day and made me a good offer.

ES: So that is how it started.

SS: I always ran in the 900 series, which at the time there was only one, the 990, that's what I wore. The 995 was just coming out. I got there and I did a perfect pattern on the 995, and I'm like, this is so awesome. I'm working on the shoe that I run in. How cool is this?

Then I got to do the 996 and the 997 and totally reinvent them, and that's history. But the coolest thing was when I saw the guys I went to school with when we were invited back to MassArt to do critiques. They all asked, "What are you doing now?" I'd say, "I'm at New Balance." They're like, "Well, we're doing important products." I'm like, "Really? How many do you make? How many people actually wear or use them?" They would say fifty of this or a hundred of that. I'm like, "I can go anywhere in the world and see someone wearing my product, because we make 50,000 to 100,000 of something." It's affordable, it's art, it's design. To this day I will still go up to people on the street and say, "I designed the shoe you have on." It's not an arrogance thing or anything. I'm just saying thank you for appreciating my art. Thank you for feeling compelled enough by my design. That means I did my job; I created an object of desire.

In those early days we competed with ourselves and with Nike, Reebok, New Balance. In the early 1990s when the Fury came out, all of a sudden we were competing with Sony. We went from competing with sneaker companies to competing against tech companies. All of a sudden, the game changed.

ES: That's very interesting.

SS: We had to compete. I had to get that kid's $100. I had to make something so compelling that that kid had to buy it. And so that changed the game, and it forced me to be a better designer and a futurist because I'm competing with the future of the shoe.

The Walkman changed the game for us. It opened the door for futurism, and sneakers were no longer just about swish, suede, and mesh. People wanted something different. It was about aerospace technologies, carbon fiber pieces. It was the top-ladder material that came from airplane emergency life preservers, or the medical devices that created the pump ball and other mechanisms. It opened the door to different resources, supply chains, and industries for us to explore.

It allowed me to do what I was really good at, or what I was meant to do. And it turned out to be fun. I can go anywhere in the world and see somebody in something I designed—that's amazing to me. ✱

MAISON MARGIELA X REEBOK TABI INSTAPUMP FURY

THE FUTURE IS BUILT upon the past, and this is especially true for the many collaborations defining future footwear. In 2020, Maison Margiela collaborated with Reebok to combine and reimagine the signature Margiela Tabi first released in 1988 with Reebok's iconic Instapump Fury from 1994.

Margiela's original Tabi was inspired by the split-toed socks with rubber soles worn by Japanese laborers, but rather than keeping the traditional rubber soles, he mounted his Tabi-inspired uppers on high sturdy heels, creating haute couture boots that were designed to appear simultaneously alien and animalistic.

The year after the debut of the Tabi, Steven Smith and Paul Litchfield at Reebok began working on one of the most futuristic sneakers of all time, the Instapump Fury. Its radical new architecture was driven by the desire for form to follow function with all excess stripped away. An air bladder allowed the sneaker to be fitted to the foot without laces but also did double duty by simultaneously functioning as the upper. The two-part sole allowed the forepart of the foot and heel to be cushioned with no additional material needed, making the shoes as lightweight as possible.

The 2020 collaboration between the two brands marked the first collaboration for Maison Margiela with John Galliano as creative director. Drawn to the Instapump Fury, Galliano wanted to create "a statement shoe for the age of the cyber-industrial revolution" by pushing the Tabi forward using Reebok's technical innovation.✳

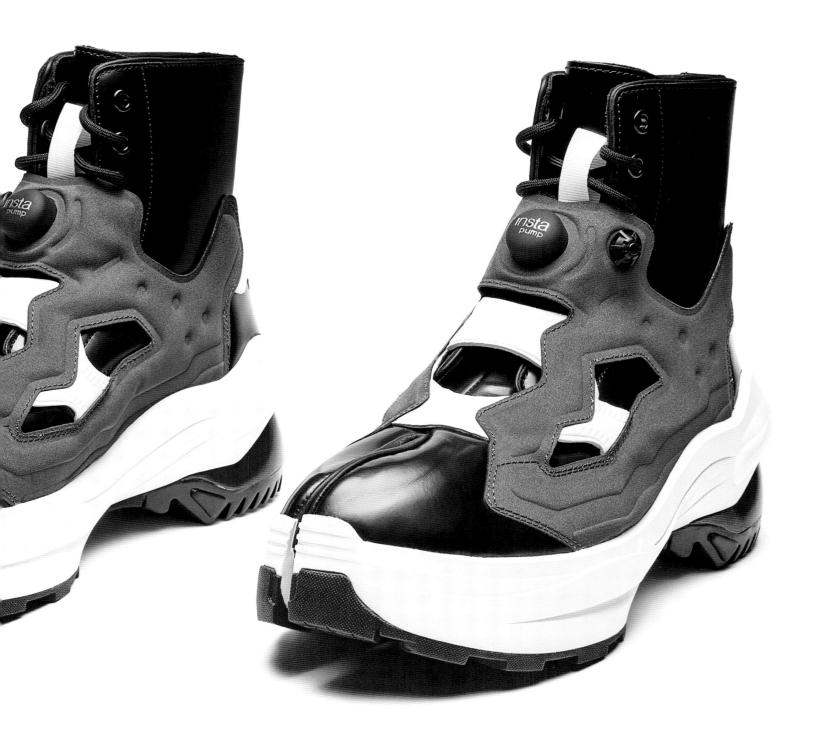

PUMA DISC XS 7000 OG

IN 1991, PUMA launched one of its most innovative designs, the Puma Disc XS 7000 running shoe. It featured a new way of securing the fit of a shoe through the use of an internal system of nylon cords that could be manually tightened by means of a small ratcheting mechanism—the disc in its name. A quick release button made removing the shoes equally simple. The innovation was heralded as the future of footwear, with one wit declaring that the disc made shoelaces as hopelessly out-of-date as buggy whips.

In 2021, Puma rereleased the original model in celebration of its thirtieth anniversary. The "retro-ing" of past designs began in the early 1990s, as companies and consumers saw value in past innovations. This trend of looking back to the future continues to influence footwear. ✻

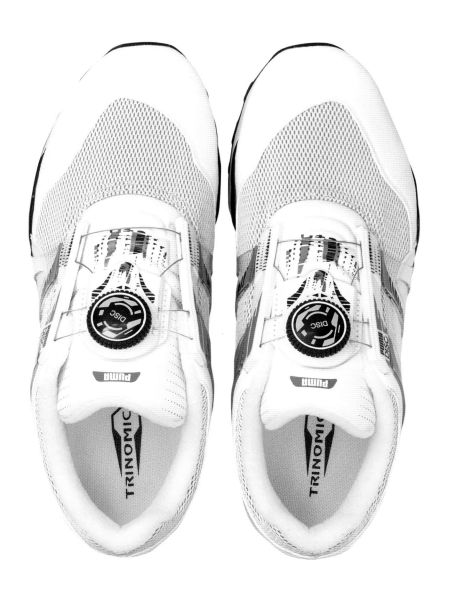

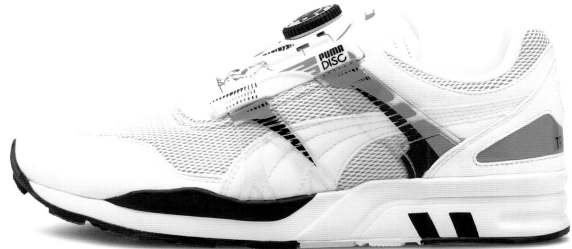

65

ADIDAS FUTURECRAFT MFG (MADE FOR GERMANY)

ROBOT WORKERS HAVE LONG been an integral part of people's vision of the future. Adidas made them a reality in the footwear industry when it created its first Speedfactory in 2015. Built in Ansbach, Germany, the Speedfactory was to be an almost fully automated facility that brought manufacturing back to Europe—closer to, and more responsive to, European consumers and thus dramatically reducing the time required to get footwear to market.

The first Speedfactory creation was the Futurecraft MFG (Made for Germany), a high-performance running shoe launched in 2016. The upper was made of almost zero-waste Primeknit knitting technology. Support for the foot was offered by "patches" placed around the upper, in areas requiring greatest support. These locations were determined through the use of ARAMIS technology, which employs high-speed cameras in tandem with flexion sensors. The BOOST sole, an expanded thermoplastic polyurethane (E-TPU) material innovated to create excellent durability and energy return was fitted with a new torsion bar to further improve flexibility.

With its first offerings successful, Adidas opened a second Speedfactory outside of Atlanta in 2017. However, it was announced that the factories were to be shuttered in 2020 and the lessons learned applied to factories in Vietnam and China. Although Speedfactories and the sneakers produced there were groundbreaking, robotic production proved too inflexible. ✳

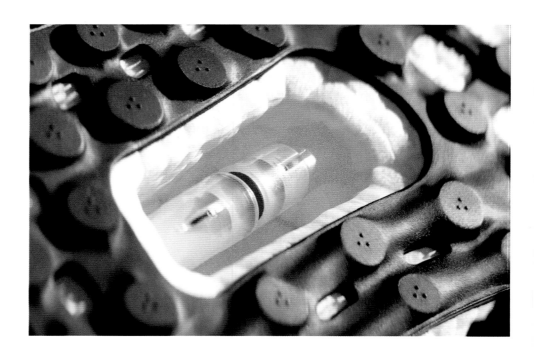

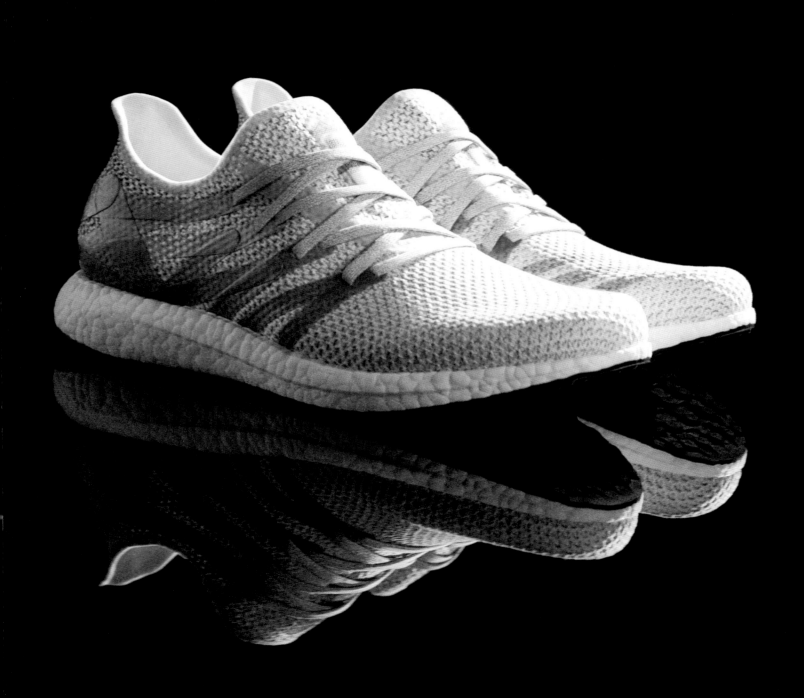

INTERVIEW WITH

BENOIT MÉLÉARD

ELIZABETH SEMMELHACK: When did you start making shoes?

BENOIT MÉLÉARD: To be honest, I started designing shoes when I was fifteen years old. I didn't know it would become a job because at the time everybody laughed at me for wanting to become a shoe designer. The idea of it as a profession was nonexistent. It was not something cool. You could be a hairdresser or a makeup artist or a fashion designer, but not a footwear designer. No, I wanted to do my own thing.

ES: When you say you were designing shoes at fifteen, were you actually designing physical shoes? Were you drawing shoes? What were you doing?

BM: I would ask my friends during class to take off their shoes and I would copy them. I would try to copy them exactly, the same proportion, how they wore their shoes, how they destroyed them, how they cleaned them. I asked to copy the J.M. Weston moccasins and boots of my friends who had more money than we had. My parents didn't want to buy a pair of shoes for this price. It was too expensive, and it was really a big frustration for me. They never bought me a luxury pair of shoes. Never. They wanted to keep the money for something else. I hung out with a band of four guys. I was the only gay guy who was thinking about becoming a footwear designer. Assaf, who's still my bro, would get a pair of shoes and I would say, "Oh, it's so cool. So cool. Take off your shoes. I'm going to copy them." Benjamin and Alexandre, these guys got only one pair per year. I was looking at them like someone with an obsession or someone who is totally in his own world. Nobody understood that except Assaf. He supported me.

ES: You are famous for making women's shoes, but it sounds to me like you started out focused on men's shoes.

Manifesto Collection SS, 2011. Gift of Benoit Méléard, collection of the Bata Shoe Museum

68

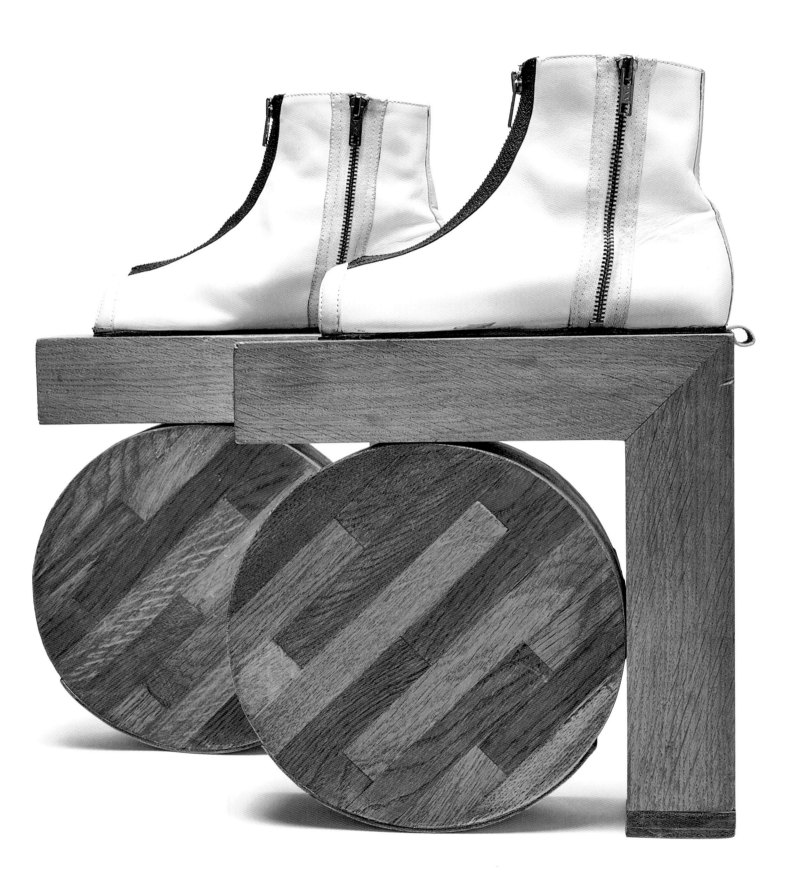

BM: I think my sensibility is for both, but I'm more conservative in my designs for men's shoes. My passion is for J.M. Weston. I think the J.M. Weston 140, the moccasin, is the most beautiful moccasin in the world, for me. Olivier Saillard is doing a fantastic job at J.M. Weston, and I'm close to him.

ES: You're constantly playing with what a shoe can be, how it looks, and what it is made of. Where does that intellectual flexibility come from?

BM: I think we are changing all the time. I think it's like in music: some musicians who started in the 1970s, they don't have the same style in the 1990s. The people who are doing only rockabilly or only heavy metal or only funk or house music, I think that they block themselves off and become entrapped. I don't want to be like that. I regret nothing. I think it was like revenge to say, "Okay, we need to say to the fashion industry that the footwear industry needs to be taken seriously."

ES: So, let's talk about your very first collection.

BM: The first one I decided had to be totally in black leather. It was the only color that I wanted to use. But the heel tab I wanted to be fluorescent yellow. I decided to make the tab my signature.

ES: What year was this?

BM: It was in 1997. I wanted to work on the upper. I decided that the shoes should have a very elliptical form, but with a lot of décolleté. It was only three pieces—very, very experimental. But the shapes were very, very different. And I didn't want to add any distraction. I wanted to keep things very simple and focused on the shape. I used the black leather and black satin to give these shapes better visibility.

ES: So much of your work deals with volume, with geometric shapes. The first collection feels a bit Russian Supremacist, like a painting by Kazimir Malevich, with its juxtaposition of geometric forms. Am I reading too much into it?

BM: No, it's absolutely that. I really wanted to be very focused on the geometry. But I started with a difficult shape, the ellipse. I was sure that the second collection would be focused on the square, and after that it would be the circle, then the triangle—like basic geometry. It was also a kind of

Cruel Collection shoes, 1998. Gift of Benoit Méléard, collection of the Bata Shoe Museum

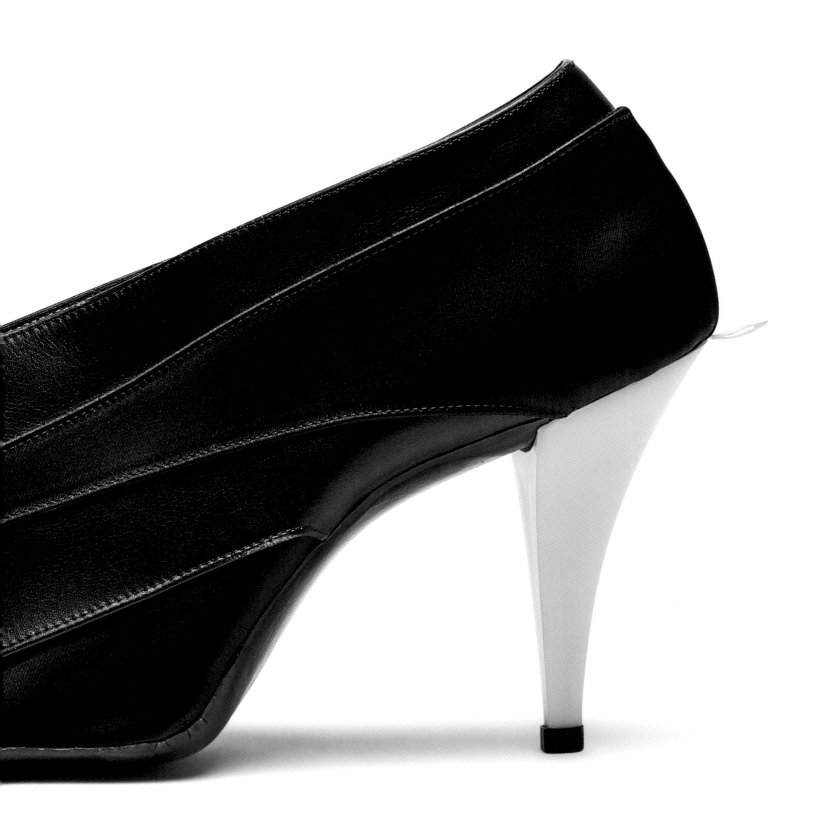

architecture, but it was very spontaneous. It was like—I don't really know how to describe that. It was not to say, "Okay, I hope everybody will love it." No, it was just to be strong, very visible, very easy for the press to understand.

ES: You often play with the architecture of footwear. How do you actually manage to make the resulting shoes wearable?

BM: It is super easy. I have a very good shoemaker in Paris, and I work on my last by myself. Technically, I know exactly all the classic dimensions and sizes for making a pair of shoes that can be comfortable and wearable.

ES: And what year did you do the circle collection?

BM: The circle, I think, was 1999. It was also experimental and focused only on the circle. Very soft, very light. Totally monochrome. And the makeup, with something like a circle on the face—beautiful makeup by Topolino. All the models had the same makeup, which was in turquoise.

ES: Do you consider these designs art?

BM: Honestly, I never wanted to be an artist. Never. I didn't want to play the role of an artist who gives their whole life for their art. I just wanted to do what I wanted. That's it.

ES: Have you ever thought about working within the virtual space?

BM: The Centre Pompidou invited me to show a collection in 2000. The skin shoes. I showed them on a truck at the Centre Pompidou. I had just lost my contract as the artistic director for shoes for Loewe, but I had engaged with a factory and wanted to start a commercial collection. So, when the Centre Pompidou invited me to show my collection and do a shoe, it was really cool. I told them that I didn't have a collection yet. I only had three weeks or one month to find a new idea. I called Publicis and the Bleustein-Blanchet foundation. They sponsored me. I slept only three hours a day creating this collection. It was crazy, but I made it.

ES: You made actual shoes for this. Or was it all digitized?

BM: I made only one at my shoemaker's. The rest we made with Photoshop. It was at the beginning of Photoshop. I decided to put it on a truck and drive it around Paris. It was

so cool. People from inside the Centre Pompidou came outside, just to see the shoe truck, a fashion shoe truck show. Afterward, the Centre Pompidou invited me to do some collective exhibition and invited me to show the shoes to Bernard Blistène, who later became the director of the Centre Pompidou. They were very happy because visually it was not only about footwear. It was a kind of art.

ES: Ahead of your time.

BM: Yeah. I think it's got to come from your head, from your belly. You've got to put your blood on something new. The virtual thing was very compatible with Photoshop, with the premise of Photoshop. A new expression. It was like in the 1980s when a new machine was invented and you got house music, or in techno musicians said, "Oh, this machine is wow, so good, yeah, we can use it." It was very interesting to work with new technology. It was very fusion.

ES: Your work seems so futuristic, but I know that it is also grounded in history. Are there any past shoe designers whose work has inspired you?

BM: You know it! Yes, Beth Levine, of course. Herbert Levine and Beth Levine, they are my favorite designers. Beth, she was my friend. Blahnik is a mentor. Roger Vivier, very French. Perugia was crazy. Ferragamo, too. Some other generations, like Patrick Cox. Oh, and my colleague in Paris Alain Tondowski. I respect him very much.

ES: What do you think the future of footwear is?

BM: I think it's about new materials and about change. You can change style all the time. It's free. ✱

"O" Collection, 2000.
Gift of Benoit Méléard,
collection of the Bata
Shoe Museum

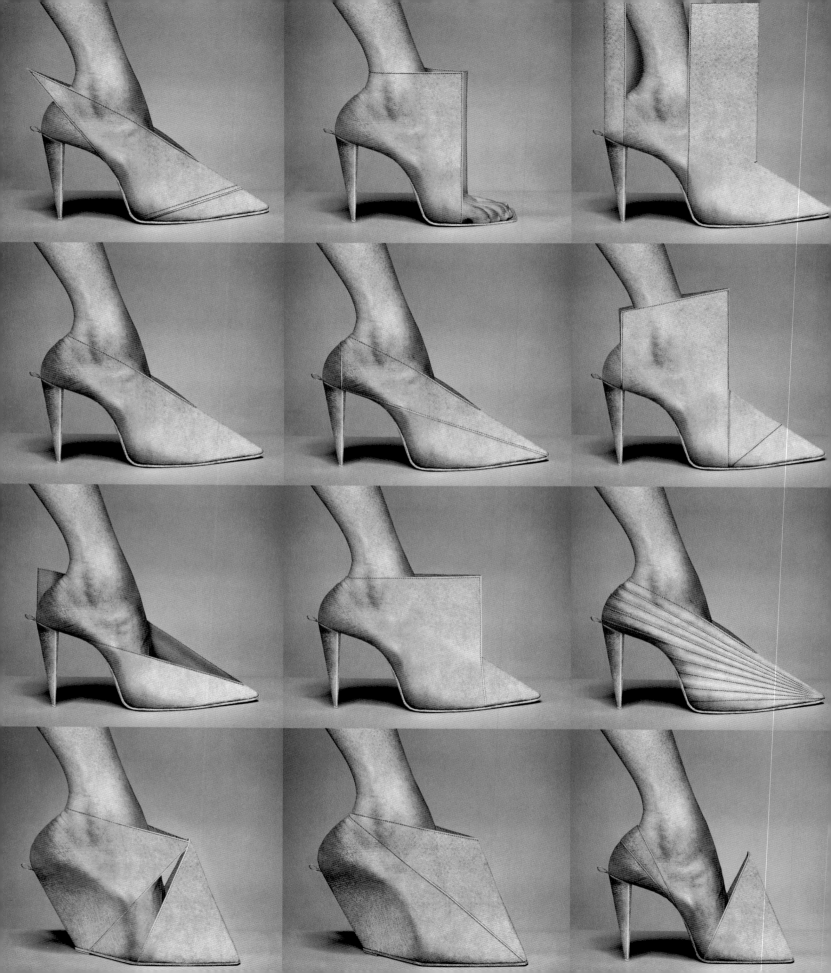

Mue Collection,
2001 at the Centre
Pompidou, Paris.
Sponsored by Publicis
Luxe Mudocom,
Champagne Nicolas

Feuillate, Centre
Pompidou Bernard
Blistène, La Mode
en Images, cyclops
numeric. Art direction
by Benoit Méléard

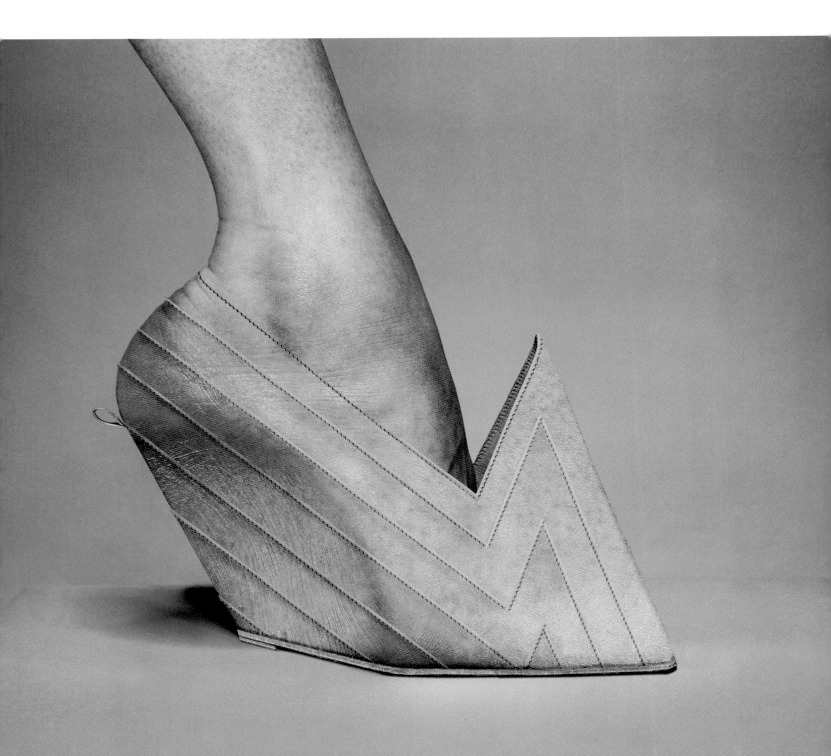

NIKE ADAPT BB

IN 2016, NIKE DEBUTED the HyperAdapt 1.0, its first commercialized sneaker with Electro Adaptive Reactive Lacing (E.A.R.L.). Three years later it released the Nike Adapt BB—BB for basketball—which combined power lacing with Bluetooth-connected firmware, allowing adjustments to be made to the lacing through the Nike Adapt app. The lights in the outsole were also controlled via the app and, like the sound made by the auto-laces, were a nod to the original Nike MAG.

Prior to wear, each shoe needed to be paired with the app, and then the shoes had to be calibrated. This was done by putting them on and allowing the laces to tighten automatically, creating the wearer's default fit. Fine-tuning the fit was achieved through the app or by using the manual buttons on the outsole. The batteries inside the shoes lasted fourteen to twenty-one days on average, and they were easily recharged using an induction charging pad that came with the shoes.

The promise of the shoe was that the app could be constantly updated with new refinements, meaning that the fit of the shoe, too, could improve with each update. Basketball was chosen as the first sport for the new model, as players often experience significant changes to foot size over the course of a game, thus making the ability to adjust fit easily particularly beneficial. ✻

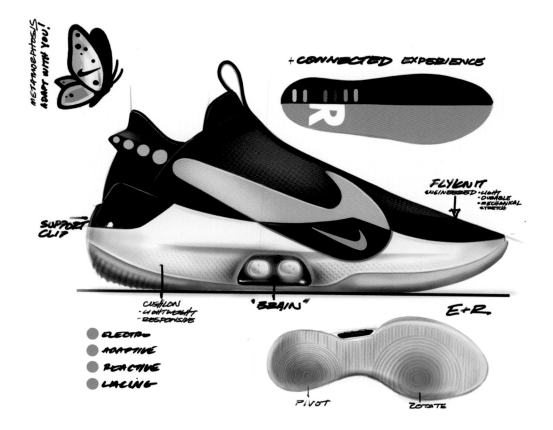

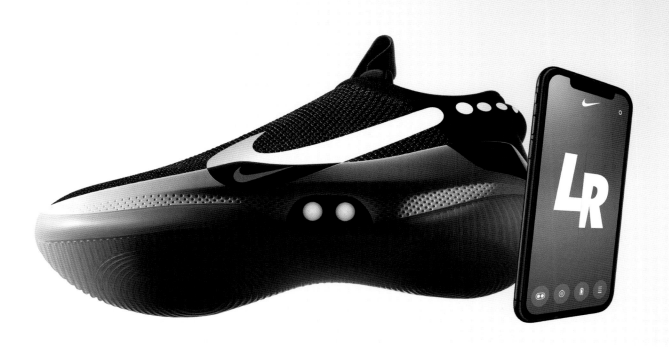

DARRYL MATTHEWS + SHAMEES ADEN/ NIKE ISPA

ELIZABETH SEMMELHACK: Nike ISPA debuted in 2018 and since then has been creating exceptionally innovative shoes. But exactly what is ISPA and what is meant by "Improvise. Scavenge. Protect. Adapt"?

SHAMEES ADEN: It's a good question. It's hard to frame it, but I would definitely say ISPA is a kind of a collective. It's a creative space in which to imagine future products and needs for the built environment. We explore social, political, environmental, and cultural movements as a starting point, too. Just how people think and feel, and what's impacting their lives and environments, from increasingly long commutes to the impacts of climate change in cities. We try to problem-solve using past Nike innovations, but also emergent innovations. And I think we try to respond with that and create products for these built environments.

DARRYL MATTHEWS: Shamees, you said it perfectly. We run a very small collective and we want to get a better understanding of why we were doing what we were doing. ISPA represents the philosophical approach of our design team. We improvise against the unexpected, scavenge technologies internally within Nike, as well as externally, to create adaptive and protective concepts.

We also recognized that while we were tackling both everyday issues and some really big ideas about the future of city life, we could also create a mystique around the work and give it a kind of magic. ISPA is homage to and part of a legacy charted by lines like ACG, Alpha Project, and Considered.

ES: How big is your team?

Overreact, Nike ISPA, 2020

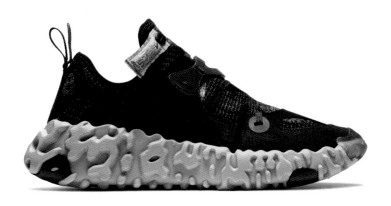
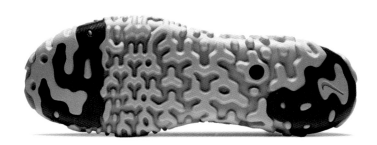
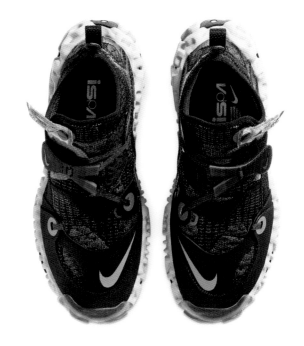
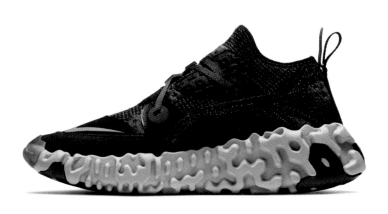
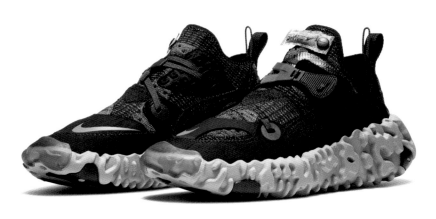

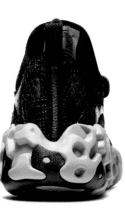

DM: The small collective rapidly grows into quite a big collective as we decide upon the right ingredients to create what we want to create. Shamees [senior footwear designer] and I [vice president, Catalyst Footwear Design] lead the product design side of the group. But we also have a material designer, a color designer, and Flyknit design, and over the past five years that we've been together, we have created an incredible cohort of likeminded people within Nike. So, depending on what the seasonal directions are, we garner all the expertise needed to help deliver the vision.

ES: Who are you designing for?

DM: I like that question, because it's not asking, "Are you designing for a consumer?" and we aren't; we're designing for people. Shamees touched on it when we started talking about ISPA, how we identify with life's challenges, whether they be social, cultural. It may not just be trying to solve something practical, like traction, or something that solely has to do

with performance. There's more of an emotive response to why we're doing what we're doing. This produces a different dialogue with what we are doing. Footwear is just the medium. We have physical movement, obviously, that we all design into, but then we also consider social movements, which are super important to us. We identify with what these movements are and then work to create a dialogue that ends up having an influence on the outcome.

SA: We are problem-solving for people in cities. I think our starting point is from a human mindset sensibility. That's the starting point for us. We try to explore the way we live in

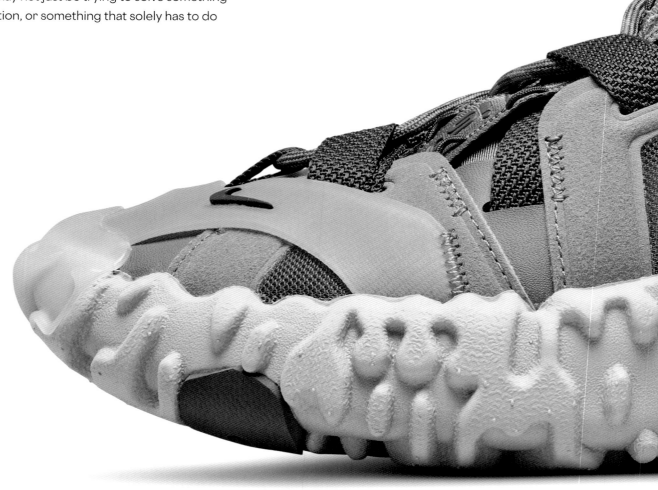

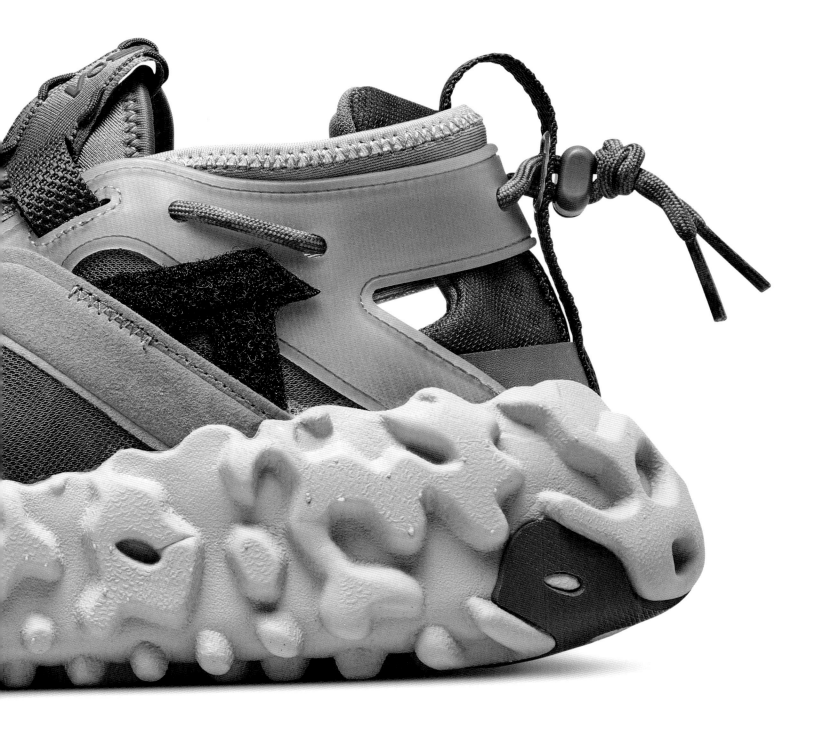

these kinds of urban environments. We consider the future of these spaces, the different weather conditions faced, or how they all evolve and change. We examine these ideas through the materiality of the product. We explore different types of materials that can help in these environments. It is not always grounded in questions like, oh, we need to problem solve for this traction issue that you might have in the city. Instead, we are more speculative about future materials or cities and the environment.

ES: Can you tell me about the Road Warrior?

DM: The Road Warrior. Where did we start with the Road Warrior? First of all, it was a fantastic moment for ISPA, for Nike design, probably for the sneaker industry as a whole. This shoe really demystified the hidden truths of Nike innovation. It visually exposed the secrets of performance technology. It laid bare a lot of Nike innovation, making it visible all in one shoe. It created a completely different dialogue. It was such a radical design, and the designer, Nikita Troufanov, borrowed from running, basketball, training, and outdoor footwear innovations to create a shoe for future urban environments.

ES: Was the split toe inspired by the Japanese tabi?

DM: No, it wasn't directly inspired by the tabi. Nike had a shoe called Air Rift [named after the Great Rift Valley that runs through Kenya and other African countries] that was released in 1995. This shoe was originally designed to replicate the feeling of running barefoot by allowing extra agility between the big toe and the other toes. The Road Warrior split-toe concept was directly inspired by the 2015 release of the NikeLab Free Rift Sandal. It's truly an example of how ISPA looks to elements of Nike's design past—scavenging multiple parts and technologies—and finds within itself a springboard to new forms.

ES: What about the Overreact Sandal?

DM: The Overreact Sandal, which was designed by Asha Harper, responds to the challenge of finding extreme comfort in warm weather, but also having adequate protection in the city. Similar to the Road Warrior, there's an element of pushing the technology to a really overt expression. We wanted to give wearers a truly unadulterated feel for the React foam, but also to double down on the computationally-derived geometries that had become the hallmark of all shoes built with React.

ES: Let's discuss other ISPA designs. Darryl, can you talk about the Drifter?

DM: The Drifter was inspired in a number of ways by traditional Japanese work shoes and garments. Unlike the Road Warrior, the split toe on the Drifter was a nod to the Japanese tabi.

The limited-edition indigo-dye version was also a nod to traditional Japanese workwear and a celebration of the craft. But paired with these traditional elements was the use of the reground ZoomX foam, one of the most innovative Nike materials reserved for elite running shoes. This particular shoe was a thank you to the place in which the concept was birthed, from a trip our team took to Japan back in 2015.

ES: You mentioned reground ZoomX. What is the role of sustainability in your work?

SA: Sustainability is central to our work. With Nike's Move to Zero and its goal of zero carbon and zero waste, we are constantly thinking about using recycled and sustainable materials in what we are creating. We also want to think about the afterlife of the shoes, how they can reenter the system to be recycled or reused so that we can achieve a circular economy. Shifting from a human-centered design approach to a more biocentric design approach that values all living things—the biosphere, plants, and animals.

ES: Are there new materials that you are excited to be working with?

SA: I'm excited to recontextualize "waste" materials— removing the notion of waste as lesser value—and focus our design and innovation efforts on the process of transformation, reprocessing, recycling, and upcycling rather than extracting.

ES: How did you both get into sneaker design and, more importantly, how did you get into very forward-thinking sneaker design?

Drifter, Nike ISPA,
2021

SA: When I was at Central Saint Martins [in London], I joined the material futures MA program, where I began to think about the future of footwear over the next fifty to one hundred years. My final project was called the Amoeba trainer and was a conceptual prototype that considered the use of new materials derived from protocells. It got a lot of attention because it asked, "What if we adopted living systems approaches into our design practice?" And that's how I ended up here at Nike in ISPA.

DM: Mine was more of a traditional path. I started in furniture design and became very interested in the physical properties of sculpture. I found myself making large wood footlike shapes and applying materials over them.

ES: **You were making lasts and then uppers?**

DM: Correct. The draping of the material was only to get a better understanding of the visual language of the forms I had been exploring. It was at this moment that I realized they were to become shoes, and from then I have never looked back.

ES: **Of course, part of where we are headed lies with future designers. Do you have any advice for those who want to enter the industry?**

SA: You have to think about who you are making footwear for. You need to think about how to use new and existing materials, and you have to be willing to ask questions. You should also be willing to collaborate. Surround yourself with people who have different viewpoints and ideas. You end up with a better design if you can approach the project by considering it through different lenses.

DM: Don't just draw shapes for the sake of a shape. It's imperative that you understand why you are designing what you create. It's a dialogue between you and the narrative through the medium of footwear. ✳

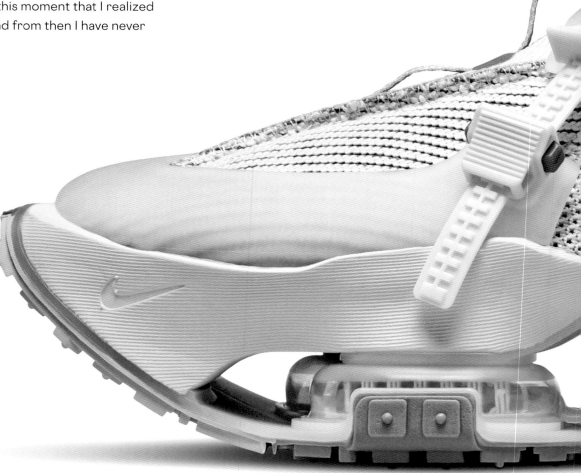

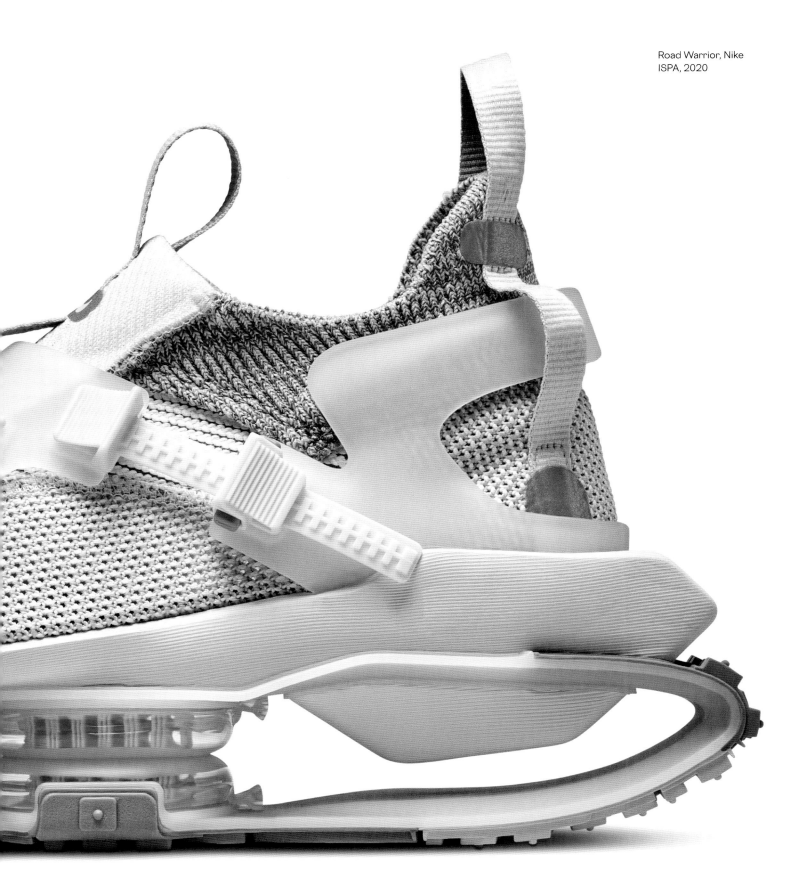

THE NIKE ZOOMX VAPORFLY NEXT% 2

STARTING IN 2016, Nike-sponsored runners began breaking speed records while wearing prototypes of what would become the Nike Zoom Vaporfly 4% and the Nike Alphafly NEXT%. For the Vaporfly, Nike vaunted a potential performance increase of up to 4.2 percent for runners, and its claim was backed by independent researchers and runners. Before long, concerns were raised that the advantages offered by the Vaporfly 4% were equivalent to mechanical doping, and there was talk that the international governing body for sports, World Athletics, might ban them from competition.

Indeed, the Vaporfly 4% did represent a seismic shift in racing shoe innovation. It had a midsole made from ultra-lightweight ZoomX foam, a material that allows for significant increase in energy return, as well as a full-length curved carbon fiber plate embedded in the midsole that retained energy like a spring, helping to propel the wearer forward. Uppers were made of VaporWeave, and laces veered off in the direction of the small toe to alleviate pressure on the top of the foot.

Although the shoes were investigated, ultimately they were not banned, and Nike continued to innovate. The Nike ZoomX Vaporfly NEXT% 2, released in 2021, was approved by World Athletics and features a mesh upper with asymmetrical lacing and a padded tongue, a ZoomX midsole, and an outsole that offers greater traction. ✱

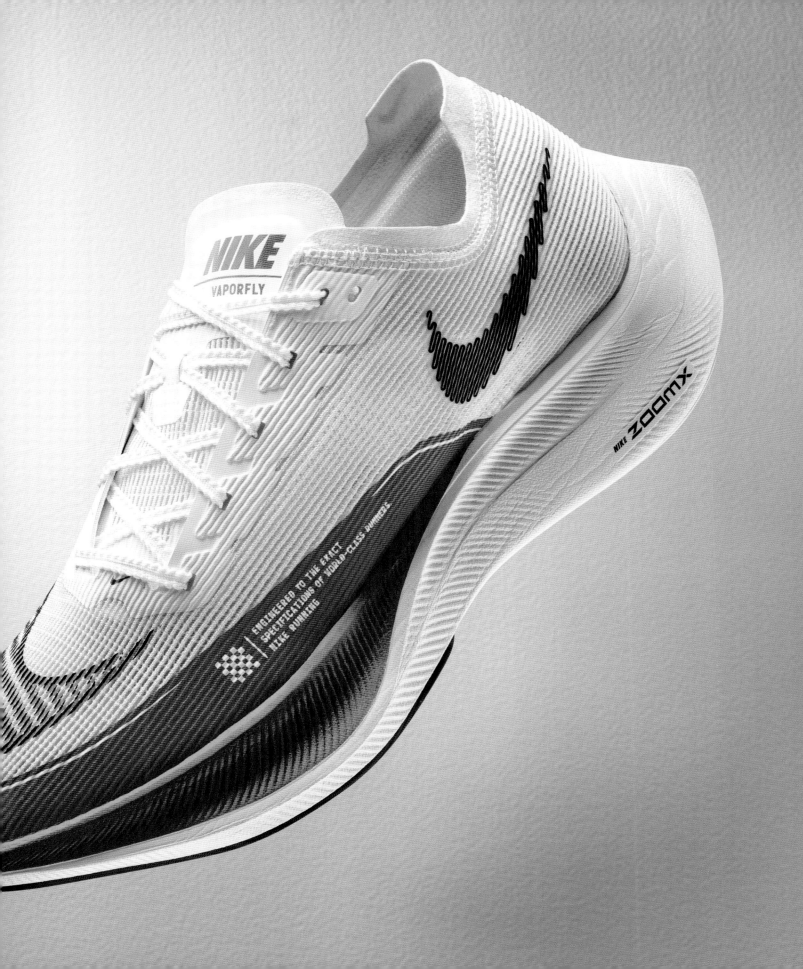

REM D. KOOLHAAS / UNITED NUDE

ELIZABETH SEMMELHACK: You have said that when you started United Nude you broke the rules of shoes not for the sake of breaking them but simply because you didn't know them. How did you end up in footwear?

REM D. KOOLHAAS: I ended up in footwear because I was studying architecture and I was looking for a way out. I figured out that architecture was going to be too big and too slow. The whole scale of it. If you become an architect, you build a smaller building first, and then a bigger one, and then a bigger one. Before you are where you want to be, easily twenty or thirty years have passed. I come from a family of architects, and I thought that that was something I didn't want to do. So, I was already looking for a way out of architecture even before my graduation from architecture school.

Then, one day, when I was really heartbroken over a girl, I started to sketch shoes and invented a new silhouette for a shoe based on the Möbius strip. I made cardboard models as architects and architecture students do and ended up making this scale model, 1:1, of the shoe. I started to show it to people and got support from friends and others who suggested that I should try turning it into a real shoe.

But as an outsider who didn't know much about shoes, I had enough naivete to create things that somebody with shoe knowledge wouldn't create. I remember when I showed my first designs to shoe designers, many would say, "You're never going to be able to produce that." It's only in hindsight that I see what a big challenge we accomplished, launching a brand of architectural shoes with entirely new constructions.

ES: Were there other aspects of architecture that bothered you?

Float, United Nude, 2014

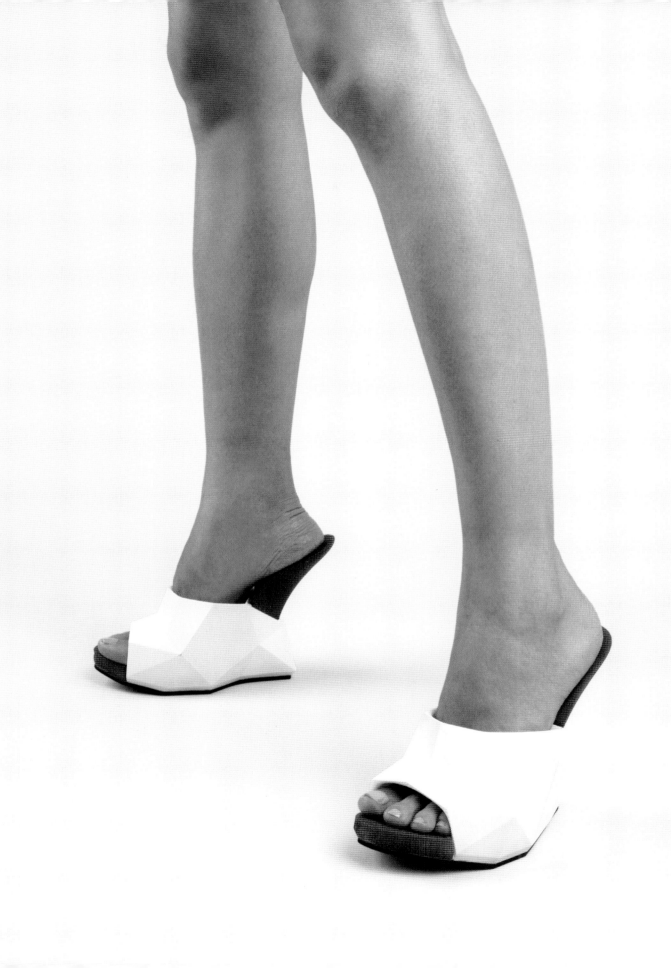

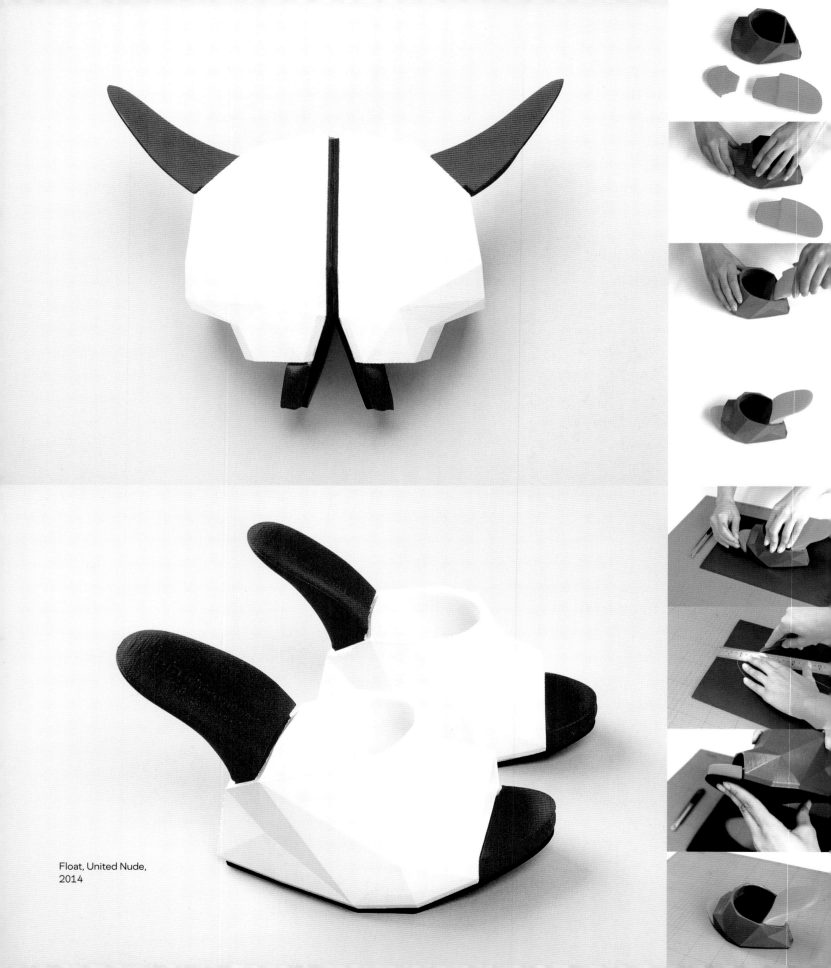

Float, United Nude,
2014

RDK: Yes, the lack of autonomy in the profession of architecture. You are constantly working for someone else. I thought if you design something and produce it yourself, then you have a lot more control over what you're actually designing and who you're working for. Although you can't choose your customers—they find you.

ES: It seems to me that architecture and footwear are very similar. Shoes are like buildings for the body. How did you realize the Mobius shoe?

RDK: I started by looking at the Mies van der Rohe Barcelona chair, which has this cross-shaped frame. I drew it and started transforming it. Then, by forcing the shapes into the third dimension, it became this figure eight on its side, and that's how I discovered the Möbius as a shoe. I grabbed a used cardboard box and cut it into a Mobius shoe. I realized that I was onto something. To my surprise I couldn't find anybody else who had made the Möbius into a shoe before. I was really surprised by that, as I thought it was so logical.

ES: It seems to me that you take inspiration from the past in your designs, but that you are also clearly forward-looking. Can we talk about that?

RDK: I first made the Mobius shoe with René van den Berg, who's a brilliant shoemaker in the Netherlands, one of the best in the world. He helped me create the first walkable pairs. But they were not constructed the right way, as they were made without the use of a last.

I then got my first lasts from my original shoe mentor Jan Jansen, who was also one of the main supporters to encourage my shoemaking endeavors.

Then, together with Galahad Clark, with whom I started United Nude, we showed it to Sergio Rossi, who offered to help us by either allowing us to work with his factory or introducing us to one of his best technical guys, who was doing all his carbon fiber heels and sneakers at the time.

We went for the last option and drove up north to meet this former car designer now shoe designer, a man named Maurizio Martignago. We worked with him on the construction of the Mobius. Engineered like no other shoe before, all parts coming together like a puzzle, and nothing was hidden.

The goal ever since is to come up with a smarter and more efficient way of shoemaking. Now, in the end, we discovered that the Mobius wasn't the most efficient or even a smarter way of shoemaking, yet it was a very clear and transparent design, where you could see the way that it works.

ES: Is it important to have honesty, or earnestness, in design?

RDK: It's what the name United Nude is about—honesty and transparency. It stands for working together in a transparent and open way.

ES: Can we talk a little bit about the footwear that you've made using 3D printing? You were very early to this technology.

RDK: We started working with 3D printing for the development of the Mobius. 3D printing is used a lot in the industry for prototyping. Then, later, it became popular for limited edition collaboration pieces and so on. Our biggest 3D printing project was called Re-inventing Shoes. We had already made 3D printed shoes, and we had already done a 3D collaboration with Iris van Herpen. But for this project we gathered five top designers—Zaha Hadid, Ben van Berkel, Ross Lovegrove, Michael Young, and Fernando Romero—as well as two product designers and three architects to make the most challenging high heels on a 3D printer. We teamed up with 3D Systems, one of the makers of 3D printers, for that. Our aim wasn't to make the most functional footwear; we just wanted to push the boundary of beautiful shapes with a very simple two-part 3D printed construction, where you have the hard part underneath the foot and a softer part over the foot.

ES: One of the things that I find so interesting about those collaborations is that you were all thinking about what a shoe might be, could be; you don't seem to have been very influenced by what shoes have been in the past. The architecture of the uppers, in particular, was radically different.

RDK: I thought that part of pushing a boundary was that the identity of the actual object should be something you had to guess. That was already the case with the NOVA shoe we made with Zaha Hadid, which wasn't a 3D printed project. It hardly looked like a shoe and could have been any kind of design object. That was also the goal: shoes that don't look like shoes can be the most exciting shoes. That goes for anything, really.

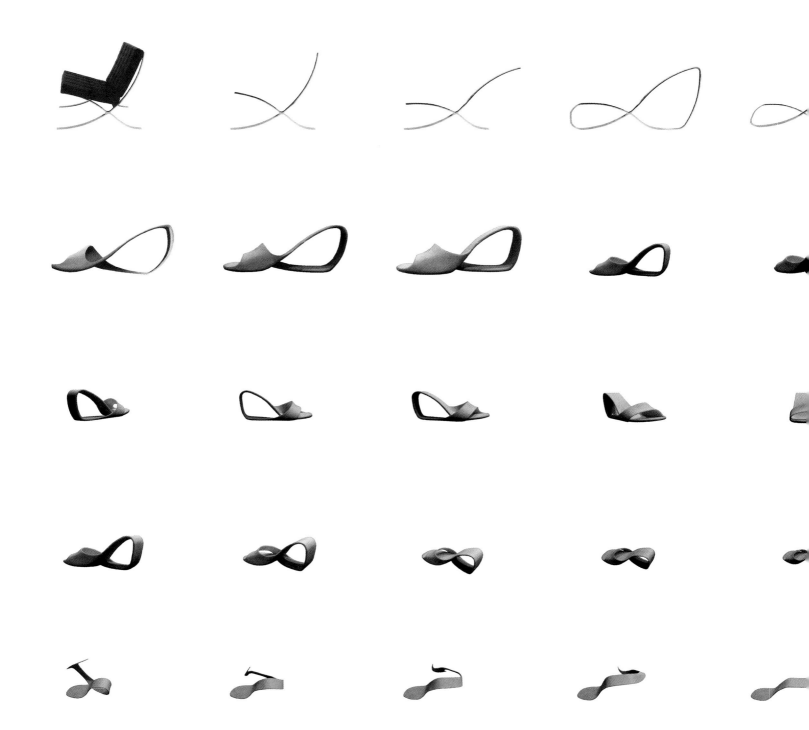

Mobius, United Nude,
2000

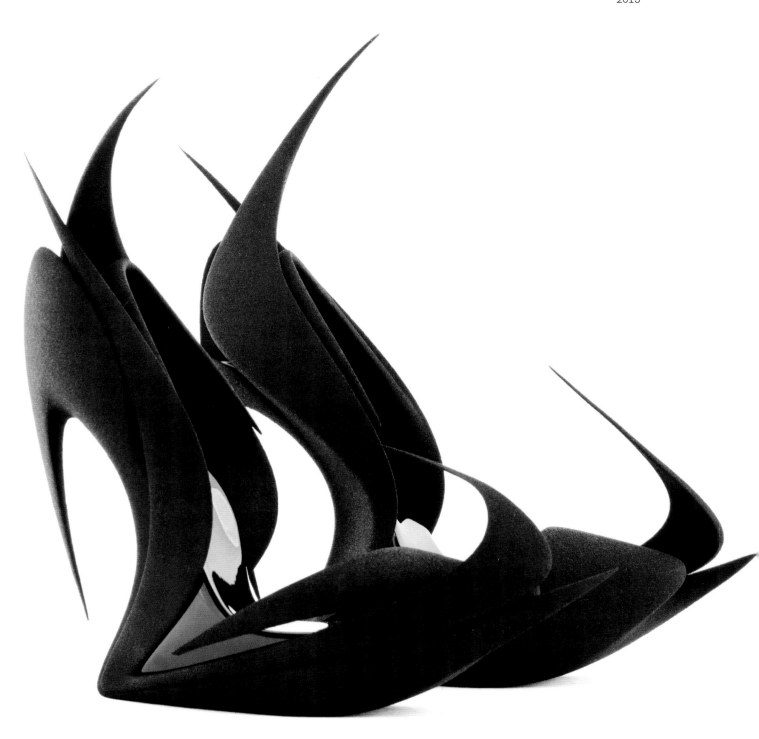

ES: My final question for you: what is the future of footwear?

RDK: Well, I'm working on it! Shoes that have a smaller carbon footprint, that are lighter, that are easier to recycle—all things that require fewer components and that are unisex.

There's no secret to die to protect. I think that many designers are working on that, all in our own way, and at different speeds, with different priorities, and so on. But footwear will become lighter and easier to make, and have fewer components, and be more comfortable. All of those things—it's happening now, and we're part of it. ✱

95

ADIDAS FUTURECRAFT. STRUNG

ADIDAS FUTURECRAFT.STRUNG was the first concept shoe and production method to use precise data to direct the exact placement and function of each string used to create a seamless upper. The focus of this first iteration was the five meters per second or faster runner. Working with runners, Adidas collected data and used these metrics to direct the Strung robot to sew the upper using threads of different strengths that corresponded to the needs of different parts of a runner's feet. Strong red threads were used to add stability to the heel, mid foot, and toe box. Softer yellow strings were used in places requiring greater flexibility. The lattice-like midsoles were made using 3D printing and were designed to work specifically with forefoot strikers.

One of the most innovative aspects of this approach is the ability to hyper-customize footwear to the individual. Knitted uppers have long accommodated the structural nuances of individual feet, but Strung has the potential to create footwear made to fit feet precisely. ✱

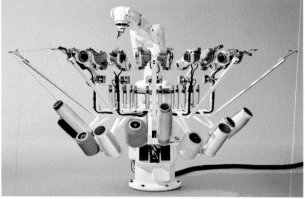

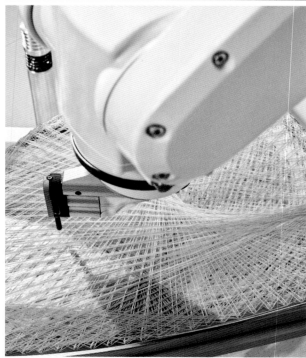

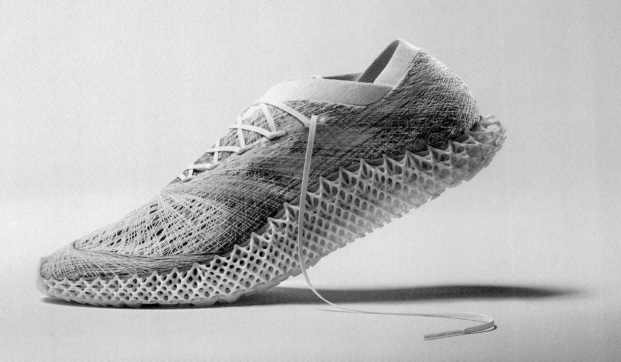

Around the world, more than twenty billion pairs of shoes are manufactured every year, and the majority are discarded as quickly as they are consumed. The environmental impact of such fast, cheap fashion has many concerned creators developing more sustainable materials and production methods to push the footwear industry ever closer to a more circular economy.

PART 2
SUSTAINABLE

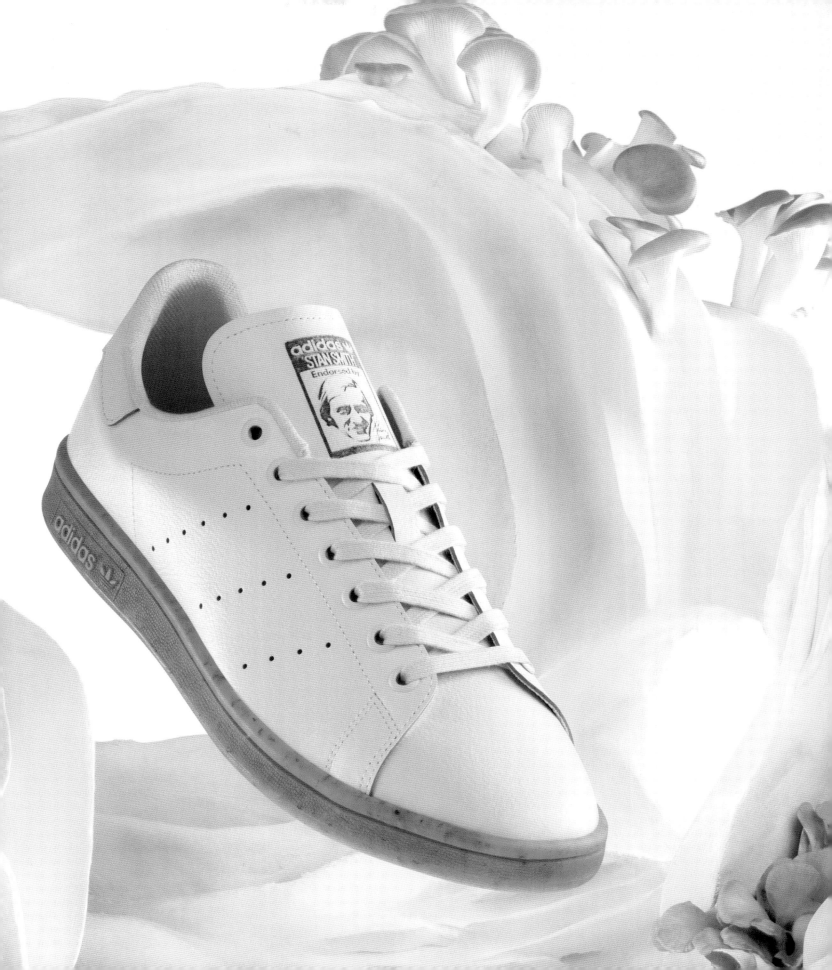

NIKE X MARC NEWSON ZVEZDOCHKA

MARC NEWSON'S modular Zvezdochka was ahead of its time when it was released in 2004. Inspired by socks the Russian Space Research Institute created for its cosmonauts, the Zvezdochka was modeled entirely using a computer and was composed of four interlocking and interchangeable modular parts—an injection molded outer cage, an interlocking outsole with a Nike Zoom Air unit in the heel, an inner sleeve, and an insole.

Its new approach to construction made this shoe revolutionary. The modular components allowed the shoe to be configured in a variety of ways depending on use, but more importantly it spoke to sustainability. The interlocking sole and outer cage eliminated the need for toxic glues, and the modular design promoted the idea of replacing parts as they wore out rather than discarding the entire shoe. Newson named the design Zvezdochka, meaning "starlet" in Russian, after one of the dogs sent into orbit on Sputnik 10 in 1961. ✱

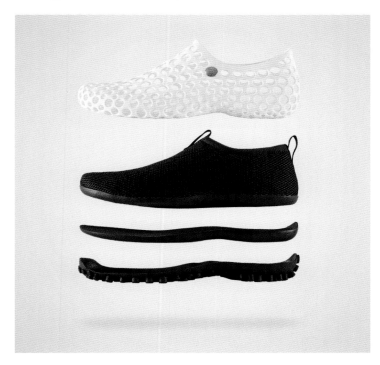

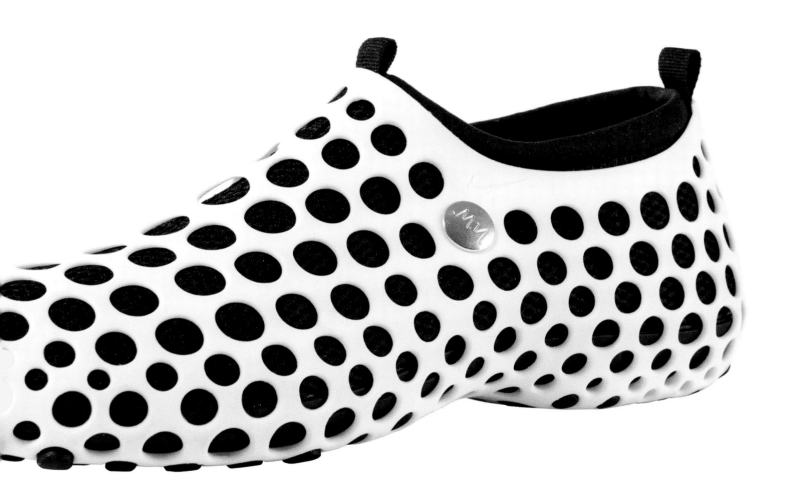

INTERVIEW WITH

ALEXANDER TAYLOR

ELIZABETH SEMMELHACK: Your design work seems driven by an intense curiosity. How did you get into industrial design?

ALEXANDER TAYLOR: The journey started back at design school, where I had the option to go down the route of either fine art or industrial design. I guess I made a pragmatic decision—I saw more opportunities to get a job as a designer than as an artist. But to be honest, it was more about the fact that I enjoy making things, I enjoy the engagement with materials. Industrial design was an opportunity to make something and see where it would take me.

I started focusing on furniture and the notion of making models that international manufacturers would pick up and make and put into production and into their catalogs. Products that would pay royalties. That's how I started. I wanted to sit alongside my favorite designers and work with the people I admired and create less but with a much more specific kind of ambition. Like I say, to work with the best.

ES: How long did you do that for?

AT: For a few years I worked for architects before starting my own studio, and I got a couple of products made. One of those products was chosen by a new British furniture company, Established & Sons, to be put into production. It was sort of my introduction, I guess. It sat me alongside some very well-known designers and that's how I came to get invited to work for Adidas.

ES: Let's talk about your work with Adidas.

AT: It actually was Alasdhair Willis who started it. He was working as a consultant for Adidas and came up with what I believe was a genius idea. He suggested that they

Primeknit, Adidas, 2013-21. Collection of Alexander Taylor Studio

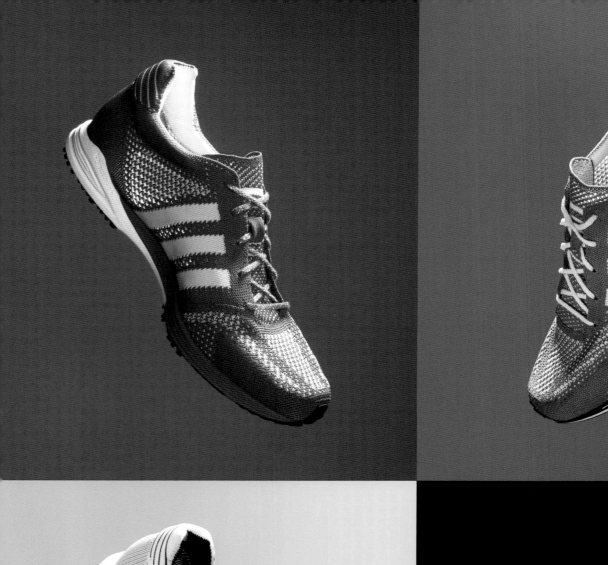
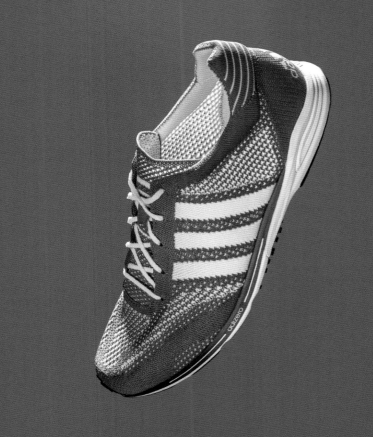
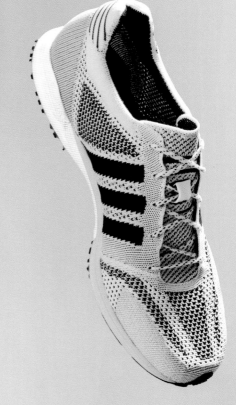

invite a small number of industrial designers and provide them with a very specific brief, to introduce technologies outside of the regular toolbox of shoemaking—more specifically outside the toolbox of performance footwear creation. None of us had designed footwear before, but that was really the charm and the beauty of it—also the brilliance of it. We were quite naive about designing footwear, but we were very process driven. That was the start, in late 2007.

It was that intense curiosity you were talking about that drove the first project. I had at that point an understanding of how things are made and knew from working on furniture that you have to put yourself in the factory. You have to talk to guys and girls who know what they're doing and rely on others to create. There's only so much you can do when you are designing furniture in the studio, so it really drove a method of working that I was able then to plug into that first footwear project. I approached designing a pair of shoes in the same way I approached designing a chair or a lamp or a table.

It was important seeing how running shoes were made at the time. There were fifteen or twenty different parts and pieces to be cut, injection molding, and gluing back together. Looking at that process with a pure rational designer's mind raised the question of how can we make this much more streamlined and efficient and apply a different way of making to this construction process, which hadn't really been challenged for about one hundred years. At that time there hadn't been any truly major innovations in sports footwear since the Air Jordan. It was quite a quiet time, prime for innovation; there was an opportunity for innovation.

ES: What was the first shoe to come out of this collaboration with Adidas?

AT: I saw a huge opportunity to pursue the project using knitting, which resulted in the Primeknit shoe in 2012. We made the first Primeknit in a factory, knitting components for office chairs. It was about taking all of the shoe parts and pieces and putting them into one machine and one process. Knitting was being used in furniture design, and I was like, why can't we make a shoe the same way? So that was how Adidas got the Primeknit shoes, and that was the start of my creating a role for myself as an external consultant with the brand.

ES: It is interesting to me how you are reimagining and using textiles—one of the oldest forms of human innovation—to create future-forward footwear. What advantages do textiles have?

AT: Working on knitted shoes actually drove my curiosity as to what could be achieved using textiles. That first shoe had integrated thermoplastic and polyester yarns twisted together that we could then heat and mold so we did not have a need for external supports or extra heel counters or toe boxes. For me, this opened up the possibility of what could be achieved using technical textiles. I went to a number of different textile fairs and events, and one in particular stood out. It was a kind of composites fair showing machines, technologies, and materials that could make high performance products to meet automotive, aerospace, and military needs. That's where I discovered tailored fiber placement machines. So many of these technologies are ready to be upgraded, and it is exciting to think about how they can be upgraded, how quickly these technologies can advance in time. The first shoe that we knitted it took fifty minutes to knit one shoe, and now it only takes about five minutes.

That first project opened doors into many different opportunities from a sustainability perspective, from a supply chain perspective, from an operations perspective, and then from a product perspective. It changed how a performance shoe could be engineered, what the yarns could be made of and how they could be engineered, and how the needles for the machines could be engineered. Everything was open to being redeveloped. That's why I think the world of textiles is so rich in opportunity. We worked with the machine makers in a two-way transaction. It's a win-win scenario for them, hopefully—that they're able to adapt and upgrade and tap new industry opportunities, and from a design perspective, you're able to be part of this process of change. The world of textiles is amazing, that's for sure.

ES: Let's talk about the Parley for the Oceans x Adidas. How were you able to take such a complicated source material, gill nets, and transform it into a material that could be used to make the sneaker?

Primeknit, Adidas,
2012. Collection
of Alexander Taylor
Studio

AT: Well, it was a testament to the way that we were allowed to work with Adidas—having parallel development and work streams running. We were investigating and working with tailored fiber placement, which is a technology that is relatively versatile. It enables you to use materials that aren't necessarily finished to the quality or the fineness that is required for use in a knitting or embroidery machine. So, we had a technology that allowed us to use the gill net material. That was one of the most important things for that first shoe that we made.

The second thing was it came back down to the power of collaboration, really. That first story was just a moment where within six or seven days we were asked to make this shoe that would then be presented at the United Nations. It was only made possible by everyone who had a shared vision and a shared goal. There were green chemists; there were the machine guys; there was us, the designers; there was Cyrill [Gutsch] and Parley for the Oceans in New York. There was also the material. The actual gill net, most of it was in La Rochelle, France. Adidas is in Germany, of course, so the project had all these people all over, but somehow, we just all worked together.

The gill net, again from a collaborative perspective, had come from the Sea Shepherd Organization whose captain Paul Watson collaborates with Parley. The material was shipped to the green chemists and they processed it based on our specifications. A filament was the first thing we needed to have in order to use the tailored fiber machine. So, the green chemists managed to clean the net of all the foreign articles, like lead and hair and everything else. Then they ground it down into a powder that could be heated up and extruded by a machine that they made just there and then, just for that operation. They did that a few times to improve the quality of material and then shipped it overnight to Germany, where we'd already made two or three sample designs using a placeholder material so that we could just plug and place the gill net into that process.

Prototypes of Parley for the Oceans x Alexander Taylor x Adidas, 2015. Collection of Alexander Taylor Studio

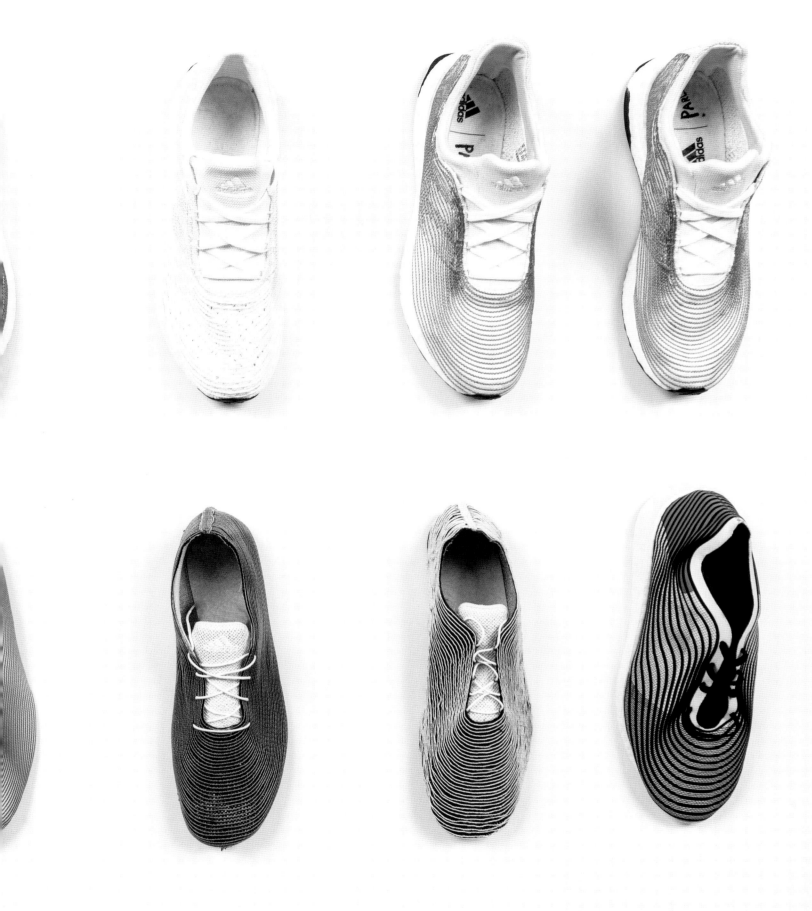

Then it went to Herzogenaurach, where the Adidas headquarters is, and they made up the shoes and then they were hand carried over to the U.N. for launch. When they were presented by Eric Liedtke—he was then CMO of Adidas and committed to working with Parley for the Oceans and trying to phase out virgin plastics—they were kind of the flag in the sand. I think looking back on it, we didn't know how big it was going to be, but we knew we had an opportunity and a responsibility as designers to create an object that would tell an important story. One of my codes, I guess, is that I like to be able to see how something is made. I like objects that tell stories, in a way, but also have very smart and intuitive processes and design solutions.

ES: You had so little time to develop the sneaker!

AT: We had six days. We got a call one evening here in London saying they needed the shoes by the next Saturday. We just didn't have time. We didn't have time to think really about anything. We just took a chance and said, "Yeah, we'll make that." And that's what we did.

ES: Well, that's how revolutions happen, right?

AT: Yeah, that's it. We just got lucky. Everyone got on board and everyone had the same ambition and enthusiasm to make this thing work. It was really great, just an amazing project to have been part of, and I probably speak about it every week, at least once a week in some context.

ES: What role does sustainability play in your work and in your imagining?

AT: If we go back to the knitting story, at the time it wasn't really part of my list of bullet points that I had to tick off. Sustainability for me means that one has to be responsible and that you have to design in a way where you ask the right questions, you partner with the right people, and you strive to make an improved product. You can only do your job as a designer, but there is no excuse for not trying to create the most efficient and the most innovative or the most responsible solution. Then it's up to the brand to communicate that, and it's up to the consumer if they want to buy into it. But sustainability for me is really born out of responsible design, and responsible design can be achieved through good working practice and method.

ES: You've been awarded designer of the future. Clearly you are always forward thinking. Do you have any advice that you would give somebody who might want to get into footwear design?

AT: Obviously, the natural response is to always encourage curiosity and encourage openness. I would tell someone wanting to get into footwear design to ask questions and to be open to collaboration and to understand that actually no one does it all by himself. For the best results, you can't have enough gifted collaborators. It's this kind of philosophy and way of thinking that breeds results. Designers shouldn't be afraid of getting it wrong and admitting that they get it wrong, because we all get it wrong. It's okay to make mistakes, but you've just got to ensure that you learn from those mistakes. If something's not working, then be efficient. Stop and change. Don't keep working on something that's not working out. There's often a reason for that. Working in this way can create efficiency, but I think it is also true that quality very often takes time and there's no way around that, really. There's this desire to be successful quickly, but for me, from a design perspective, good design takes time. ✱

Parley for the Oceans x Alexander Taylor x Adidas, 2015. Collection of Alexander Taylor Studio

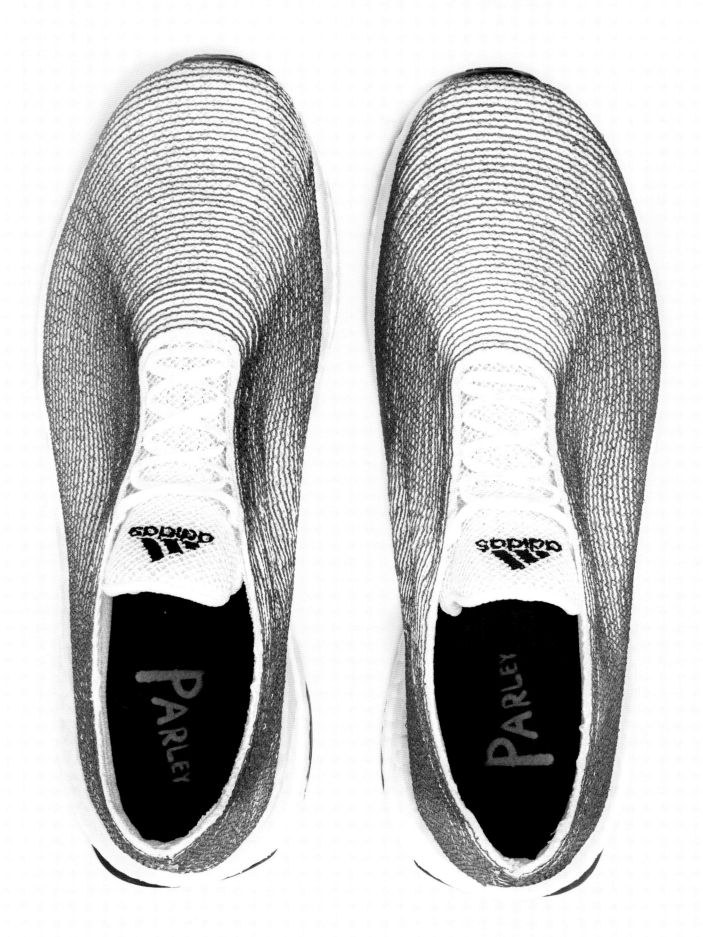

NIKE FLYKNIT RACER

NIKE'S FLYKNIT TECHNOLOGY, unveiled in February 2012, grew out of a desire to create a socklike running shoe that was lightweight, offered support to the foot where needed, and furthered the company's sustainability initiatives. To achieve this, Nike developed a digitally engineered knitting process that allowed the upper to be knit using different techniques in different parts to ensure support and durability. Knitting the upper also did away with the waste created by pattern-cutting, representing a 60 percent reduction in waste. The first iteration was the Flyknit Racer, which debuted at the London Summer Olympics in 2012. ✳

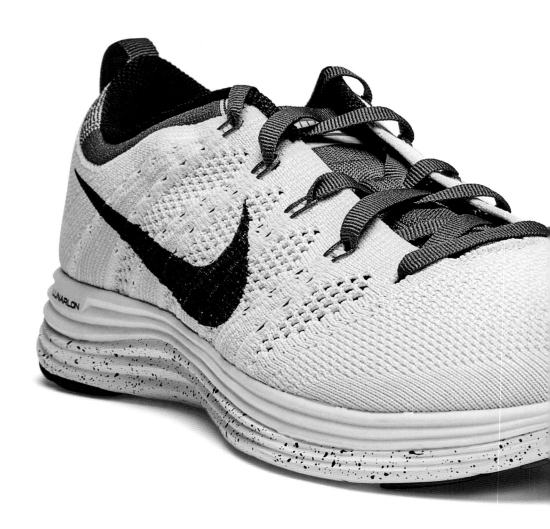

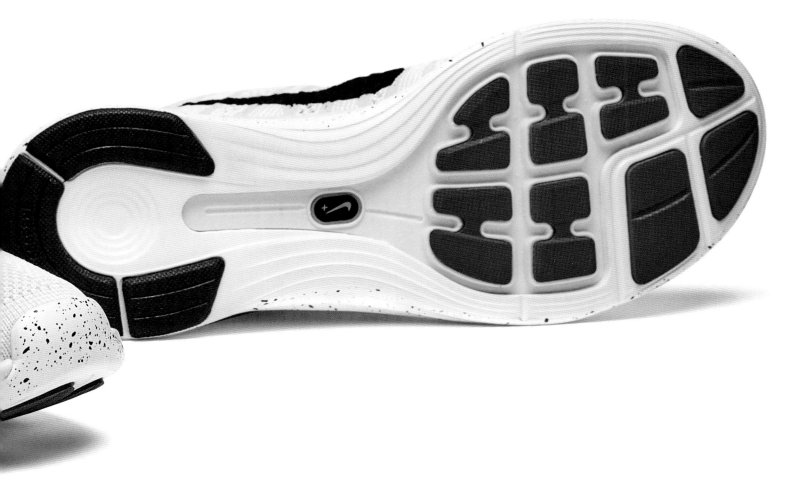

ADIDAS STAN SMITH MYLO

IN 2021, ADIDAS UNVEILED a new concept shoe, the Stan Smith Mylo, made using mushroom leather. The company's sustainability initiatives coupled with the need to use materials that can be mass-produced led it to invest in Mylo, a scalable mushroom leather created by Bolt Threads and supported by a consortium of companies, including Kering, Lululemon, and Stella McCartney. Mushroom leather is created from mycelium, the interconnected root structure of mushrooms. Under controlled conditions, mycelium cells can be added to beds of sawdust mixed with other organic material and encouraged to grow quickly into a dense structure that in turn can be tanned and dyed to make an all-natural leather substitute. It mimics the breathability of leather, is cruelty-free, requires fewer resources and time to produce, is renewable, and is biodegradable.

When Adidas decided to make its first mushroom leather sneaker, it chose the iconic Stan Smith. The upper and heel tab are made of Mylo, while the sole is made of natural rubber. ✱

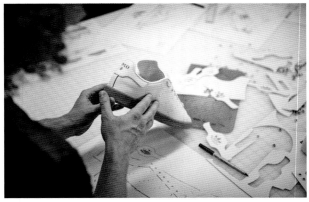

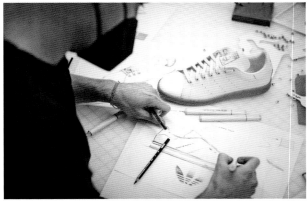

CONVERSE RENEW CHUCK 70

CONVERSE WAS ESTABLISHED in 1908, making it one of the oldest sneaker companies in the world. For more than a century it has been producing the iconic Converse All Star using canvas and rubber. Recent concerns for the environment led Converse to reimagine its signature shoe as a model of sustainability. The 2020 Renew Chuck 70—an updated iteration of the 2013 Chuck 70, itself an updated version of the All Star—features a knit upper made using 85 percent recycled polyester thread to reduce material wastage. The laces are made from 100 percent recycled polyester, and the translucent sole features 12 percent recycled rubber scraps collected from the footwear making process. *

IRIS VAN HERPEN MAGNETIC MOTION

DESIGNER IRIS VAN HERPEN has long been driven by her curiosity about the nature of things. In a 2021 *Fast Company* interview, she said, "Nature is very intelligent; it is full of interconnected systems where nothing is wasted, and everything is perpetually renewed. I am interested in how we can mimic some of these processes as we design systems. How can we transform fashion into a closed-circle economy, where materials are continually recycled? This is the way that nature works."

Indeed, many people claim inspiration from the natural world, but van Herpen delves deep into its systems of movement and regeneration. She has made multiple visits to the CERN (the European Organization for Nuclear Research) center in Geneva to see the Large Hadron Collider. Her 2015 Spring/Summer collection Magnetic Motion was inspired by these visits and included footwear created by Jólan van der Wiel using magnets. The spiky appearance of the shoes was achieved by adding iron filings to resin and then manipulating the resin with magnets to create the desired effect without wasting material. Over the years, van Herpen has experimented with new methods and materials, including 3D printing and using recycled ocean plastics, in an effort to incorporate sustainable practices into her work. ✱

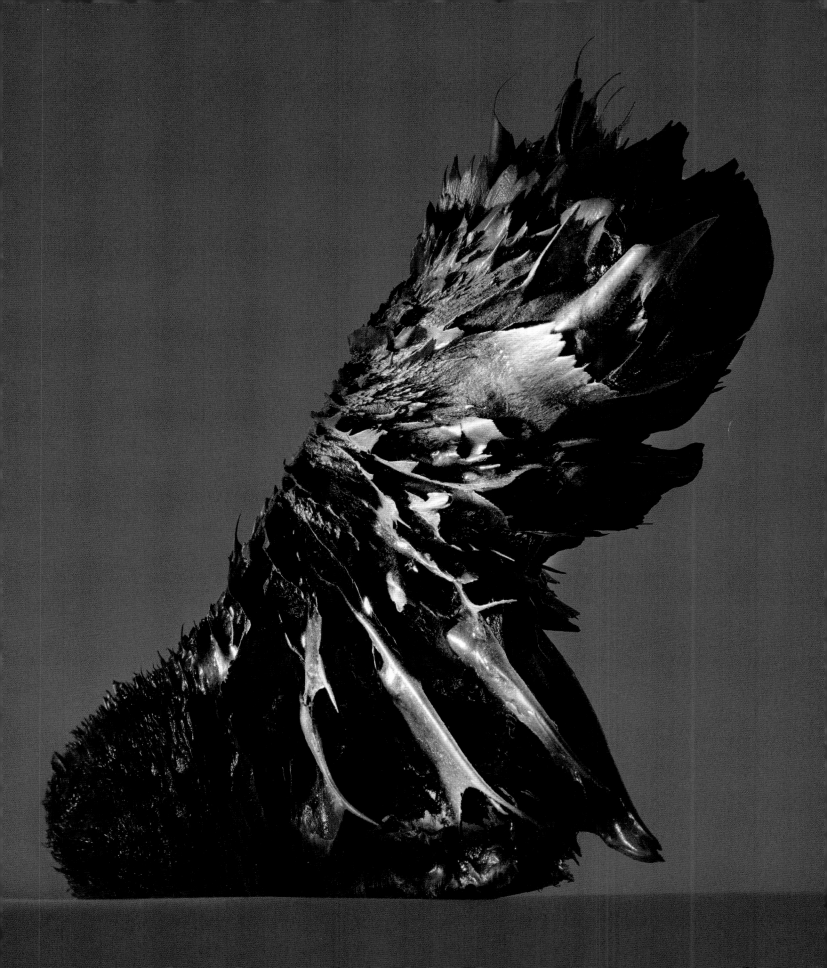

11.11 / ELEVEN SLIPON

11.11 / ELEVEN WAS FOUNDED by Mia Morikawa, a graphic design graduate from Central Saint Martins University of the Arts, London, and Shani Himanshu, who holds an M.A. in fashion design from Domus Academy, Milan, to promote ethical slow-made fashion that dissolves geographic and gender boundaries. Working with artisans across India, 11.11 / eleven develops footwear and clothing that supports heritage techniques, including spinning, weaving, dyeing, and sewing by hand, as a way of keeping crafts alive and minimizing the carbon footprint of its products. The cotton used is indigenous to India and the dyes are all natural, in keeping with the seed-to-stitch philosophy. This pair of babouches was crafted from handspun and handwoven cotton dyed ocher yellow using pomegranate skin. ✽

119

NIKE SPACE HIPPIES

IN 2020, INSPIRED BY discussions of how footwear would have to be made on a resource-limited and distant planet like Mars, Nike created Space Hippies. Each of the four models—01, 02, 03, 04—relies on recycled materials, including Space Hippie Flyknit yarn composed of 85 to 90 percent recycled material, a midsole made from surplus ZoomX foam, and Crater Foam outsoles that incorporate 12 percent Nike Grind recycled material. The Space Hippie aesthetic features raw edges, and the shoes have a handmade look to reflect the In-Situ Resource Utilization approach used by NASA, which requires people in deep space to reuse all of the resources to which they have access. ✱

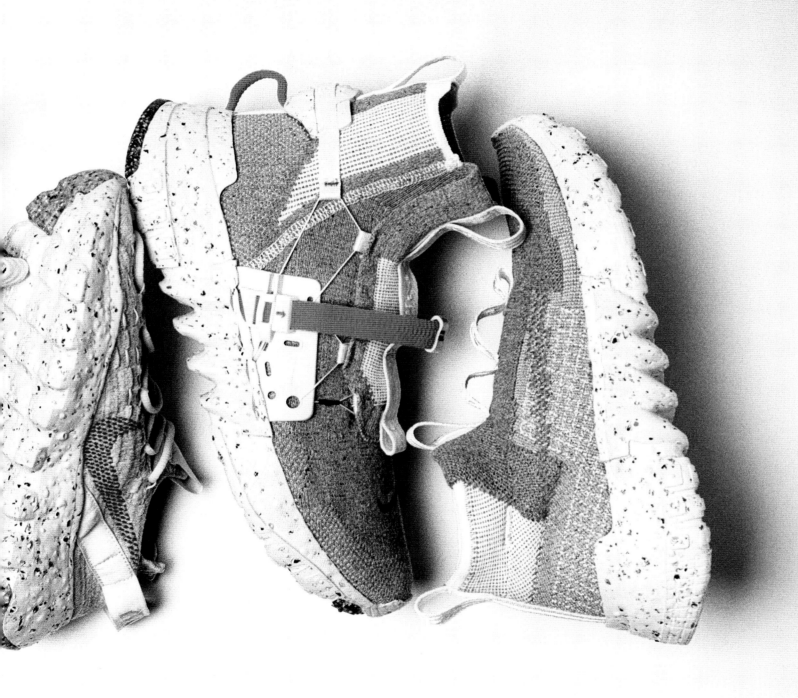

F_WD XP4_MAVY

F_WD, PRONOUNCED FORWARD, was founded by Onward Luxury Group in 2019 as a streetwear brand dedicated to sleek sustainability. Its first collections were created by the Seoul-born, Paris-based shoe designer Raphael Young whose futuristic designs were vegan, PETA (People for the Ethical Treatment of Animals) approved, and made of recycled and recyclable materials. This XP4_Mavy sneaker features recycled microfiber uppers, recycled polyester soles, and sustainable canvas pull tabs. ✱

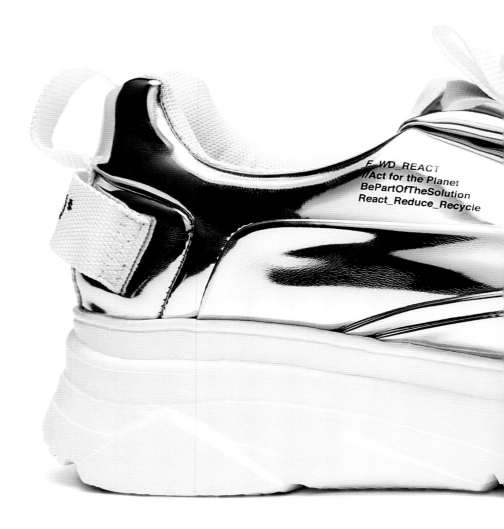

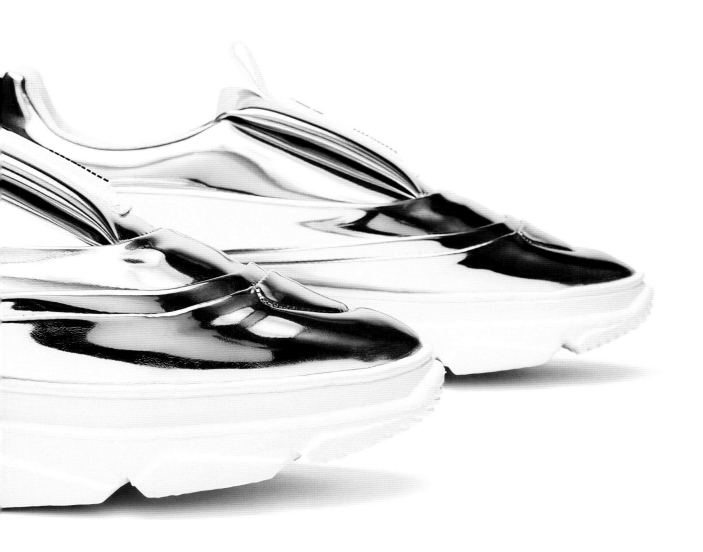

CENTRAL SAINT MARTINS X PUMA KYRON FOR THE LOVE OF WATER

IN 2020, PUMA COLLABORATED with graduates from Central Saint Martins, the world-renowned fashion and design school in London, to create a capsule collection dedicated to sustainability, specifically water conservation. The seafaring-inspired clothing used low-water dyeing and digital printing to limit water consumption, and the footwear was made using recycled mesh and undyed, ethically grown cotton canvas.

One of the pieces in the collection was a Puma Kyron reimagined as a boot. The deep black outsole, cowlinglike toe cap, and quarters contrasted with the raw canvas upper and made the boots seem both futuristic and archival. Quotes like "For the love of water" on the back quarter of the Kyron can be found throughout the collection. This collaboration demonstrated more than just concern for the future of the environment—it was a proclamation of Puma's interest in working with the next generation of designers and represents an investment in the future. ✱

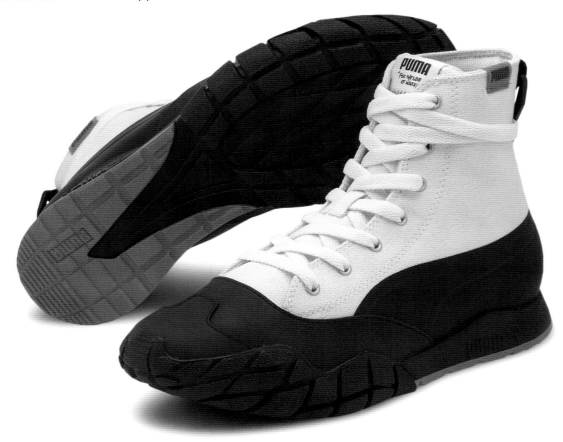

"FOR THE LOVE OF WATER"

RICK OWENS X VEJA VENTURI

VEJA IS THE PORTUGUESE word for "look" and was chosen by the company's founders, Sébastien Kopp and François-Ghislain Morillion, to invite consumers to interrogate how Veja conducts business. Its pledge is to be transparent about everything from labor practices to materials. In order to meet those goals, Veja does not spend money on advertising but instead pays higher prices for materials and labor. It manufactures in Brazil, a country known for its strong legal protections for workers, and all of its logistics are handled by the French-based not-for-profit organization Ateliers Sans Frontières, which helps vulnerable populations with job reintegration.

In 2017, fashion renegade Rick Owens reached out to Veja to collaborate, as he was increasingly concerned about sustainability. He explained his thinking in a 2019 *Vogue* interview with Emily Farra: "The main gesture is really about sending a message that even an old hypocrite like me can change directions . . . Maybe I can be a voice suggesting there are new, better ways to consume." The 2020 vegan Venturi, which featured a leatherlike upper made from corn waste, a sole made from recycled plastic, and wild, ethically harvested, natural rubber, was deemed as sartorially savvy as it was ethical by no less a fashion arbiter than *GQ*. ✱

TIM BROWN / ALLBIRDS

ELIZABETH SEMMELHACK: How did you decide to start a footwear company focused on sustainability?

TIM BROWN: I was living in New Zealand at the time, just coming out of a professional sporting career. One of the great things about playing professional sport, in my case soccer, was that I was sponsored by some of the big global brands in the space and got lots of free gear. The initial sort of insight that led me to create shoes was the observation that many of the sneakers I was getting tended to be overly logoed and overly synthetic. I began to ask myself questions about natural materials and footwear. I come from New Zealand, the land of lots of sheep. It is a really important part of our country's culture that had been through years of decline, so the opportunity to use wool and merino in shoes suggested one of those questions: why has this not been done before? So, I set out to try and work that out and it took years and years and years, hundreds of prototypes to work out how to make a shoe. Making a shoe, I don't need to tell you, is very difficult. And doing it with materials that have never been used before is especially hard.

So that's what I did. I worked on this idea for over five, six years, then I went to a World Cup with New Zealand, which was a great part of my sporting career, and then retired to focus even more intently on this process. Along the way I met Joey [Zwillinger] my cofounder. He had a similar vision of a world that was going to need to find different, better ways to make products and services that they use every day. We agreed that climate change was the problem of our generation and that there was a real need for more environmentally thoughtful manufacturing. He'd come out of a biotech business, had a background in engineering as well as research and development. So, we came together, and the purpose for Allbirds was found in the

Wool Runners, 2021. Allbirds. Collection of the Bata Shoe Museum

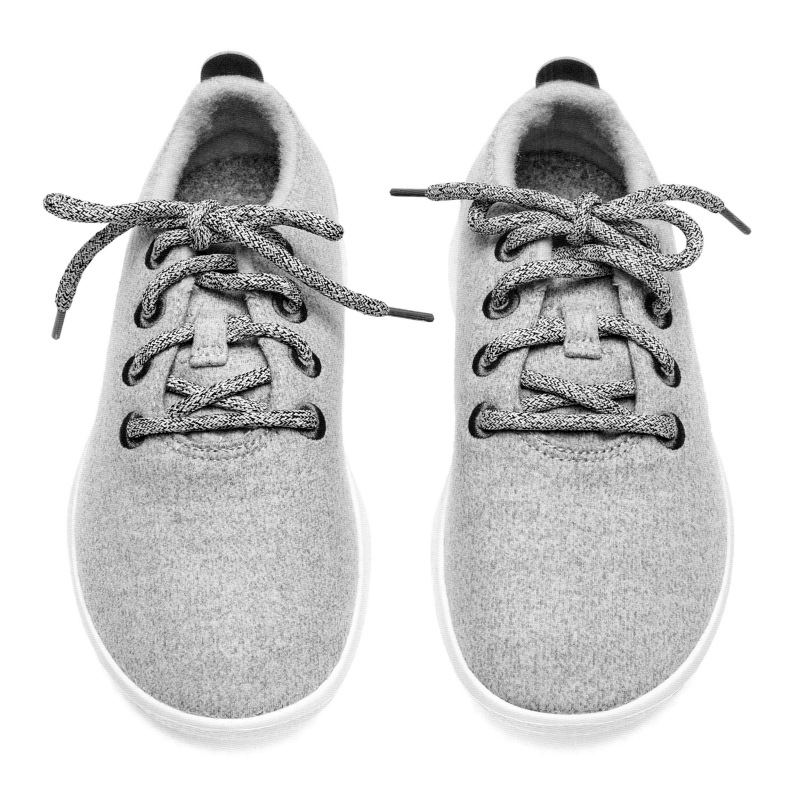

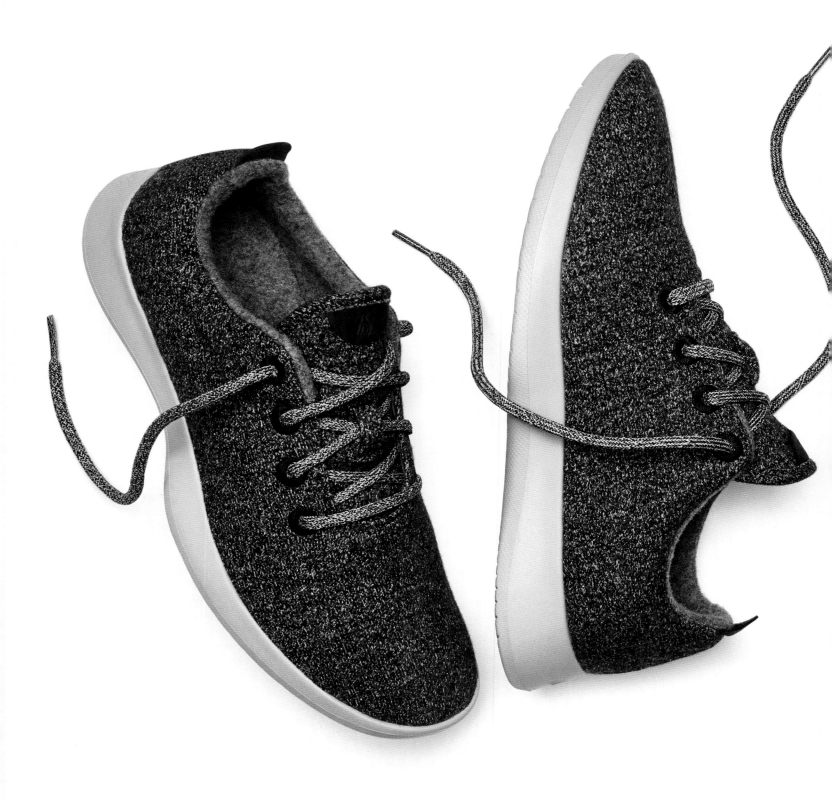

Wool Runners, 2021.
Allbirds

collision of our two visions—neither of us were from the footwear industry.

I did, however, have a design background and clarity about the kind of product I wanted to produce and I'd spent a lot of time working on that first shoe. Joey had this larger vision for an opportunity in the footwear and fashion space, which, when we founded the business in 2015, had only been paying lip service to the idea of sustainability. True sustainability, including the transformation of materials and manufacturing, and greater measurement of environmental impact, are all things that we've tried to do in the five years we've been around.

ES: One of the things that I'm finding in my interviews for this book is that some of the most radical thoughts on the future of footwear are coming from people outside of the industry.

TB: Yeah, sometimes you're able to ask the questions, the seemingly naive questions, that years and years of experience might preclude asking. It's this outsider mentality that has allowed us to sell only one shoe for the first eighteen months of our business. We went to market and launched the shoe only online as a vertical business. No wholesale; it's never been part of our model. And we've done some things counterintuitively. There were plenty of people along the way, experts in the shoe industry and experts in the wool industry, in the early days, who said, "Hey, we looked at this," or, "It can't be done," or, "It won't work." Sometimes that's just the way that innovation happens. That being said, along the way we've added deeply experienced footwear folks to help build out our team.

There are behaviors or processes in the mass manufacturing of shoes that have not changed for a long time. The industry is still heavily reliant on manual labor, and it is predominantly about the use of cheap synthetic materials. Some of those things are difficult to change because they're related to margin, and they're related to factory capability and infrastructure, and they're related to wholesale models of doing business. So, it took a number of different things coming together for us to be different. It is very complicated, and it's just very, very hard and takes a long time to make a shoe and to work out how to do it in specific ways.

ES: Let's talk about the range of natural materials, from wool to eucalyptus, that Allbirds has used to create footwear.

How does something like eucalyptus get transformed into something that will be used to create footwear?

TB: In the case of merino, we didn't invent sheep; we didn't invent wool. But we did bring in an enormous amount of emphasis and focus on how it could be translated and engineered into something that would be suitable in footwear. It was driven by this insight about comfort, this idea of the incredible properties of natural materials and what they can do for you. They wick away moisture, regulate temperature, are incredibly soft. But wool also had some limitations, especially for wear in hot weather. The cooling nature of the eucalyptus fiber combined with a new manufacturing process around open mesh netting was something we worked on for a long time before it became a part of the sole unit.

Our R&D and our creativity are consumer driven. At the end of the day, people don't buy sustainable products—they buy great products. But for a product to be great it must also be sustainable. In the case of the eucalyptus, it was a consumer insight around temperature and the cooling quality that drove it.

ES: Why did you decide to make one of your innovations—SweetFoam, made from sugarcane—open source?

TB: The story of SweetFoam, a green EVA, is one of our favorite stories about material R&D. We leveraged Joey's previous industry contacts to work with Braskem, one of the biggest green-energy companies in the world, located in Brazil. Together we took one of the by-products of the production of sugarcane and turned it into a green EVA—carbon negative in its raw form—to replace the petroleum-derived EVA that's one of the most predominantly used materials in casual and athletic footwear. We supported that with an open-source business model that allows anyone to use it, and we did that with the idea that to have true environmental impact, the more people who use it the better that would be. Also, the more people who use it, the lower the cost. In the case of the SweetFoam, it wasn't enough just to make the material. It required a new business model and a new way of thinking about R&D and materials, which, traditionally, in the footwear industry, is all about secrecy. So, we've been trying to do a lot of things differently.

Sole made from
SweetFoam, 2021.
Allbirds

ES: You have also made the groundbreaking choice to partner with another major shoe brand, Adidas. Why, or how, did cooperation trump competition for you?

TB: At the end of the day, we are constantly asking ourselves how we can go faster and further in the pursuit of our purpose. It seems like every single company is, admirably, coming out with a pledge or a strategy for reducing their footprint, but these statements are followed by the hope that the goals are reached by 2040 or 2050. That's important, don't get me wrong, but one of the questions we were asking ourselves is what we can do right now. How could we go faster and further in our pursuit of making more environmentally friendly products? This is why we introduced a carbon methodology, a carbon footprint framework that has us print the carbon footprint—the kilograms of carbon that are emitted in the production of each product—on the products we produce in the same way that the calories in food are added to food packaging. It's our measure of environmental impact, and we think it's better for it to be fully transparently displayed on the product.

It was a big moment for us when we decided to label our products with their carbon footprint, and it brought a great deal of clarity over what we need to do. The goalposts became very, very clear. We need to make products that have zero impact—0.0 kilograms of carbon. The average carbon footprint in the footwear space is somewhere in the 12 to 14 kilograms of carbon range. So, we asked what we could do to accelerate our progress. The idea emerged of working with one of those storied brands in footwear, leveraging its decades of manufacturing experience and global supply chain. A New Zealander runs Adidas in the Americas, and I met with him, and we agreed to work together. It took a little over twelve months; it was an incredible project. We landed at 2.94 kilograms of carbon, which is a little over half the carbon footprint of a hamburger. I think it just goes to show that when you commit to this, when you're measuring your impact, when you're very focused on innovation and understanding what levers you can pull to truly reduce impact, real progress can be made. That was the equivalent of running a three-minute mile, and hopefully it's an example for others to follow. Hopefully that's the number we can go and beat and even exceed sometime soon.

Tree Dasher Relay,
2021. Allbirds.
Collection of the Bata
Shoe Museum

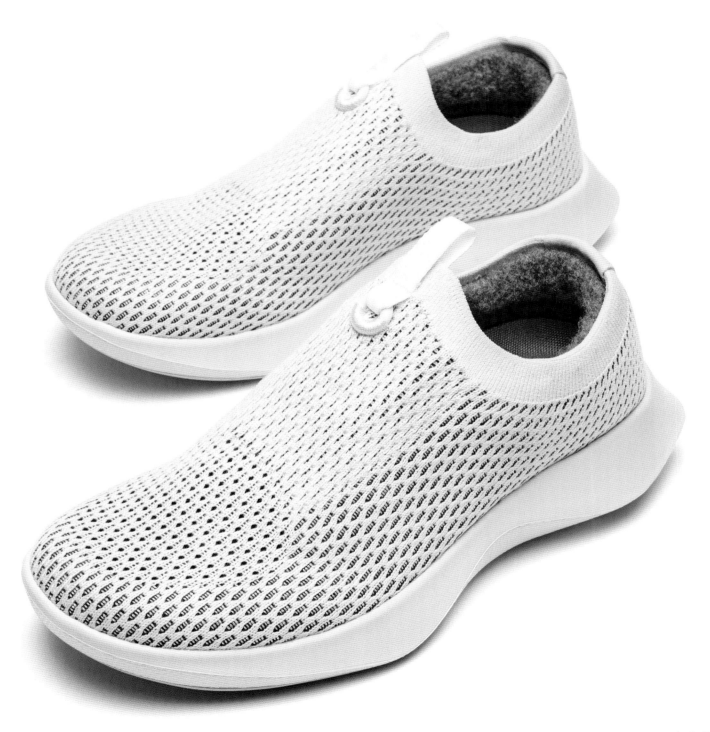

ES: What does it mean to you to be a certified B Corporation?

TB: You know, from the beginning, we enshrined being a B Corp in our founding documents of the business. We made the environment one of the key stakeholders. At the time, in 2015, that was a little unusual. It's less so now, in the most positive of ways. But really it was sort of about saying this pursuit, this purpose is not a CSR initiative or something that gets tacked on at the end. It's absolutely intrinsic to why we started the business. When Joey and I first came together, we imagined a business we'd tell our grandkids about, one that truly contributed to this conversation. Becoming a B Corporation was a way of really making it clear that even if we disappeared one day, these ideals would still be embedded and enshrined in the DNA of the company. Being B Corp certified means that every two years you have a publicly disclosed score that is a measure of accountability and transparency that ensures we are improving and doing all the things that we can to be the right type of business, including contributing to the community that we do work in.

ES: This is my final question: what do you think the future of footwear is?

TB: I think at the moment, loosely speaking, when you set out to design an objective, you think about three things. You think about what it costs, what it looks like, and what the utility of it is—what it does. One of the most exciting things about the future is for industry to add a fourth constraint around carbon. Sustainability is a complicated thing. It also means a lot of different things. It's about air quality, land quality, water quality, fair trade, labor, recyclability, end of life. All of those things are very, very important. They matter. We believe that a north star for sustainable innovation is carbon. So, seeing it as a constraint that is embedded from the very beginning of how we conceive and make and create products is really exciting.

I think when people hear the word *sustainability*, they sort of assume it is about all the things you can't do. And that is right. There are a bunch of practices and processes and materials that we need to stop using. We need to shift from synthetics and plastics, to run away from oil and to natural materials. We need to think about water usage, and we need to have ethical supply chains that treat people well—the people who are helping to make and create products. We

need to think about shipping, all of those things, but the idea that this carbon footprint is a singular metric opens up a kind of creative innovation opportunity. It turns sustainability from defense to offense as we start to imagine a new way of creating things. I think this is going to evolve into a new design language and the limited use of carbon will be prevalent as a marker or a pillar of how we innovate and create a product. ✳

above
Sugarcane

opposite
Wool Runners, 2021.
Allbirds

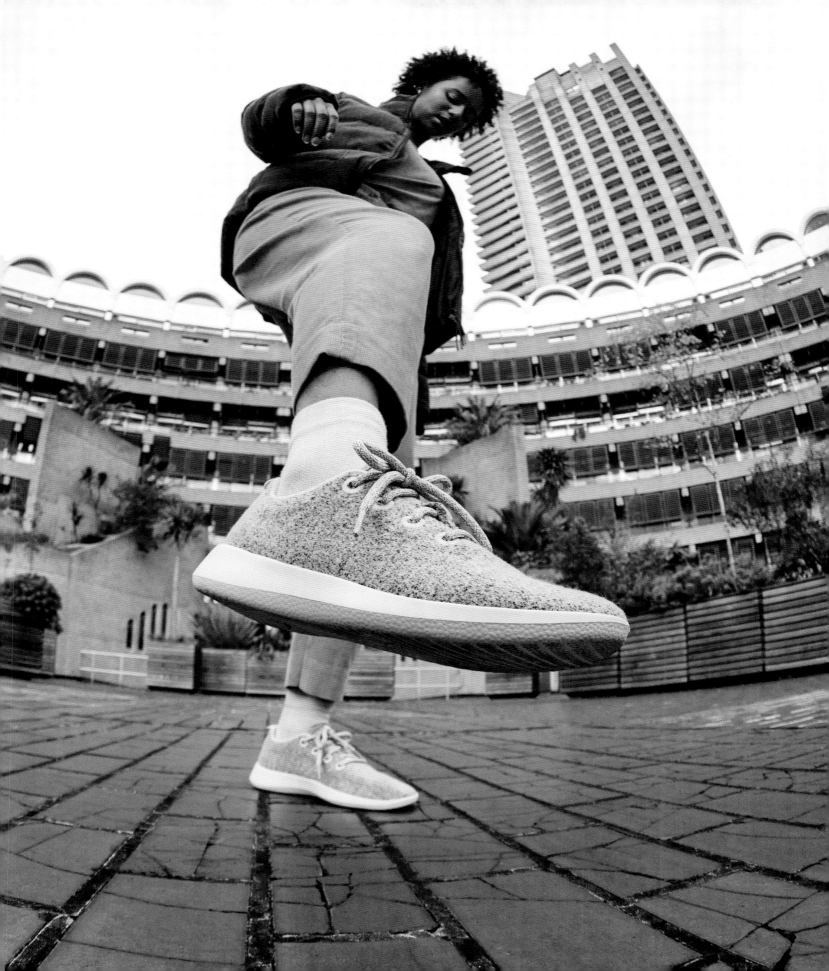

VÆR
PHOENIX

VÆR IS A COPENHAGEN-BASED company focused on making upcycled sneakers. The idea came to one of the company's founders, Lili Dreyer, in 2018 while she was still a university student searching for a solution to textile waste created by the fashion industry. By 2019 she, along with cofounders Linda Egtved Olesen and Emma Hjortdal, launched VÆR with the goal of creating upcycled footwear.

However, upcycling—the repurposing and reusing of discarded material to make something new—has been challenging to achieve on an industrial scale. The goal of VÆR is to take discarded textiles and use them to make sneaker uppers, but the lack of uniformity in discarded textiles can make them very difficult to work with, as factory machinery is generally not designed to handle a wide variety of different types of materials. In order to alleviate some of this complexity, VÆR predominantly recycles jeans and workwear for the uppers of its shoes. Insoles are plant-based and laces are recycled cotton, and in an effort to be environmentally friendly, VÆR soles are made from 70 percent recycled natural rubber and 30 percent virgin rubber. The company also accepts worn sneakers whose soles can be recycled into new ones. This 2021 sneaker, appropriately named Phoenix, was made at the company's Portuguese factory. ✳

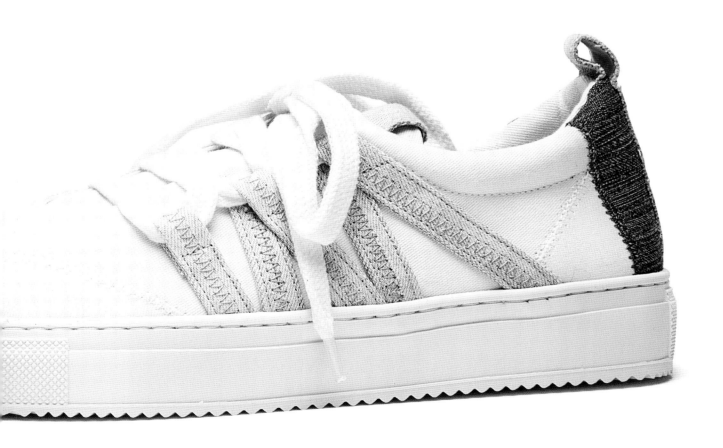

STELLA McCARTNEY X ADIDAS ULTRABOOST 21 METALLIC

DESIGNER STELLA MCCARTNEY, dubbed fashion's conscience, has made sustainable and cruelty-free fashion both a personal and professional mission. In 2005, she became the first high-fashion designer to sign with Adidas's sports-performance division and brought this ethos to the collaboration. Since the beginning, all of McCartney's Adidas footwear has been vegan, and over the years it has become increasingly sustainable. McCartney's 2021 take on the Adidas Ultraboost 21 incorporates Primegreen knit made from 50 percent recycled polyester. ✱

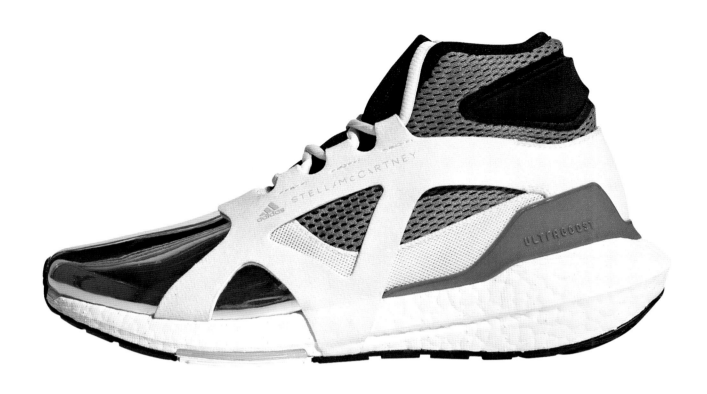

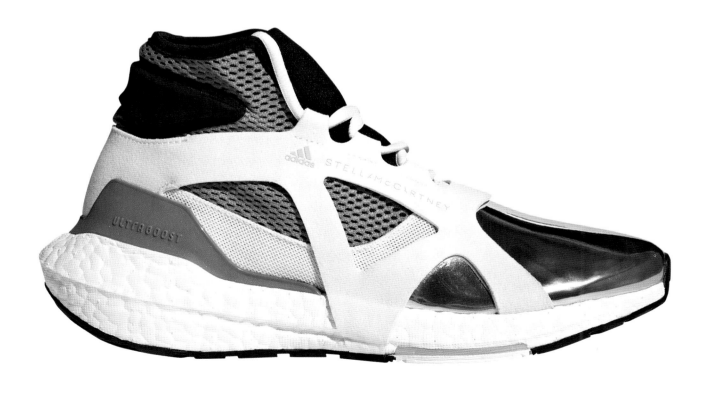

MY CELL

JULIAN ZACH DESIGNS industrial footwear by day, but on his own time he works on imagining the footwear of the future. His concept shoe, My Cell, explores step-by-step how consumers of the future could grow their own footwear at home using a mixture of corn flour, mycelium, and water. To make the shoes truly bespoke, each consumer would have a reusable last—the foot-shaped form shoes are traditionally built on—made to the individual specifications of their feet. Then, whenever desired, they could make custom mushroom leather shoes that ensured the perfect fit. The simple mixture could potentially have color added to it to give the shoes an additional personalized touch. Once the shoes were no longer needed, they would simply be composted, leaving no waste behind. ✳

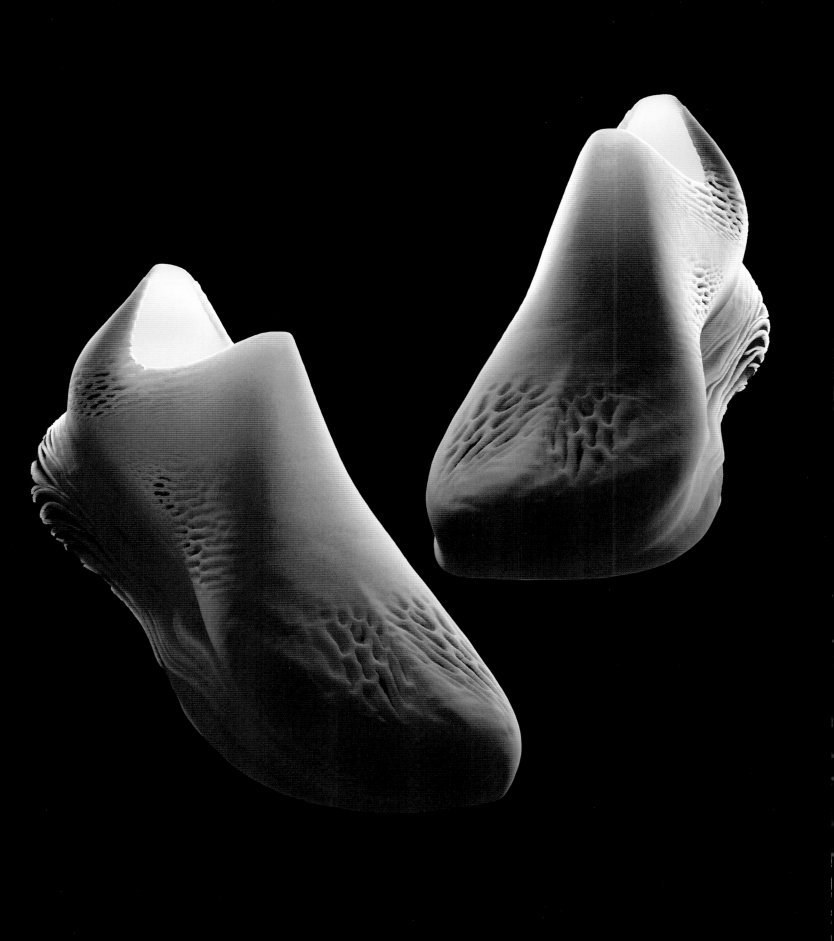

INTERVIEW WITH

ZIXIONG WEI / SCRY

ELIZABETH SEMMELHACK: How did this venture begin? Why did you choose the name SCRY?

ZIXIONG WEI: Everything started with my Instagram id, @scccccry. I typed these letters randomly in 2018. When I decided to set up the lab in 2020, I found that *scry* actually means looking into the future. So, I decided to use it as the brand name. I have been working on shoe innovation for the past three years, from innovation design of the footwear industry to AI design to 3D modeling and sustainable development. I am interested in how to make the process of shoemaking more sustainable.

ES: That's so interesting.

ZW: Yeah. I trained this AI engine to help designers generate ideas. But that project is different from SCRY. All of the SCRY designs were created by myself without the support of the AI project.

ES: Do you have formal training in footwear design?

ZW: No, but I have always had a high degree of enthusiasm for footwear. At first, I tried to use the knowledge of other creative industries to intervene in footwear design and produce some conceptual designs. But then, I gradually became dissatisfied with just designing images, so I started learning engineering and technology to feed my vision of the future of footwear.

ES: People coming from outside of the discipline of footwear design bring fresh eyes, right?

Shadow, 2021. SCRY.
Collection of the Bata
Shoe Museum

142

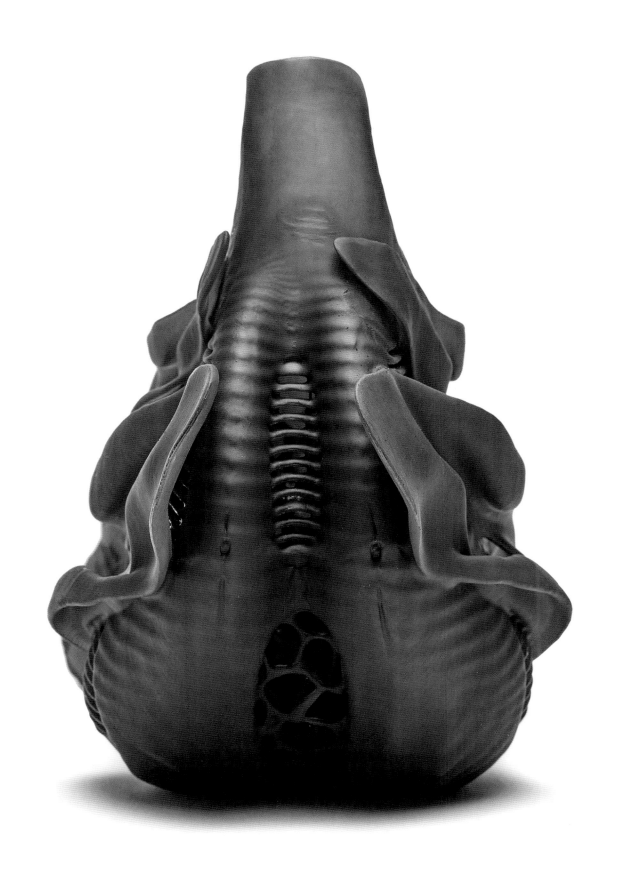

Shadow, 2021. SCRY.
Collection of the Bata
Shoe Museum

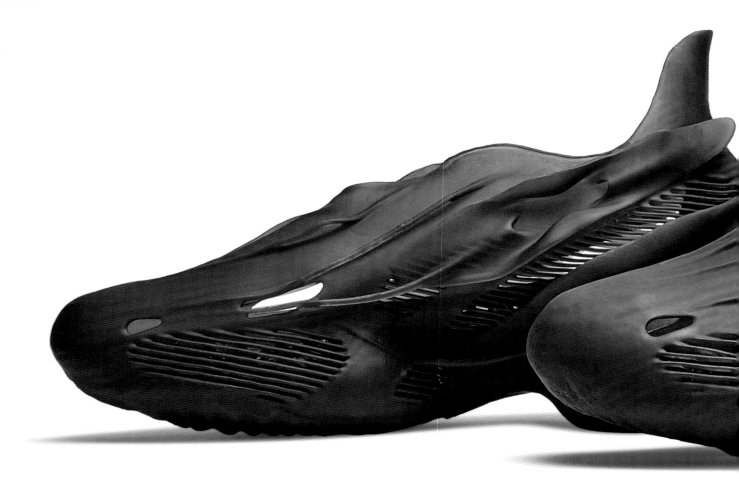

ZW: Exactly. That's why we use this kind of methodology to try and experiment in different industries. This year shoes are one project. We also have projects in other industries, but I have particular insight into footwear. The traditional shoemaking process takes so long, and our shoes can look very different from what a trained footwear designer might be familiar with. When I figured out that we could go from creating prototypes to making finished products quickly, it was a big leap. We decided, let's see, let's go with this, let's do a brand together and make this an actual experimental product, but not a prototype. We also wanted to make sure that the shoes were comfortable rather than difficult to wear, which can happen when FDM, or 3D printing, technology is used.

ES: Why shoes?

ZW: We wanted to use shoes as a starting point to explore design because shoes are not easy to make. We have loved shoes for a long time. We also like that shoes are a kind of a mixture of aesthetics, economics, and technology, so we don't think of shoes as just shoes.

ES: Does SCRY have a company philosophy? Is there a guiding principle?

ZW: We are trying to create a more open and diverse culture for footwear innovation. The traditional shoemaking process takes a long time, and it requires different time-consuming techniques, as well as technicians to perform them. We wanted

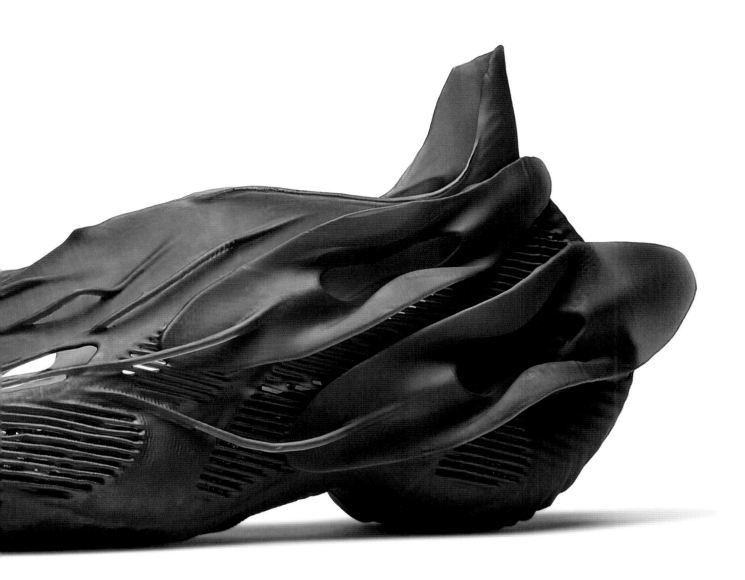

to start with digital design and link it to digital manufacturing so that we could create a platform for people to enter into shoemaking easily. In addition, in this way the costs can be low but the quality of the footwear designed can be high. Also, using this new way of producing helps us to create new aesthetics or new styles that could not have been achieved in the past. We're building this platform and would like to invite artists and designers from other fields to work with us. We will provide a tool kit on this platform, and then they can play.

ES: Is it part of your plan to enable people to do smaller runs with you? For example, if somebody came to you to make footwear for a specific disability or a different but very specific need—something that didn't necessarily have

mass appeal—is that something that your platform might be optimal for?

ZW: Yes, 3D designs and 3D making can make this come true. In our plan, we have two lines. One line allows for customized high-end designs for people who want to make unique footwear. The second line is for what you just mentioned, for people with different needs. We are thinking about doing collaborations with hospitals. We have already done some research with hospitals for people who have disabilities or injuries.

ES: What other goals do you have for SCRY?

ZW: We hope to further develop our AI-assisted design system. Whether it is a new platform or a new technology,

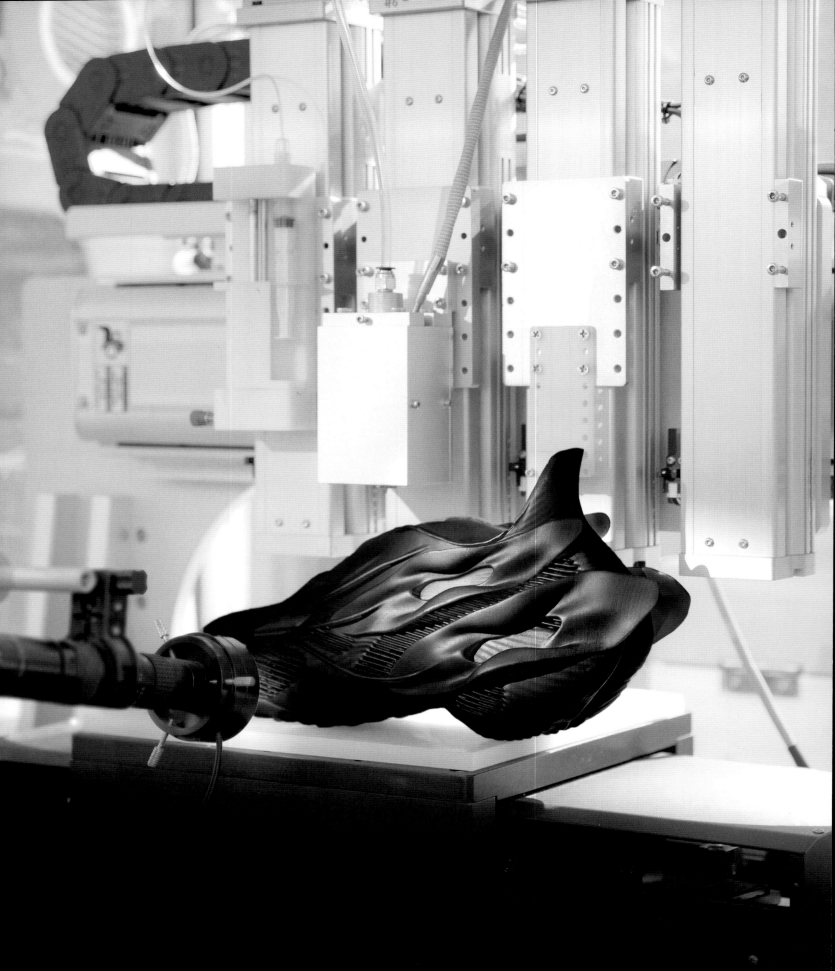

the goal is to assist in forming a more diversified and open footwear ecology.

ES: Let's talk about design. Your work seems both otherworldly and inspired by the natural world. What is driving you?

ZW: I like to explore and study cutting-edge things. Some avant-garde explorations in architecture have given me a lot of inspiration and the feeling of "I can think like this," which inspired me to think about shoes outside the traditional framework. Different design methods will yield completely different design results; most of the time, I just design the design method itself. As far as aesthetics are concerned, I like natural things. The way that nature works, through a set of complex laws that cannot be clarified always puts people in awe of how profound and genuine life itself is. Of course, I am not just indulging in organic forms; I also like to combine and collide with different popular cultures and other ideas.

ES: Are SCRY's designs always unisex?

ZW: Our first project, Shadow, proved that we could achieve fully 3D printed shoes. These were unisex. Our second project, CORE, is also unisex and can be worn in a range of different situations. But we are also collaborating with a number of designers who make women's footwear, such as Iris van Herpen. The shoes for her are really crazy, but also very elegant. We are doing experiments in this field now. We want to show how diverse this way of producing footwear could be.

ES: Can we talk about SCRY in the virtual world?

ZW: Yes, we already tried to do AR in our previous designs, and it seemed that people liked them. People shared images on Snapchat and Instagram; we really appreciated that. We are also thinking that customers who buy the physical shoes could also own a pair of virtual ones online. Maybe, later on, we might offer virtual shoes that don't have physical counterparts.

opposite
Shadow, 2021. SCRY

right
Concept drawings and prototype shoes by Zixiong Wei, SCRY

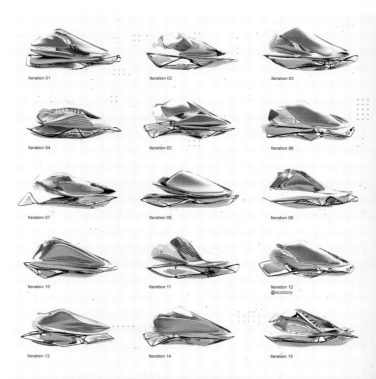

ES: What role does collaboration play at SCRY?

ZW: We are happy to collaborate with very open-minded brands that are crazy and exceptional in their fields. We really appreciate the collaboration with Iris van Herpen because we are both making probably the most experimental stuff in our fields. We also welcome other artists, architects, and people from different areas who are experimentally minded.

ES: The last question, which I've been asking a lot of people, is this: what do you think the future of footwear is?

ZW: We believe what we are doing right now is the future. We are actually making and trying to make the future we want to achieve, because we can't sit here and wait for people to make it for us. It is also in our genes, in our DNA, that we're trying to create innovation in different places. What's really important in footwear is allowing customization, because in the past it was very difficult to create customized shoes for people with different needs. Aesthetic needs, but especially functional ones. With this new technology and the current state we are in, we are able to do this. I think linking health care and footwear together would be very important, as aesthetics are already being explored.

Although what we're doing right now is more about aesthetics, we're also trying to push to the most pioneering level we can reach. We also think about sustainability, not only in the environment, but also in the industry. How can we continuously create innovations in this industry? If we could facilitate to connect brands, inspire some people to be more innovative, or do something crazy in their fields, that could all generate a creative environment. So probably sustainability in environments, in culture, and also this customization. We are trying to use what we do to bring more people into shoemaking with the hope that it will generate more innovation. ✽

Core Lunar, 2021.
SCRY. Collection of
the Bata Shoe Museum

TRANSFORMATIVE

Change occurs when the status quo is disrupted.
From striving to build a more inclusive future
to pushing the boundaries of design, the most
visionary creators in the footwear industry are
reimagining the future by breaking old molds
and inventing new possibilities.

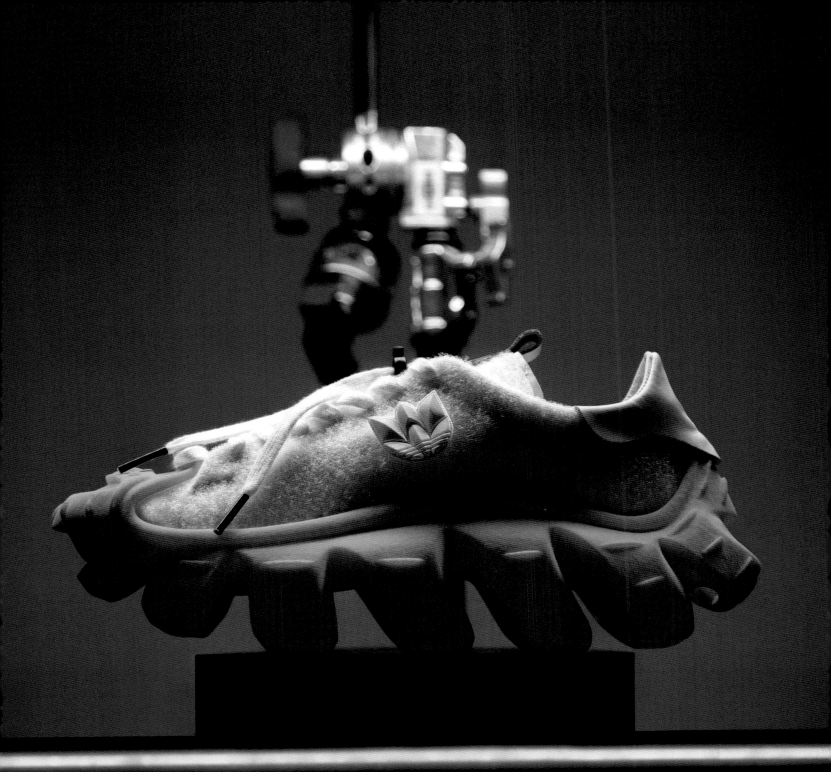

YOHJI YAMAMOTO Y3 KAIWA

JAPANESE DESIGNER Yohji Yamamoto has long pushed the boundaries of fashion, reimagining and challenging silhouettes to push design forward. His collaboration with Adidas, one of the first between a high-end fashion designer and a sportswear brand, led to the founding of Y-3 in 2003 and allowed him to create some of the most futuristic sneaker designs of the twenty-first century. One of his most popular models is the Kaiwa, the Japanese word for "conversation." Indeed, the design is a conversation between high design and athletic aesthetic, from its use of sculptural details on the midsole to its woven, socklike upper that ensures a comfortable fit. Since 2018, the Kaiwa has been released in a number of colorways, including Semi Frozen Yellow in 2021. ✱

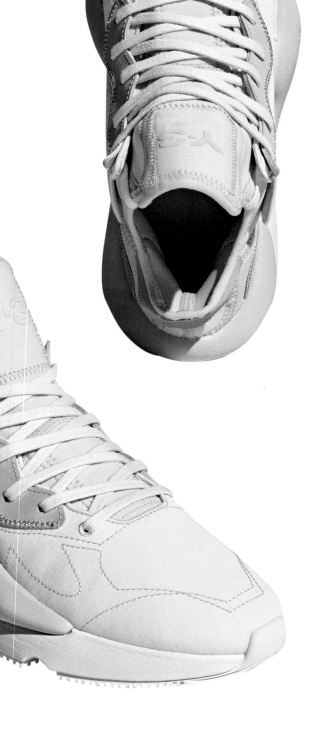

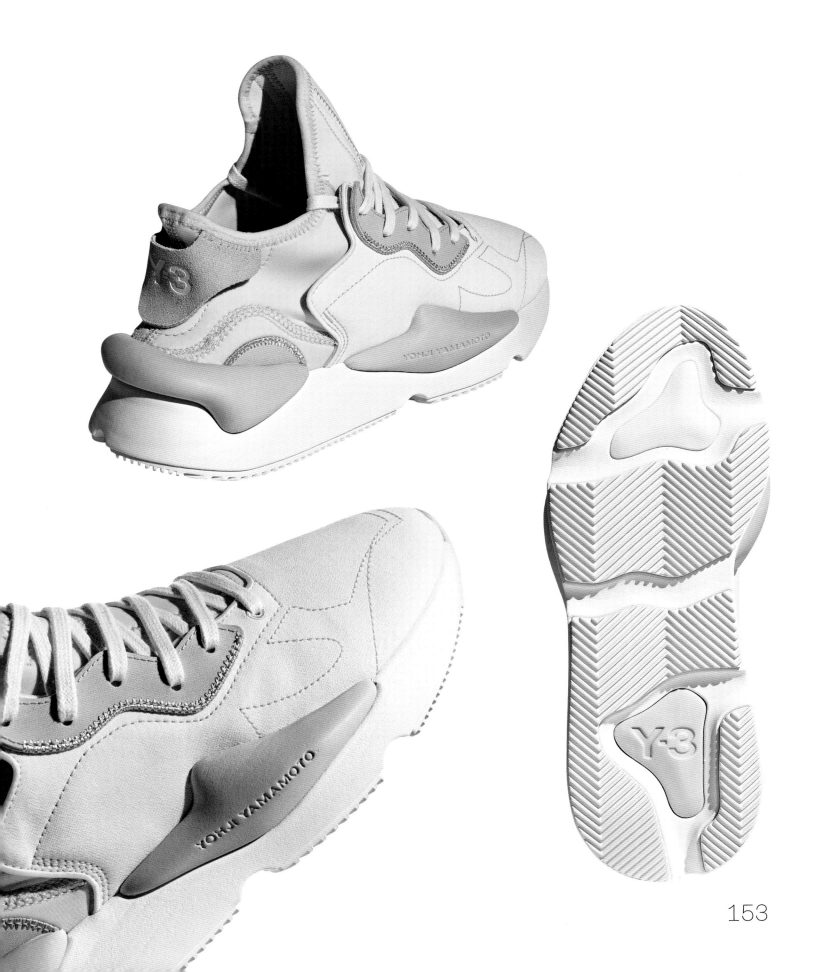

153

PYER MOSS
SCULPT

KERBY JEAN-RAYMOND, founder of Pyer Moss, has been called the future of fashion. He seamlessly mixes politics and fashion with the goal, as he told *WWD* in 2021, of creating "self-sustaining Black economies and self-sustaining Black narratives so we're not at the mercy of institutions and systems that continue to erase us." His dedication to racial justice and promoting Black talent not only sees him frequently reaching back into history to remind the world of Black innovations from the past, but also has him seeding the future, particularly through his support of new talent. One of his most wide-reaching achievements to date was his 2020 appointment as the global creative director of Reebok.

That year also marked the debut of the Sculpt, the first "in-house" sneaker for Pyer Moss. The futuristic sole is matched with a luxury suede and mesh upper that features the Pyer Moss signature contrast white topstitch, which as the brand states, "connects the design to our current reality of extreme contrasts made beautiful." ✱

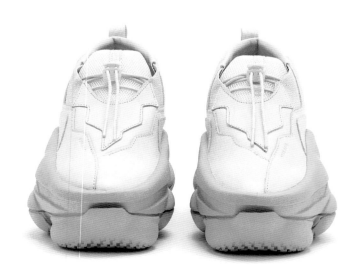

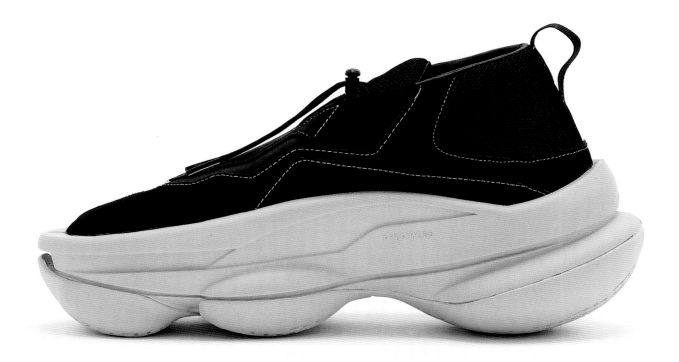

ALLYSON FELIX/ SAYSH

ELIZABETH SEMMELHACK: I have been starting many interviews for this book by asking the subjects how they got into footwear. Your story is a bit different as you are a superstar Olympian athlete—shoes have been a tool for you. Now you are one of the first elite athletes to create her own sneaker company. Why did you decide to start Saysh?

ALLYSON FELIX: I cofounded Saysh with my brother, Wes. During my pregnancy, I faced a gender injustice that I couldn't run from—my then-sponsors did not support my motherhood. I was told to know my place and essentially was asked to choose between being a professional and being a mother. No woman should have to make that choice, and as a result, Saysh was born. Saysh is a community-centered lifestyle brand for and by women. It is a platform for women, and a place to share truth.

ES: Can you tell me about the development of the Saysh One? Who did you work with? Who is it intended for?

AF: The Saysh One is a lifestyle sneaker for and by women. I worked with Natalie [Candrian], our designer, to create a breathable sneaker that could be used for everyday wear. The design is inspired by the lines of a wrap dress and is sculpted to fit the shape and form of the female foot. The single heel piece and snug lacing system produce an elegant, graceful silhouette that's both supporting and comforting. Saysh's consumer is a graceful soul with an ethical conscience, aesthetic sensibility, and an athletic mindset. I want this sneaker to inspire her to find the graceful power of self, while remaining authentic.

Saysh Ones, 2021

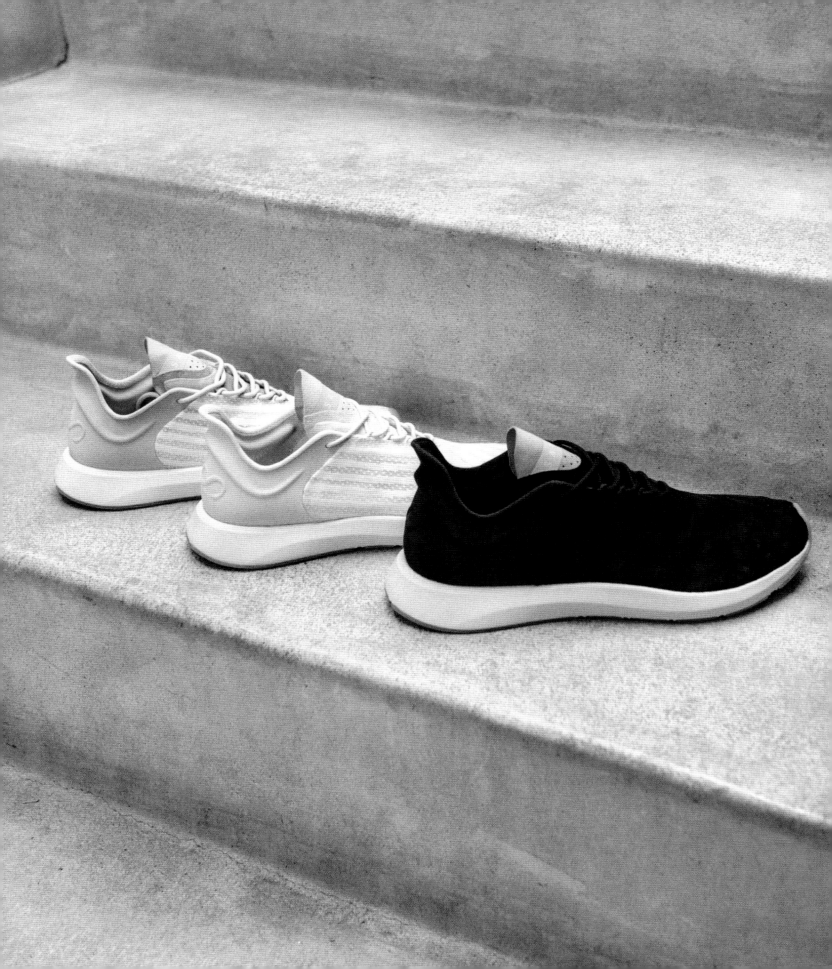

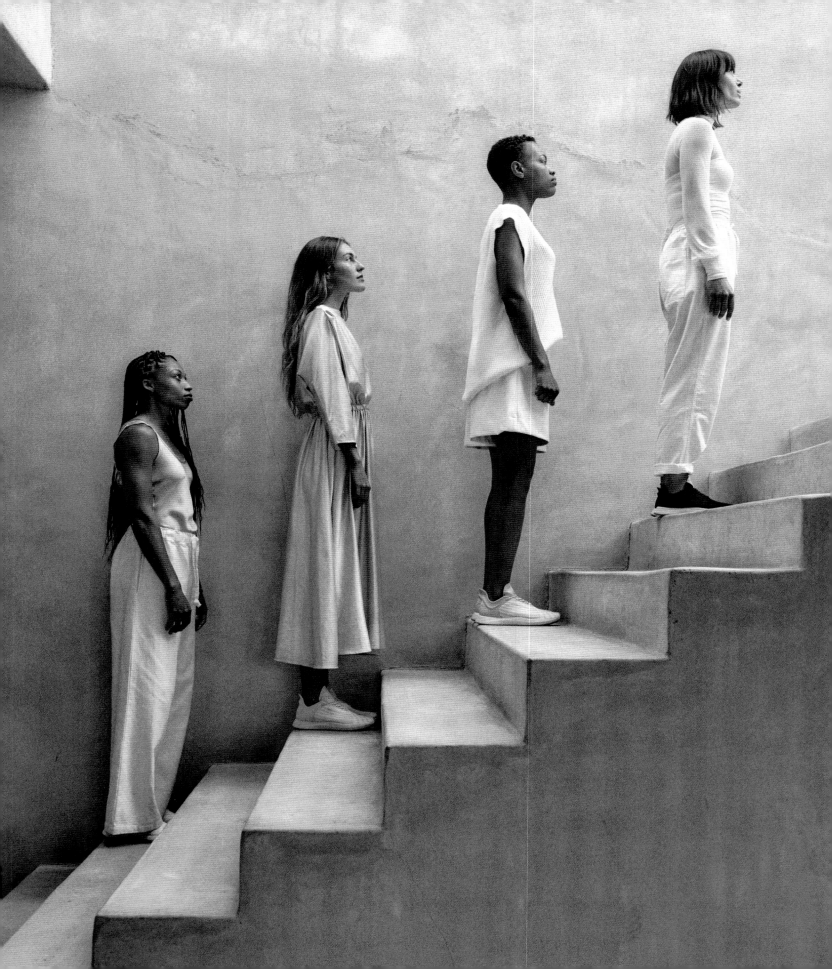

ES: You also seem to be building more than a shoe or a brand—you seem to be building a community. Why is that important to you?

AF: I believe that building community is about two-way engagement, meeting our collective where they are, and helping them to see themselves in our content. Community is a relationship. It's people talking, sharing, and being vulnerable. Community is people. Community is not size. Our community started with my brother and me. I shared a problem—I didn't have shoes to wear in the Tokyo 2020 Olympics. My community, which was Wes, listened and provided a solution: Saysh. Saysh is a community built to celebrate, educate, and empower women. We are committed to listening, hearing, and then working to find a solution. That is why we established the Saysh Collective, a community that will offer connection and correspondence for women everywhere.

ES: What do you think the future of footwear is?

AF: While athleisure was a natural starting line for us at Saysh, we aren't limited to this category. Saysh's vision is a future in which inequality is undermined by female creativity and athleticism. More than anything, I envision a future where no woman or girl is ever told to know her place. A woman's place is wherever she decides it is. This has always been a male-dominated industry, but I'm going to change that. ✱

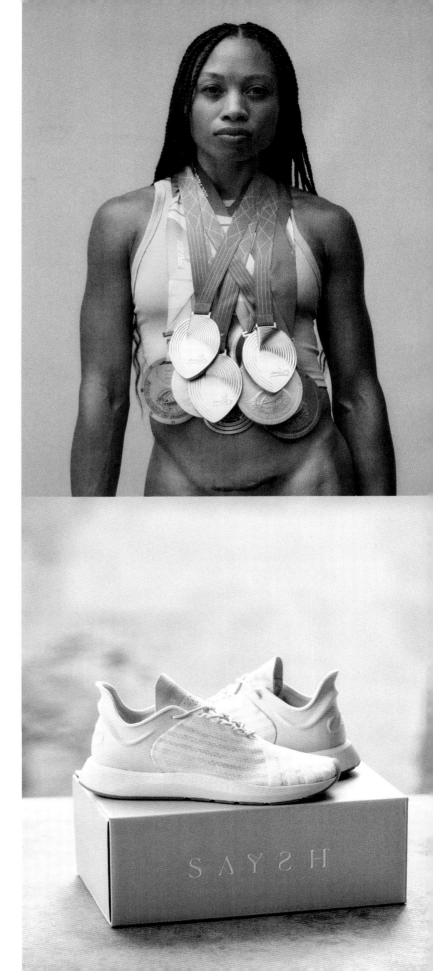

opposite
Saysh Ones, 2021

right top
Allyson Felix, 2021

right bottom
Saysh Ones, 2021

NIKE GO FLYEASE

THE GO FLYEASE WAS CREATED to allow even those with limited mobility to slip easily into a pair of shoes, as there is no need to lace and unlace them. The hinged sole and tensioner band allow the wearer to insert their foot directly into the shoe and then, by pushing down into the sole, lock the sole into position. Removal was also designed with accessibility in mind: the back heel protrusion allows the shoe to be stabilized by one foot while the other is pulled out of the shoe. As part of the movement toward adaptive fashion—fashion that considers the needs of those with disabilities—the Go FlyEase received a great deal of attention. Many people with disabilities who had been looking forward to wearing the shoe found getting it a challenge. Its usefulness, high design aesthetic, and limited availability made it sell out instantly with resellers scooping up the majority of the shoes. However, the success of the Go FlyEase provides proof that universal design that is both inclusive and fashion forward is the future of footwear. ✽

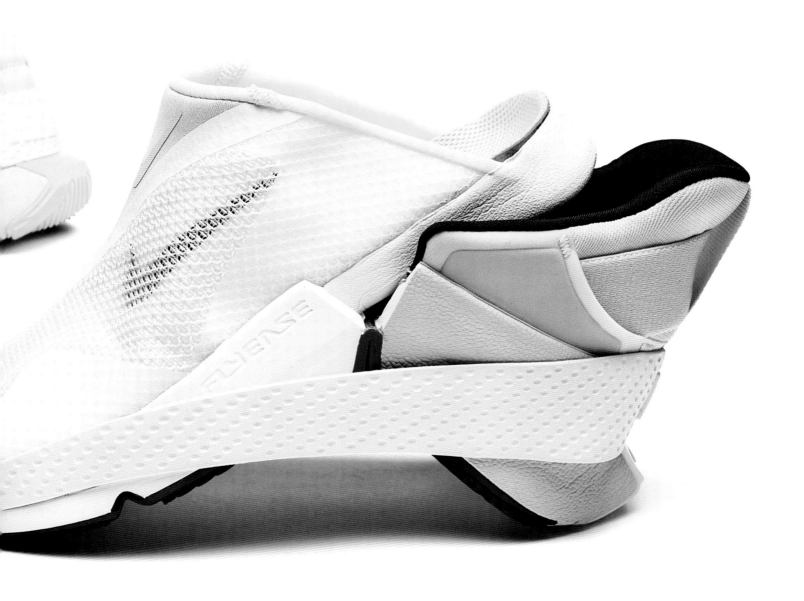

INTERVIEW WITH

SALEHE BEMBURY

ELIZABETH SEMMELHACK: Were you always interested in shoes?

SALEHE BEMBURY: Yeah, I was always interested in shoes from a young age. It wasn't necessarily the design; it was more about the environments that they were found in and the people who wore them and how they ultimately made me feel, whether it was through sports or comedy. Design has, I think, a very real connection to emotion. Will Smith would make me laugh and then I looked down to see his sneakers. Or Michael Jordan would dunk and that would be a feeling, but then I'd look down and see his sneakers. It was almost as if acts were associated with or tied directly to the product. I think as I got older, I learned that I could participate in that experience from a design perspective because of my artistic talent.

ES: How do these early experiences with footwear make you think about the impact of your design on the wearer?

SB: As a designer, I have to think about the consumer as a whole and the consumer is multilayered and represents so many different kinds of people. There's a majority, there's a minority, there's early adapters. There are people I might think have bad taste, but I still have to cater to them. You can maybe even argue that they represent a larger section of the market, and I still have to cater to them. It's really an exercise in just being unbiased and trying to put—pun intended—your feet in other people's shoes.

ES: But you are also always pushing the envelope of design, which arguably has the potential to make some people uncomfortable. The new Crocs, for example. You didn't just take the Croc and decorate the surface in a unique way. You actually changed its form, its shape. You're pushing your audience through this design. Are you trying to guide consumers toward something?

Salehe Bembury x Anta
SB-01, 2020

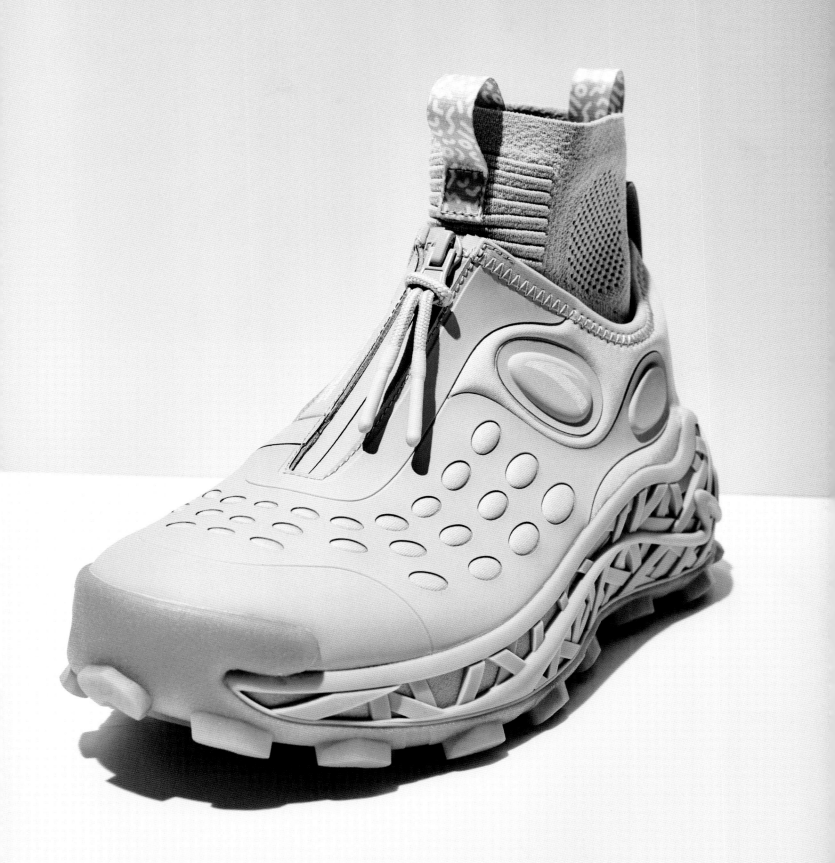

SB: Well, I think it's about finding that balance between a product that's commercial, but then also moving the needle a little bit. I recently heard an interview with Steven Smith, and he was talking about the fact that we've grown up on *Back to the Future* and *The Jetsons*, and it's 2021 and the world looks nothing like that. He said that the designers get an opportunity to design the future we were promised, but never got. I think that's genius. That's damn near the quote for this book. A lot of designers are trying to satisfy a boss, but I think it's really exciting when you are lucky enough to present something that, as Tyler, the Creator put it, makes the consumer look at it and go, "What the fuck?" Said so simply but genius at the same time, because it's rare that you see a product and think, "What the fuck?"

ES: How do you approach your work?

SB: I'm adapting with every design problem that I'm presented. When people tell me that there's cohesion in my color palette or the way that I design, that's nice to hear because all good designers are consistent and they have a hand-style. I don't know if I necessarily am trying to keep that. It might just look like that because it's coming from me, but I've definitely become a little addicted to the moment of introducing new products to the market. And by new, I mean innovative. The first one for me was the Chain Reaction. I got to see how people reacted to that and how excited people got and how it created business for Versace. So now I've gotten a little bit addicted to that kind of moment. Also, now when sitting down with brands, the first thing they ask is, "You're going to make something crazy, right?" I kind of look at them like, "I guess." So now, it's almost as if I have a reputation to uphold.

ES: I wanted to ask you about the Chain Reaction outsole. It is so brilliantly Versace.

SB: I think the tooling of the outsole is one of the most, if not the most, important aspects of footwear, from both a visual standpoint and a functional standpoint. If you take it a step further, every known sneaker brand has a design language for their outsoles, right? In creating an outsole for Versace, I really had to consider balance. The balance of not making their core consumer uncomfortable while honoring the heritage of their brand so that when any audience saw

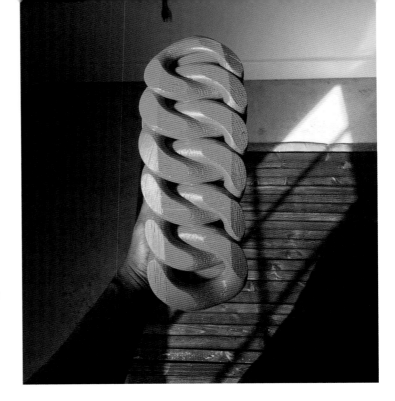

that shoe now or ten years from now, they would know it was a Versace shoe. I also had to acknowledge the sneaker consumer who has a certain level of taste and ultimately demands a certain looking sneaker. Balancing all those things led to the Chain Reaction outsole.

ES: One of the things I always say when people ask me about curation is that curation is an exercise in constant constraint. You're constrained by the size of the room, the objects you can get your hands on, the budget, and so on. What you just described to me was a set of maybe not constraints but considerations. How do these considerations play out in your collaborations? Does having constraints propel you forward, or are they frustrating?

SB: Collaboration exists on a spectrum. When you work for a company, you're ultimately collaborating—you just don't necessarily get to put your name on the product. Now I'm blessed enough to be able to put my full government name on product that I used to buy. I used to line up and camp out

above
Chain Reaction sole prototype, 2017. Versace

opposite
Chain Reaction sole, 2018. Versace. Collection of the Bata Shoe Museum

for shoes, and now kids are camping out for my shoes, so it's full circle. I think when I was a younger designer, it was a little ego-driven. I thought I could just draw what I wanted and slap the logo on it and then that would be the final product. But I've since learned that, as a designer, you have to adapt to the hand-style of the company. If you design for a sneaker corporation, you can maybe put 10 percent of your personality into your design, but the other 90 percent will read through the lens of that company. So, when working in companies, it was about being versatile and adapting to both the company and the consumer, and then having a little bit of leeway to push things.

But now that it's about product with my name on it, that 10 percent of personality increases to maybe 70 percent. That comes from the brand's willingness to take chances, because it's a marketing exercise. Also, collaborations usually represent slightly lower quantities than designs created for mass market execution. I want my shoes to be successful and I want them to be coveted and potentially even scarce, which means balancing interesting design with design that leads to a sellable shoe.

ES: Let's talk about your Crocs collab. This seems to me like one of those 70 percent projects. They let you make a whole new mold, right?

SB: Yes, it was the first time they let a collaborator open a mold. It was awesome. I would definitely say this is 70 percent. But that 30 percent is extremely important because people needed to look at my design and immediately see Crocs. I didn't want to create something and then just throw their logo on it. I wanted to honor the heritage of their brand. I love the story of their brand because it's a company that people laughed at when it was first introduced, maybe even for a full decade. And now they've become one of America's iconic silhouettes, anyone under the sun has been seen in or is familiar with Crocs. It's an honor to be working with the brand, but it's also really cool to get the opportunity to push it forward and to start the conversation of what the next chapter of the silhouette can be. That opportunity is given to few, when it comes to large brands like Crocs. While I wanted to create something compelling and to have that what-the-fuck moment that I mentioned earlier, I also needed the design to scream Crocs and not scare people.

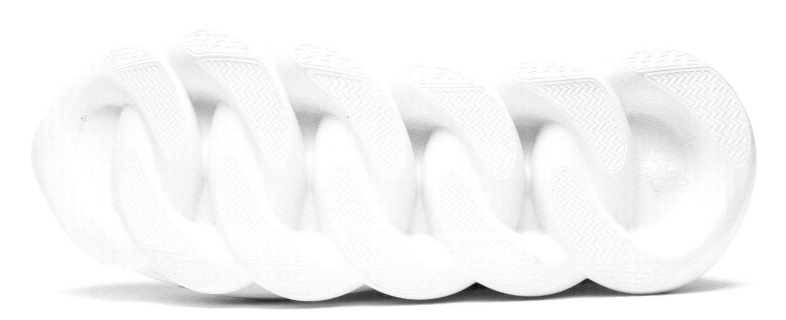

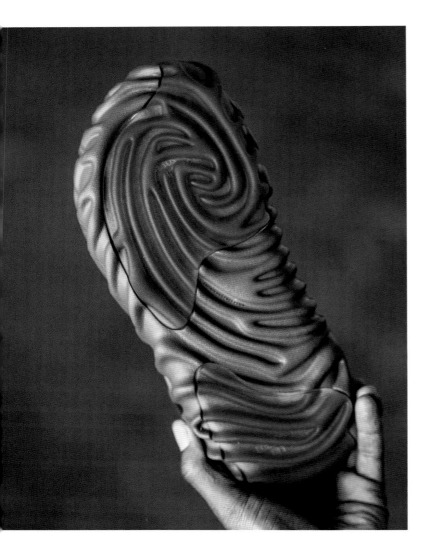

when you are outdoors in a wet environment, all of those channels are designed to channel out water. It may be my industrial design background, but I like to create from both a functional and aesthetic standpoint.

ES: What about materials? Are there any futuristic materials that you'd like to get your hands on?

SB: Well, I'm not sure if I would look to use futuristic materials without reason. I need to work with materials that meet my sustainability standards. My brand is really nature focused, so I think it wouldn't make sense if I was out here hiking and then not considering the environmental impact of the materials I was using.

ES: Would you venture into the metaverse?

SB: I think that if I were to participate in that world, I would really need to ensure that I was coming from a place of authenticity, because I know how foolish brands look when they try to attack the sneaker space and you can immediately see that they don't know what the hell they're doing. After the Chain Reaction, a lot of high fashion brands tried to create sneakers with crazy outsoles. But their designs didn't have the DNA of sneakers and didn't respect their own brands' DNA so they just looked ridiculous.

ES: Your work is very tactile, very sculptural, and gives a clear sense of your hand, with an end result that is often super futuristic looking, or envelope pushing. What do you think is the future of footwear?

SB: I love to hear that because for me, every time, I'm just trying to hit the mark. Strangely, I see myself as someone who isn't able to look that far into the future. But then people think that my designs are very forward, so it's ironic. ✱

ES: The design is inspired by a fingerprint. Why?

SB: My brand identity is the fingerprint. I have also been a really big fan of wood grain. I used to carry a wood briefcase, and there's a lot of nature reflected in what I create. So strangely, I actually have this full image of a fingerprint next to the wood grain of a tree stump right next to each other. They're pretty similar. Basically, the Croc is me continuing to explore the fingerprint identity from both a visual standpoint and a three-dimensional standpoint. And, similar to the Chain Reaction, it was me targeting a brand identity and then realizing that it could be functional. The fingerprint pattern on the bottom offers amazing traction for both lateral and medial stability, and all the lines on the upper, from a visual standpoint, look cool, but from a functional standpoint,

above
Salehe Bembury
x Crocs Pollex,
Cucumber, 2021

opposite
Salehe Bembury
x Crocs Pollex,
prototype, 2021

following
Salehe Bembury x New
Balance 2002R Water
Be the Guide, 2021

166

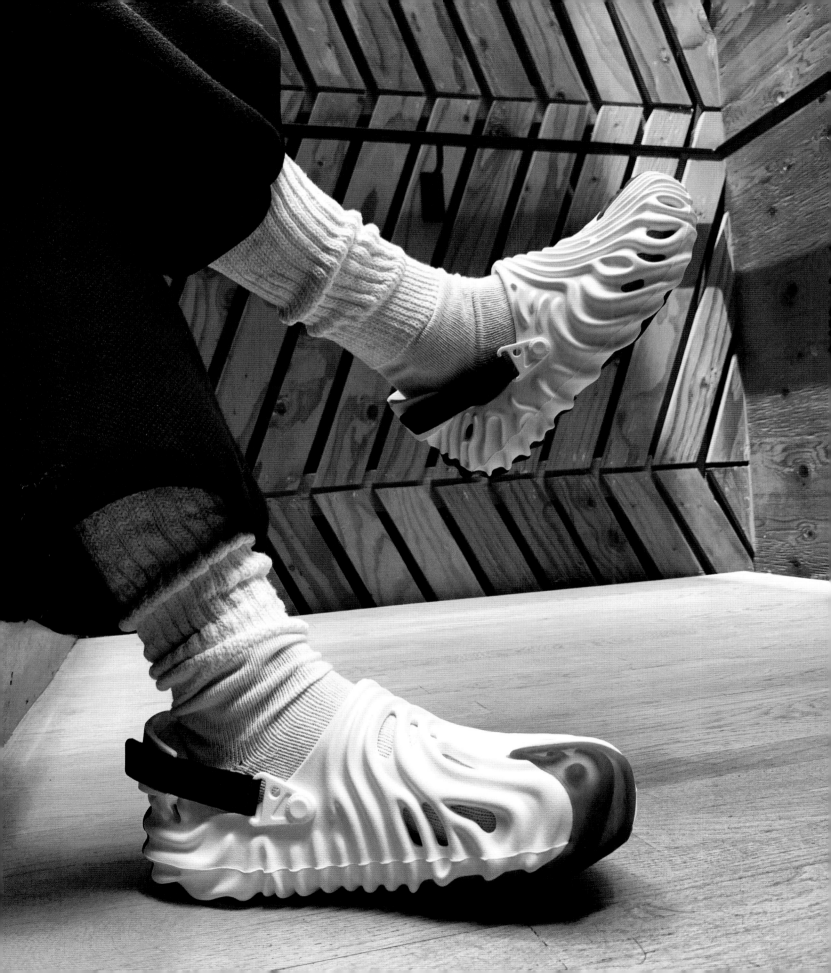

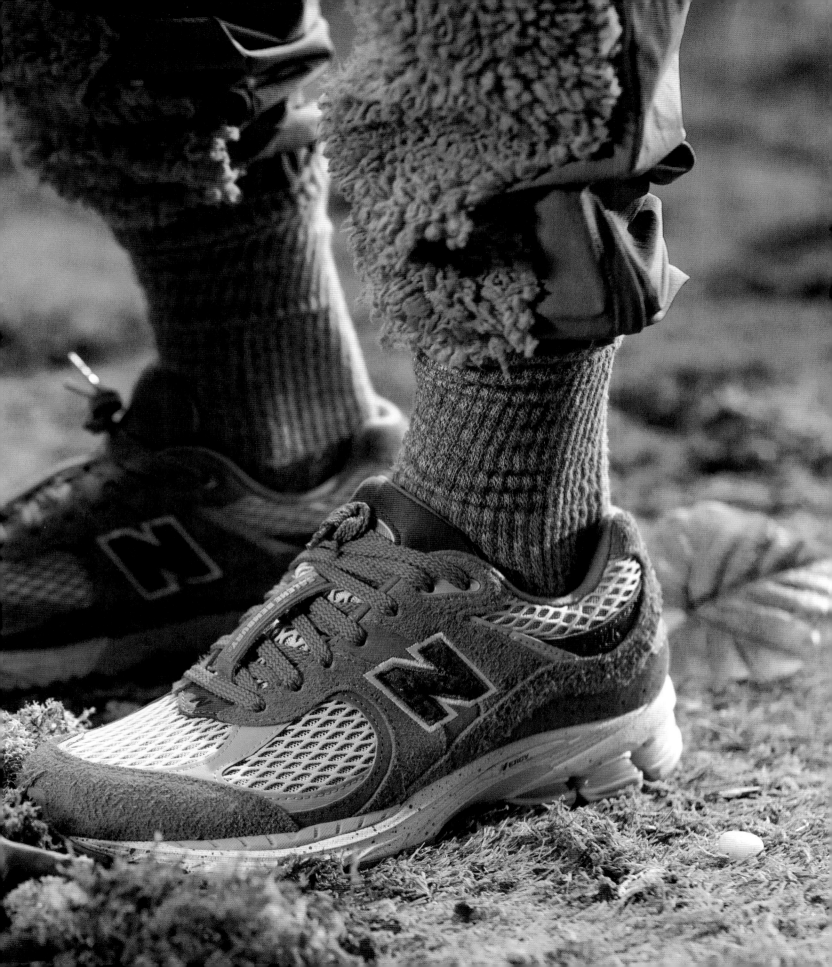

NIKECRAFT X TOM SACHS MARS YARD OVERSHOE

NIKECRAFT, ARTIST Tom Sachs's fifty-fifty collaboration with Nike, is grounded in ideas about both the present and the future. The 2012 Mars Yard sneakers were created by Sachs for intellectual "athletes," such as those who work in aerospace engineering, and were made out of space-age materials in ways that suggested hand manufacturing. His moonboot-inspired Mars Yard Overshoes were made to address the more terrestrial challenges of winter sludge in the city. These "waterproof enough" boots feature nylon reinforced Dyneema uppers to offer lightweight protection, nylon donning straps, and Fidlock magnetic ladderlock buckles to secure the boots, and sticky rubber outsoles for greater traction. Despite all of these functional features, their greatest value for many is as a collectible. ✱

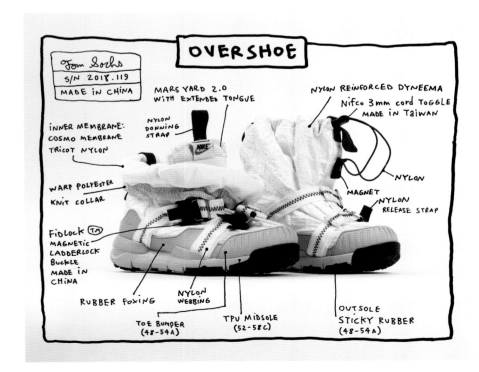

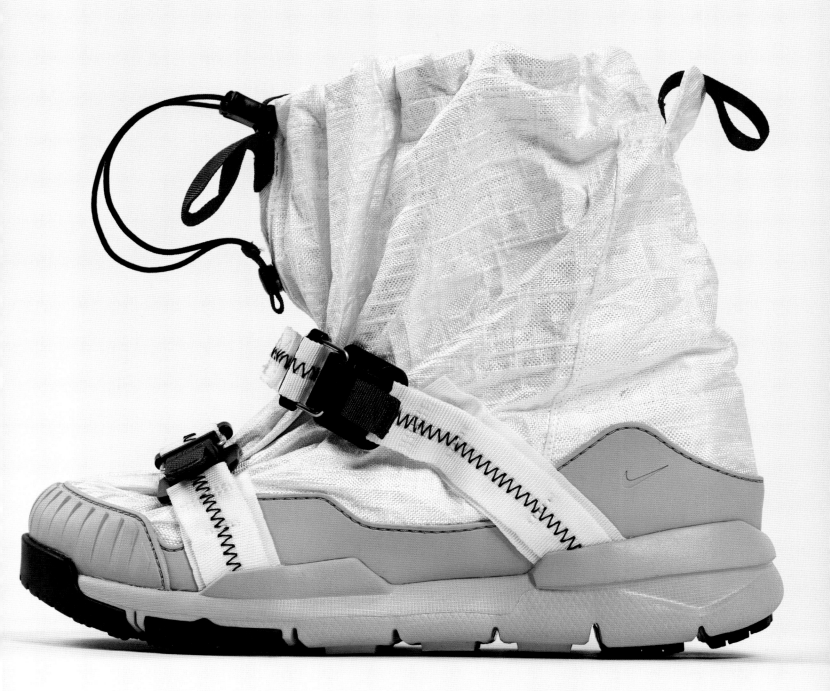

ALIFE "ART" CROC

THE 2018 ALIFE "ART" CROC was the first collaboration between Crocs and a streetwear brand. The cement gray Art Croc, part of a trio of Crocs designed by Alife founder and chief creative officer Robert Cristofaro, came with 3D printed Jibbitz featuring seven New York City landmarks: the Brooklyn Bridge; the Empire State Building; the MetLife Building; the Guggenheim Museum; the Washington Square Park arch; the Unisphere at Flushing Meadows Park; and the Statue of Liberty.

Jibbitz have long been used as low-relief decorations that can be applied to Crocs, but for this collaboration, they were morphed into miniature sculptures whose size and detailed rendering suggested that this collab was meant to function more as a work of art than as footwear. Their frequent depiction with the Brooklyn Bridge connecting the pair further emphasized this idea and spoke to the increasing importance of footwear as a collectible, admired for its form rather than its function. ✱

173

MR. BAILEY

ELIZABETH SEMMELHACK: How did you get into shoe design?

DAVID BAILEY: I had been into sketching since I was really young. My auntie was studying architecture, and she'd always give me these little sketching challenges. Two-point perspective, three-point perspective, things like that. I was always drawing. I was doing industrial design/product design type sketches without really knowing it. Then I ended up falling in love with basketball. And I think basketball and footwear are kind of synonymous with each other. Every basketball player loves footwear.

I went from sketching whatever to sketching a lot of sneakers. When I was maybe thirteen, I had my own imaginary shoe brand. I remember sketching shoes in math class and getting in trouble with the teacher. But basketball was really my first passion and then footwear kind of fell underneath that. I left England to play basketball in America. But after a bunch of injuries, I realized that basketball wasn't going to be the way. When I had this realization, I was studying graphic design, but it was really about, what can I study to play more basketball?

When I stopped basketball, I started to take my studies a lot more seriously. I started getting good grades and getting more into design in general. Then I applied for an internship at Nike to study footwear design. But at that time, they were only taking product designers, not graphic designers. I had never even heard the term product design, but I was lucky that the university that I had just transferred to had a product-design degree that was only about a year old at the time. I fell in love with product design. I initially started in sneakers and then got into everything else, from everyday products to automotive conceptual design. I ended up meeting Omar Bailey, same last name, no relation. He's one of my very

Sketch of sneaker design inspired by Takashi Murakami's *Dobtopus* sculptures for the exhibition *Sneakers for Breakfast* at ComplexCon, 2018

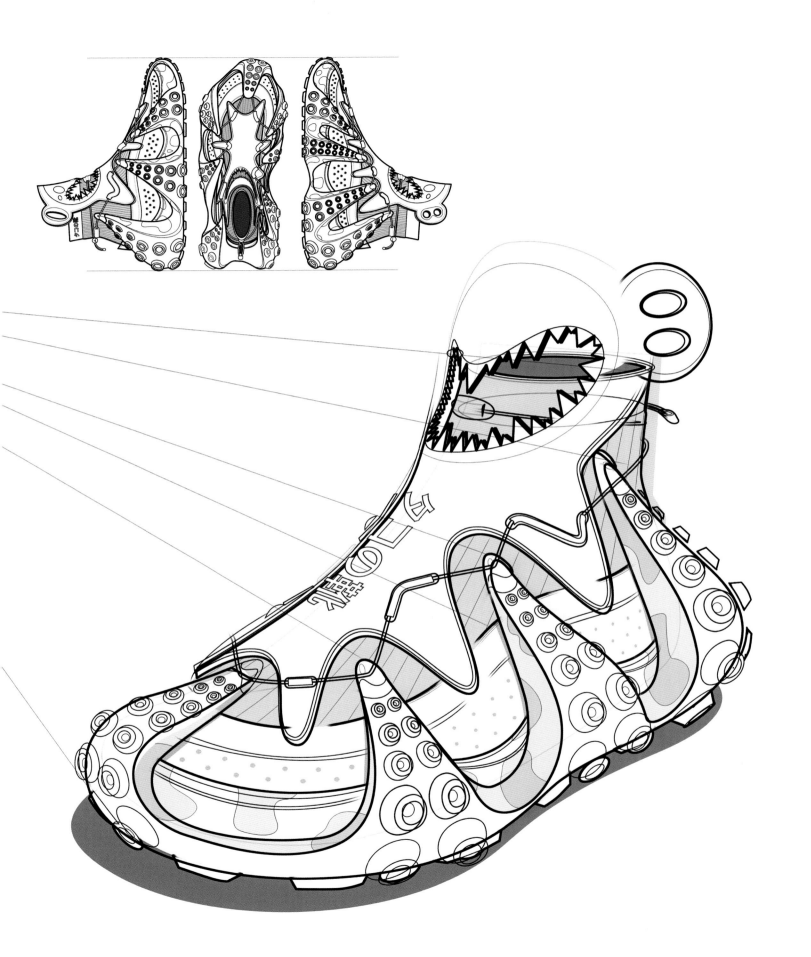

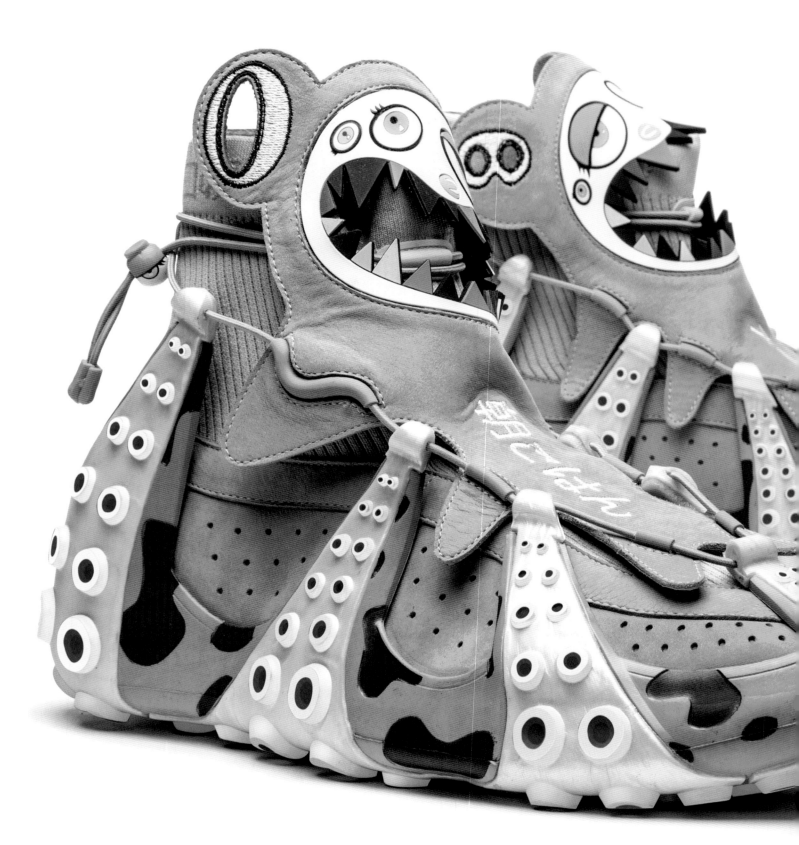

Octopus shoe, 2018.
Mr. Bailey

good friends now, and he was an independent designer based in Manhattan. He kind of took me under his wing and took me to factories, showed me the lay of the land, and that set my path from there on out.

ES: Now you are an independent designer and have your own studio, but you also do a lot of collaborative work. Can we talk a little bit about that process?

DB: The collabs started happening more recently. The first few years I did whatever I could to survive. Then as the platform of CONCEPTKICKS grew, and as my résumé grew, my skill level got better. Opportunities to work with these different, interesting brands and people just became more and more prevalent.

There ended up being an interesting little community that emerged within what we were doing—from far-flung Instagram followers to very close friends who happen to be in the same industry. For the most part, I've always been in the background, doing ghost projects for people. It wasn't until the whole Takashi Murakami thing happened that I stepped in front a little bit more and people got to know who I was as a designer. That experience shaped a lot of stuff.

ES: I was blown away when I saw the sneakers you made for his *Sneakers for Breakfast* exhibition at ComplexCon in 2018.

DB: It was just one of those opportunities when someone says, "Hey, look, I'll give you my platform. You just do whatever you want to do. No limitations, just go wild." With his aesthetic, you can really take it as far as you want. I also wanted people to see that just because I'm an independent doesn't mean that I can't do some pretty wild stuff. A lot of times, with footwear brands and people in general, you're limited by what you can do and what can be executed in the factory. I wanted big brands to see these and be like, "How did they do this?"

ES: Was the outsole 3D printed?

DB: No. The early prototypes were 3D printed, but the final sneaker has a rubber outsole and EVA midsole.

ES: It seems like you take inspiration from a wide range of things, from the natural world to contemporary art. How

does that process work for you? Do you see something and say, "I can make that into a sneaker"? Let's talk a little bit about that process.

DB: The idea for CONCEPTKICKS, which I started about nine years ago, really came from my rabid appetite for imagery. I was constantly having conversations with friends about how amazing I thought the industry was, because I didn't find out about it until quite late, and I was like, "Wow, people should know about it. No one should have to, like, stumble on it." And I felt really lucky but also wanted to put more information out there, to share how incredibly talented I thought the people were who were involved in footwear, from designers and developers to marketing people. I just wanted to put information out there. At first, what I really wanted was to have CONCEPTKICKS be a place where these people could share what they were doing.

I didn't realize how tricky that would be because of image rights. Sometimes brands would reach out and ask me to take images down. At the beginning, there was a lot more of that than there is now. If anything, brands now send me stuff to post, which is great. I think the industry is a lot more open to sharing and being a bit more transparent now. That makes my life a lot easier.

What's also great about CONCEPTKICKS is that it is a design agency and studio, and, of course, also a platform to share ideas and a footwear research program. Then there is the Mr. Bailey stuff. Mr. Bailey is me as a designer, whether it's collaborative or my own stuff. CONCEPTKICKS is more of a platform, more of a group or a design studio that is either researching things or designing things for brands in the background.

As CONCEPTKICKS has grown, it has allowed me to dig in more on the Mr. Bailey side and utilize some of the stuff that I have through CONCEPTKICKS to help me with Mr. Bailey. What tends to happen is that a project will come along, a potential collaboration, or I'll have an idea or the team will have ideas, and we'll go deep into research mode. Some of my team is incredibly good at researching new stuff and finding things out and sharing them. What happens a lot is either I find a bunch of interesting stuff or the team finds it, and I'll just look at the images. There will be a predetermined direction in my mind, and I will just start looking. Sometimes I'll see something

and I'm like, "Ah, there we go. That's it. Let me turn that into something." That's usually how it happens, and there's no timeline for that. It could be the first day I'm looking at stuff, or it could be six months. You know what I mean?

ES: Yes, I know that exact feeling.

DB: Yeah. Very frustrating, but great when you have the "aha moment." Sometimes it doesn't necessarily have to be new images. I have this large pool of imagery that I find really inspiring—I don't always know why I'm saving the images. I just have them. And my process is that whenever I have a new idea or direction in my head, and I then go and look at those pictures, it gives new meaning to those pictures. They might as well be completely new.

One of the things that serendipitously happened through the whole process is there's been a big lean toward the natural world. That's something I was always incredibly inspired by, and I think nature is something that you're never going to run out of inspiration from. That's what happened with the Ammonite shoe. I was learning about how these crustaceans have internal coil systems and other things to create their structural stability.

ES: Did you make the Ammonites in your size? They're a one-off, right? I would love to know what they felt like.

DB: They are not my size. They're US 9, I believe. They're fully functional. You can walk around in them. But they weren't designed to be a fully commercial shoe. For that they would need a little bit more engineering. But as crazy as any shoe is, there is thought behind what the next step would be to make it more commercial.

ES: Okay, we've talked about you working on sneakers. Is there another type of shoe that you have designed or that you would like to design?

DB: Absolutely. I'm open to everything, really. There have been times where I've drawn high heel concepts. It's a really interesting field. I think a lot of people tend to think I'm a sneakerhead, but I'm not really. I value shoes as a product

The Simple Things
Sneaker, 2019. Mr. Bailey

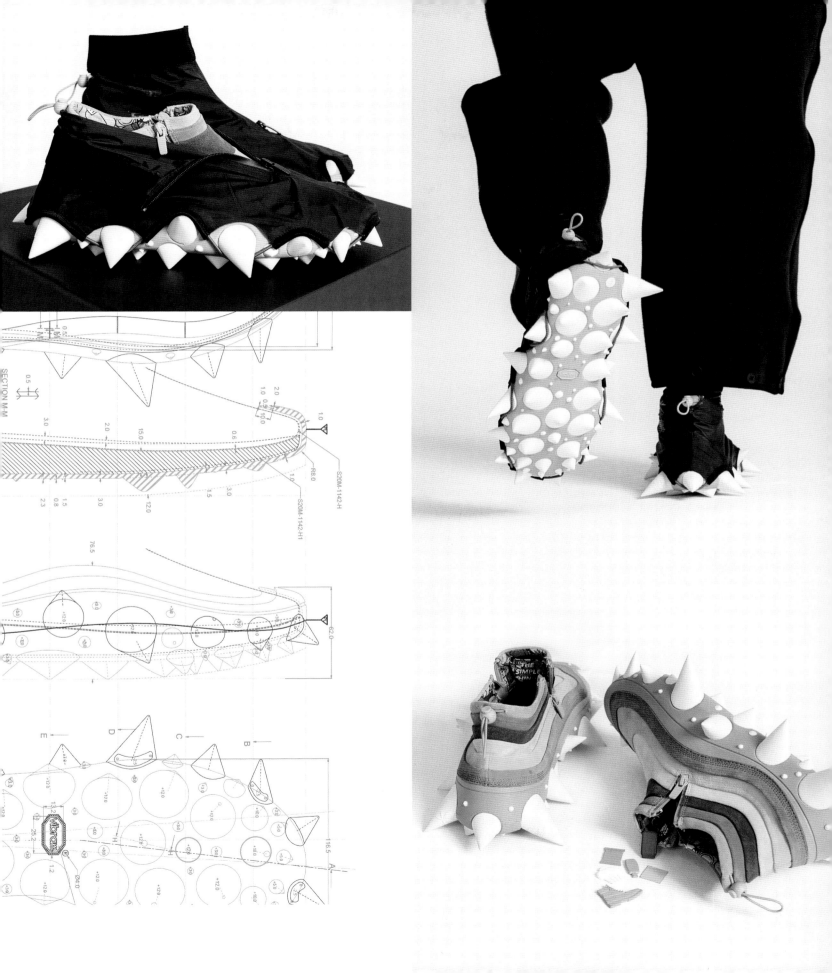

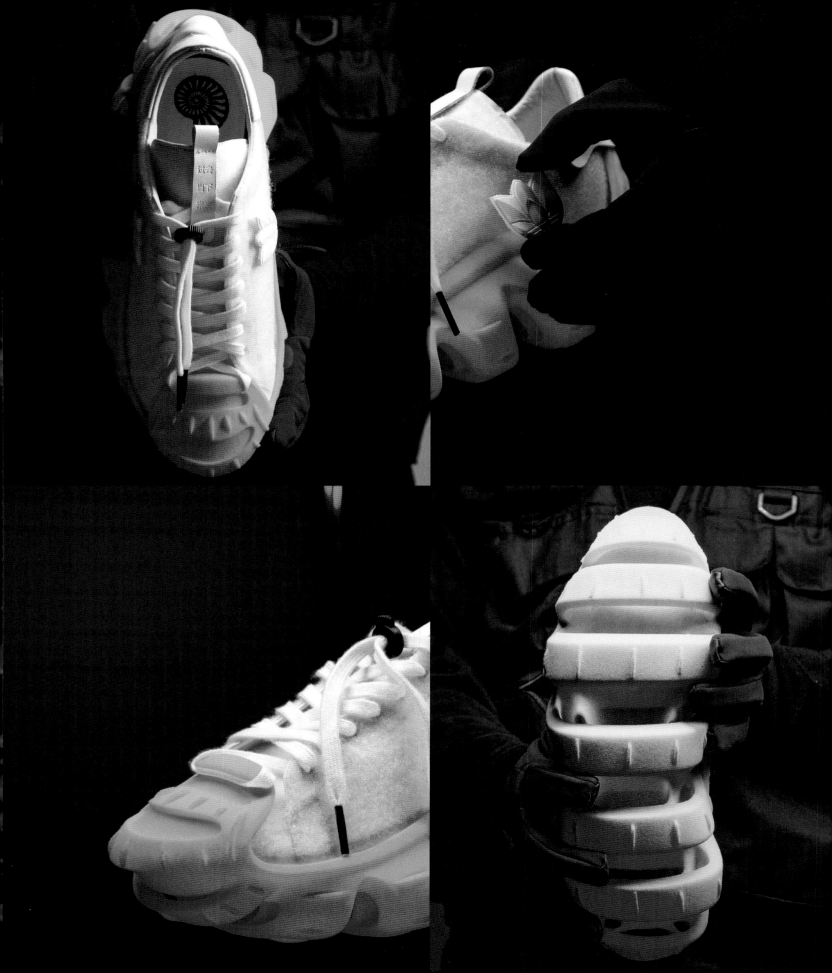

and how quickly you can turn them around. Sometimes the process to develop them takes a bit longer than you'd like, but for the most part, as a product, making shoes is a pretty amazing way to get your creative visions turned into a tangible object.

ES: One of the reasons I enjoy working on footwear and exhibiting footwear is that it doesn't require the body. You can imagine the body standing in it, but footwear retains its shape off the body. It retains its sculptural qualities even when it's not worn.

DB: Yeah. I think that's also what I love—the sculptural aspects of it. That's how I feel when I'm making a mold. It feels more like a sculpture.

ES: Would you ever try making or collaborating on virtual footwear?

DB: Yeah, definitely. With the type of the footwear that I do, the digital aspect is definitely interesting. Part of the joy for me at the moment is I've lived in both 2D and 3D for a long time. By 3D I mean digital 3D, and now I'm finding a lot of joy in turning out functional real-life objects. That's where I'm at right now. But I also see so much potential in that world. There are different rules. Or maybe I should say there are no rules whatsoever.

ES: It's so amazing: in the metaverse, shoes no longer have responsibilities.

DB: Right. There's no functional requirements and that's exciting. I think that I'm just kind of waiting for the right moment or the right project.

ES: Okay, last question. What do you think the future of footwear is?

DB: I have absolutely no idea, but I've thought a bit about it. From a consumer standpoint, I feel like we're in a good place because I think there's been somewhat of a lull in what consumers have wanted for a long time. For a while now it has been mostly retro versions of existing silhouettes that are safe bets. They tug on that nostalgic part of you from when you were a kid and couldn't afford the original. Now you can, so you just go get it and the shoes go with your outfits.

In terms of design, I feel really encouraged by three brands I always mention: Nike ISPA, Yeezy, and Y-3 from Adidas. Y-3, because they've been doing it so long—they've always bridged that gap between style and technical beautifully. Obviously what Kanye is doing with Yeezy is pushing aesthetics and construction, and what Nike ISPA is doing with the Road Warrior line that they just came out with. With Yeezy and Nike's ISPA sub-brand doing such innovative silhouettes that seem to be more accepted by the masses, we're looking at a new era where consumers are more willing to be open to design, which I think is only a good thing.

There are also new tools like Gravity Sketch and VR sketching that offer a middle ground between 2D sketching and 3D modeling, allowing young designers to be more exploratory in regard to form. When these ideas are mixed with the ability of injection molding to create complex forms, we begin to see designs that we have never seen before.

From a creator standpoint, I think because of social media, there's been a lot more transparency about who's doing what and what's involved in making things. I think that people now have more power to do what they want. I think with this more empowering zeitgeist we're going to see creators push design a lot more. At least that's what I'm going to try and do.

ES: I wonder if there will also be a pent-up interest in, and desire for, new forms and new types of footwear post-pandemic.

DB: I think there will be. I think that people will have an appetite for new, wild stuff that they can wear, and that's probably going to help stimulate design. I'm here for it. I am here for the crazy. *

Mr. Bailey x Adidas
Ammonite, 2020

SAFA ŞAHIN

CUTTING-EDGE DESIGNER Safa Şahin established his own label in 2012 and over the years has worked for a number of brands, including Nike. In 2019, he became the head of sneaker design at Balmain, where his work is pushing the envelope for the brand; his B/EAT slides for Balmain Spring/ Summer 2022 took the fashion world by storm. Şahin's futuristic footwear designs are both playful and surreal and often turn long-standing sneaker innovations on their head. A perfect example: recent concept shoes that build on the potential of inflation technology, a technology first introduced in the 1980s but only as a component of a shoe, not the entirety of a shoe from sole to upper. ✱

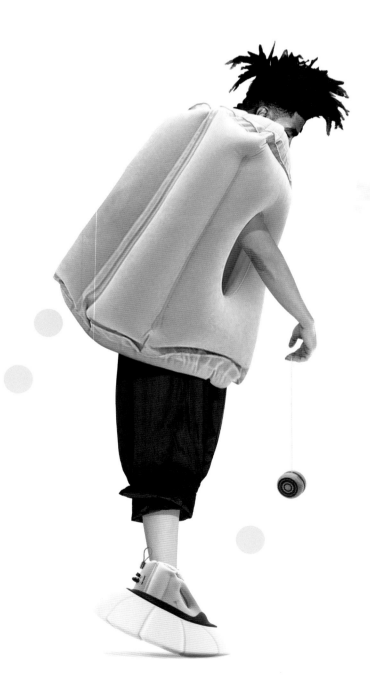

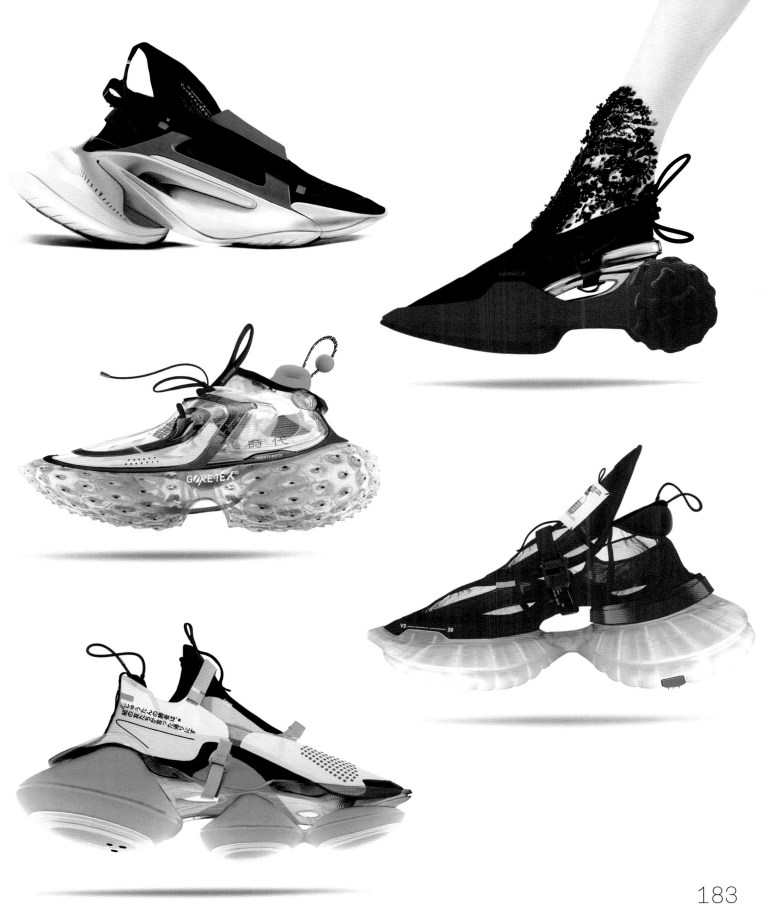

183

INTERVIEW WITH

D'WAYNE EDWARDS / PENSOLE

ELIZABETH SEMMELHACK: I want to talk to you about the future of footwear and sustainability, which can take many forms. But first I'd like to ask you about future designers. Why did you start Pensole Design Academy?

D'WAYNE EDWARDS: I started Pensole because future designers need to be different than they are now. They need to be different from when I got into the industry thirty years ago. They need to be different from the people who came in twenty years ago, ten years ago, even five years ago. And unfortunately, traditional education is not preparing these kids for future jobs. It's preparing them for the jobs that have already happened or currently exist. A lot of what Pensole does is not only help the student understand the design part of the equation, but also understand the rest of the team that he or she or they will work with. It's important that they are able to understand the product marketing side. To understand not only the design side, but the color design side, the material design side, the engineering of product, the development of product.

In the future, footwear creation won't be as siloed. The designer won't be asked only to design while someone else does the color, someone else does the material, someone else does the engineering, someone else does the marketing. So, the better the designer is prepared to understand the holistic journey, the whole ecosystem of what they create, the better a creator they'll become.

ES: In some ways that echoes what shoemaking was historically. It did not become fractured into hundreds of separate operations or functions until industrialization.

DE: Exactly. Yes. Yes.

ES: It's back to the future.

Sketch by Pensole
student, 2020

DE: Yes. We're going right back to the beginning.

ES: Where do you think the push toward sustainability will take us?

DE: I would say the future of sustainability is business first. In the ideal world, true sustainability is less product, right? But can you imagine that you have a company, and a consultant shows up and says, "Hey, all right, this is what you need to do. You need to make 50 percent less product right now, which is going to mean you make 50 percent less money." In order for that to work, you would have to change your business model to have fewer employees or only one person who could do four or five people's jobs.

ES: If sustainability requires less footwear production, will the industry start to play with the idea of footwear as an investment? We see it now in the resale market. Could customers be convinced that they should buy less footwear of potentially higher quality?

DE: I don't think so. It's all about consumption and flipping it. Right?

ES: Is sustainability going to put pressure on the companies to change attitudes? How do we get attitudes changed so that we can slow down consumption?

DE: The companies only do what the consumer tells them to do. Meaning, if the consumer wants more, the company will produce more.

ES: It'll just keep going.

DE: Right. So, it's going to be the consumer who drives this. The consumer has to say, "No, I don't need a new shoe every week. I don't need these things." And that will take some time to change because the behavior will have to change based on that individual's lifestyle, whether that person grows up with the idea of sustainability and less is better, or they don't have as much disposable income, or they get older and start to have kids and get married and they have less disposable income.

There are all these different factors that will go into why someone will stop buying as much as they buy. But I think the older consumer will get it first, before the younger one. Because the younger one is still more influenced by the older one, and the past of having all of these things that came out before they were even born. Or because they just feel like they have to have it.

ES: So, the power lies with the consumer.

DE: Absolutely. But the consumer doesn't know that. They are aware, but they don't really understand the power that they have.

ES: Let's switch gears for a moment. Since you are schooling the next generation of footwear designers, do you see any emergent trends or have you been surprised by some of the things that your students are bringing to the table? Ideas that they want to explore, new materials?

DE: When we started eleven years ago, everyone wanted to work at Nike and Jordan and Adidas and the big brands, right? As we've grown every year, that's become less and less of the focus.

ES: Interesting.

DE: I'm starting to hear "Oh, I want my own brand." Or, "You know what I want to do? I want to work at a smaller company." So, the mindset is shifting a little bit. I would say that's the first part, the behavior part. On the design side of things, there's a small group of them that have a real grasp of design. Because a lot of them come in just through the lens of the sneaker culture. And we teach them that the future of our industry is not going to be the current version. Therefore, we are not going to look at sneaker culture because we're not going to learn anything there.

We're going to learn stuff from other industries. We're going to learn stuff from the other things that you buy and that occupy your time on a daily basis. Your phones, your cars, the restaurants you eat at, the types of foods that you eat, the preferences that you have for hotels—all of those things are going to influence future footwear design. If you only look at what already exists in footwear, you're not going to bring anything new to this industry. That's why all the portfolios look bad. They're only looking at what's at retail now and doing their version of that, versus looking at another industry and bringing something new to the table that does not look like everything else that's currently available.

ES: What are your thoughts on footwear in the virtual space?

DE: You know, it's interesting because I remember back in 2003, when I was in Portland at Jordan, we would go up to EA Sports in Vancouver, Canada, or they would come down to see us. They wanted to take the photos of the shoes so they could put them in the video games. One day we were up

in Vancouver, and we were just playing around, and we were like, "We should make a whole collection that just lives in the video game." Because at that point they had started the skill of unlocking things. That's where the whole unlocked sneaker thing started to happen through video games. And then we thought, let's make shoes that never come out in real life, just to see the response of how many people try to buy them virtually. We used the video game as the test to see how many people were interested in it before designing the shoe in real life.

ES: So, the video game was a test market?

DE: Total test market to see what the popularity was based on a virtual collection of products. So now here we are in 2021. I do believe there will be a future marketplace for virtual products. I mean, it's already here. I think it will be a future market where virtual products drive physical product. When it becomes a business opportunity, the game goes away.

ES: This is maybe a difficult question, a political question— you've been committed to changing the face of who is designing sneakers within the footwear industry. How much is the industry embracing what you're pushing forward?

DE: I would say I'm not trying to change it; I'm trying to evolve it. Because right now it's limited. For me, I honestly see the industry through the lens of my seventeen-year-old self, a kid who supported a brand through purchasing products because the brand put someone in an advertising campaign or in marketing who looked like me, to convince me to buy the product. And what I'm trying to do is help the

company understand that that kid has more value than just being a consumer.

And shame on you for telling that kid that the only relationship they can have with your brand is if they buy product. So, what we're trying to do is really help the companies understand that there are thousands—hundreds of thousands—of kids out there who have other aspirations besides playing basketball or picking up a microphone. And right now, you have an obligation to tell them that they can be more than just picking up a ball or picking up a mic to be successful. These branding people say they don't know how to reach these kids or communicate to these kids, but they do it all day long, right? Honestly, if all the brands collected 1 percent of their sports marketing and advertising budgets, that could create one of the largest universities in the United States. Wait—in the world! 1 percent! So, for me, it's more about helping these brands be more conscious and less hypocritical.

We want the brands to expand the conversation with kids to "Hey, you can try to be one of these 3 percent of the people in the world who can play ball or pick up a mic who makes millions of dollars or you can be one of the 97 percent of the people in the world who can actually be a designer, developer, marketer, engineer, sales, finance, or HR employee. There are way more opportunities out there. The companies just don't speak about them. What we're trying to do is help give these kids a future. Some of them don't know that they can have one. Some of them know that they don't have one, which is worse, and they just kind of give up. We're trying to show them that if your hoop dreams don't work out, that doesn't mean you still can't have a relationship with sports.

ES: There are so many people working at large corporations who remain shrouded in mystery. The companies themselves don't want to pull the curtain aside to let you see who works there. Do you think the time has come for companies to reveal themselves so that the lack of representation will be made clear?

DE: Yeah. That's one of my biggest opportunities when I present to brands—I tell them that these kids are only influenced by what they see. The brands know this because that's why they have endorsees. That's why they have athletes, actors, rappers, and celebrities representing the brand. And it goes a long way to highlight more diversity of people working in the organization. It's not something they're making up. It's not something they even have to pay for. All they're going to do is broadcast the truth.

Now, this is where problems come into the equation. One, the company is hesitant to highlight employees for fear that someone will take that employee. But at the same time, that means you're not doing something right to make sure that they stay. So that's your problem, not the employee's problem.

We also live in what I would call an open-communication society. Meaning it's really hard to hide stuff now. Everything

Pensole Design
Academy in action,
2021

is public knowledge. Except for corporations. Corporations are still learning the hard way that there is a thing called social media. There is a thing called employees with social media accounts. Information is going to get out. It's going to get out. . . . So why try to hide the truth? Whether it's good or bad, why try to hide it? If it's bad, that means you need to fix it. If it's good, you should celebrate it.

ES: One of the things that I think is exciting about future footwear is shifting technologies, new materials. Is this something that you are watching at Pensole?

DE: Absolutely. I tell my designers all the time that the future of this industry is not just in design. It is with the engineer working with the designer. It is the engineer who can make new materials; the engineer who can make new colors, make new things. The engineer is going to be the new star. The more you understand engineering the better a designer you will be. If you're a creative with an understanding of engineering, that gives you way more value because most engineers aren't creative. This is only going to increase in importance because of the push for sustainability, which means that we have to re-engineer how things are made. And whatever that puts out, that's what it looks like. A lot of what we have to do has to go in reverse. You have to start from how the consumer receives the product, whether they are in a store buying a shoe or they're sitting at home on their computer buying a shoe, and then work backward to how do you make the whole system more efficient.

One of the examples I give our students is, as a kid, I would hear a song on the radio and I would jump on the bus and ride the bus for a half hour to an hour to the record store, buy the whole record, get back on the bus for another hour, get home, play the whole album. And I would just like one song. That took three hours. Now, it's one minute. You can do that in one minute now. You don't have to leave. You jump on, you see the song you want, and you pay just for that song. Footwear and other products that you consume are going to have to figure out how to make it that simple.

ES: Do you think that we'll ever get to a point where consumers will be producing footwear in their own homes?

DE: Absolutely. Whatever company is brave enough to allow consumers to work with their IP [intellectual property] will win. Most will not let anyone touch their IP even though consumers are already doing it. Once they buy a company's shoe, they own that shoe, they can change their new shoes however they want. This is what the Shoe Surgeon does. He doesn't have Jordan's permission to do what he's doing. He has a certain skill set. His team has a certain skill set to be able to pull that off. Other customizers have the skill to pull that off. It's just a matter of time. Right now, it's too technical. You can go make a T-shirt in your garage really quickly right now but not shoes yet. But absolutely, that will happen more and more and more.

ES: Do you think that we'll ever get to the point where you can buy something made completely of sustainable materials, use it for a while, and then stream it back into that footwear production system, or maybe into another system, so that there is zero waste?

DE: Some companies have done it on a super, super small level. Right now, it's just like anything that starts off. It's complicated. But then the more it happens, the more it becomes normal—just the way things are done. I absolutely do believe that this will happen. I think it will be almost to the point of how, when you recycle things in your home, you separate plastics and this and that. I think product will be in that vein as well, where you'll be able to disassemble it to where you can actually put it in the appropriate place for it to be recycled. But this is how it must happen; the future of sustainable footwear is looking at the end and going backward. You can't currently recycle footwear because everything has glue, everything has stitching. Everything is built to last. What we need is everything built to come apart. The future is about how you build something to last, but it comes apart. Now, there are many ways we could probably get there. They have time-lapse ink that can disappear or appear over time.

ES: This is a nightmare for museums.

DE: Absolutely.

ES: How will places such as museums preserve culture once objects are made to purposely disappear?

DE: Actually, purposely disintegrate. Or at least purposely disassemble. Then decay and disappear at some point.

ES: Do you think that a move to this kind of sustainable approach will destabilize the collecting market?

DE: Oh, absolutely. But it will also be the birth of new opportunities—the business of preserving things. A lot of those late 1980s and early 1990s basketball products, if they were kept in a box, are crumbling as we speak. That's a clue to how you can take that negative and reverse it and turn it into a positive where you actually want it to crumble.

But most definitely going forward brands will have to make less product. Not only fewer styles, but fewer colors. As we get closer and closer to products that are intuitive to your body—intuitive to your DNA—all you will need will be an all-white shoe that changes color based on when your DNA engages with the material. And you will be able to change it to whatever you want it to be.

ES: It will be the mood ring of the future.

DE: Yes, it will. It totally will. All of it, or a lot of it, is going to be based on science starting with an individual's DNA. And that DNA will dictate what things look like or how they respond in the same way that the environment will also dictate what they look like and how they respond.

ES: That's very interesting. I think we often use clothing to conceal. What happens if we end up with smart clothing that reveals too much?

DE: I think things are going to be much more intuitive. They have to be. I mean, especially when I think about performance. It might help reduce the rate of the injuries that are occurring with athletes, because in some cases their bodies shouldn't be doing what their bodies are doing. So, I think there's going to be preventative. Through your DNA, the products that you wear will be able to sense when your muscles are working too hard, when your ligaments and tendons are working too hard.

ES: This is all computer-based?

DE: It's chip-based, but it's also cell-based from your DNA standpoint. Because it's individual human interaction.

ES: Are there any last things you'd like to say about the future of footwear?

DE: Everyone's talking about sustainability as a buzzword, and I think that we shouldn't look at just the product. Sustainability needs to be the way that we function and operate. In order for businesses to be sustainable, they need to become B Corps, which means that they are signing on to be sustainable companies. This is when it becomes serious. When you say, "This is how I'm going to run my business," that's when you're serious. And this is the last thing I will say on sustainability: it's not just an individual company's problem; it's the whole world's problem. I think collaborating in a purposeful way will move us forward. This new type of collaboration would ask, "How do you collaborate with another sustainable entity to make both of you better?" Sharing information, sharing processes, all of that. That's where it's going to happen: when you see multiple companies that are, in some cases, in the same business working together. Take Allbirds and Adidas. They're both there for the same goal, a green sustainable product, and together they make something even better. I think sharing information to make things better is where it's really going to happen. ✱

PART 4
VIRTUAL

The metaverse is a new frontier, a compelling space for creators that offers infinite potential for virtual footwear. From NFT sneakers to virtual try-ons, the futurists working in the metaverse are blurring the boundaries between the physical and virtual worlds.

VIRTUAL PLAYSTATION X NIKE AIR FORCE 1

THE INTERTWINING OF GAMING and sneakers began in earnest when PlayStation and Nike collaborated on the release of an Air Force 1 in 2006 to celebrate the launch of the new PlayStation 3. Only 150, all numbered, were released and went on to become one of the most desired sneakers of all time. The black patent leather upper of the sneaker mirrored the sleek all-black look of the PlayStation 3, while smooth leather quarters, embellished with the PlayStation logo in gradated purple to blue, mimicked the console's start-up screen. The sneakers also featured a PlayStation graphic on the insole sock and purple laces. In 2018, Nike revealed a smooth leather sample with red laces that never went into production. ✱

RYAN SANTOS/ EA SPORTS

ELIZABETH SEMMELHACK: How did you get into this line of work and when?

RYAN SANTOS: It was an interesting journey. I started my game development career in 1997. Before that I was in art school doing fine arts. I always knew I wanted to do something creative, but I didn't really know what. I had a friend who was working at EA at the time who basically said, "Hey, why don't you come try this out? We have these jobs as game testers." This was at EA Canada headquarters in Burnaby, British Columbia, on the outskirts of Vancouver. I got a job there as a game tester in the sports genre. NBA Live 98 was the first sports game I ever worked on. I'm a huge fan of basketball and everything that comes with the culture—sneakers, hip hop, fashion, and all the icons who helped pave the way in basketball.

I quickly moved into the art department and started creating our virtual characters, this was way back in the PlayStation 2 days. I was creating NBA characters in 3D and moving through the whole pipeline of how we bring these real-life players to virtual reality within our sports games. At the time we obviously had a huge portfolio of sports games, but basketball was really my calling. I worked on a lot of our basketball titles, including NBA Live, March Madness, and NBA Street.

Eventually I moved into art direction, and shortly after that I developed a passion for the entire interactive experience. I shifted into game design and that became my path, moving into creative direction and looking at the entire player experience. I think my passion for the culture that surrounds basketball helped drive a lot of my creativity around bringing these larger-than-life NBA players into our games, and to our fans.

top
Madden NFL 99 Club x Nike Force Savage Elite 2 in-game cleats, 2019

bottom
Madden NFL 99 Club x Jordan Air Jordan I "Bobby Wagner" in-game cleats, 2019

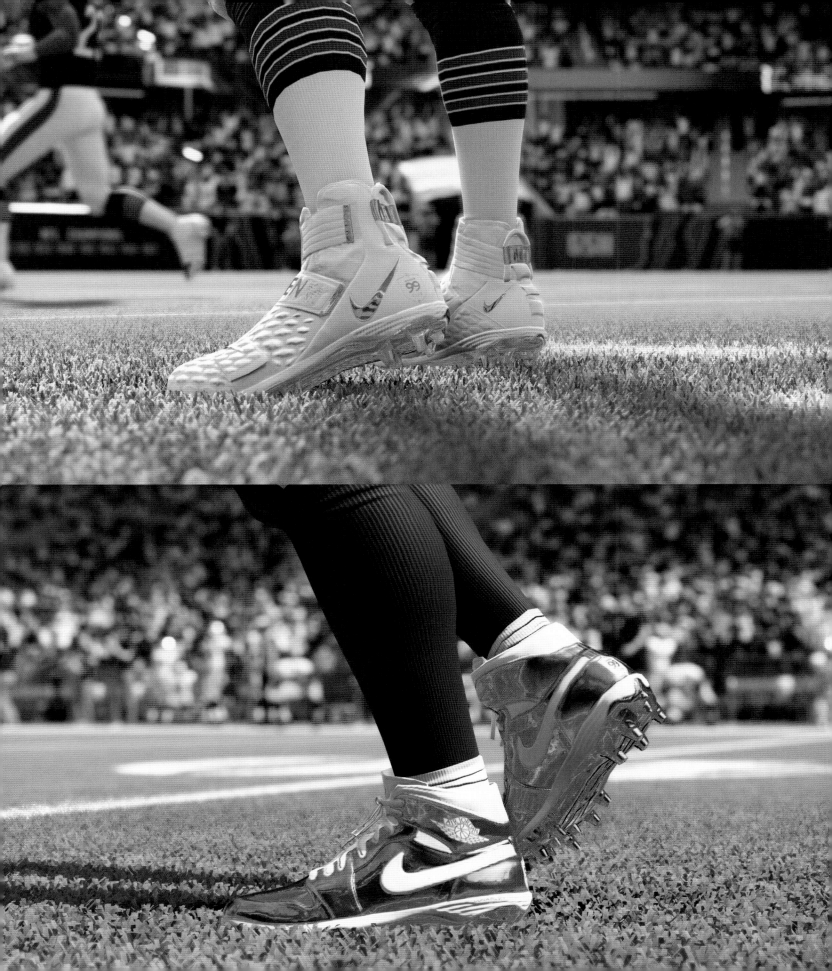

ES: EA Sports is famous for its high fidelity. Do the players have any say in how they are depicted, or do the companies whose clothing and shoes the players are wearing have a say?

RS: Our partners are the various sports leagues, and through our licensing deals with them, we get the rights to players' likenesses. How they look on the court, top to bottom, is how we represent them in the game; we try to make it as accurate and close to real life as possible. Some athletes even give us a heads up saying, "Hey, I updated my hairstyle," things like that.

We see the footwear they're wearing game to game, and we want to mimic that, and work with their brand apparel sponsors to get the latest and greatest. We really align with the Nikes and the Jordans of the world, and make sure that we're in lockstep with them as they roll out footwear with their athletes. It is multifaceted when it comes to athlete and brand involvement and our licensing deals. Also, there are certain players who will get on social media and talk about their likeness, their ratings, and we'll react to that feedback as much as we can.

ES: That seems like a lot of spinning plates.

RS: It's a lot. It's definitely a lot, and we're representing hundreds of players in these games. We have to make certain priority calls to see who we focus on first, and what the fans want. We talk to our gamers, ask them what they would like to see in our games—what players and what sneakers they want to see featured. We take that feedback and make decisions from there.

ES: Can we talk a little bit about the evolution of realism in sports games and how it plays out at the footwear level?

RS: Absolutely. I think as technology changes it gets better and better. There is an expectation that we will get it as close to real life as possible. EA Sports specializes in simulation sports. So our tagline "EA Sports, it's in the game" has been our mantra since the company's inception. As the hardware continues to advance and get more sophisticated, it unlocks more of our capability to mimic reality. We are at a point now where the hardware is pretty much one-to-one with cutting-edge real-time graphics. What we used to see in computer-generated imagery (CGI) in film was unachievable on the old hardware. But now when you look at the power of these

Madden NFL 99 Club
Air Jordan I cleats
made for Bobby
Wagner, 2019

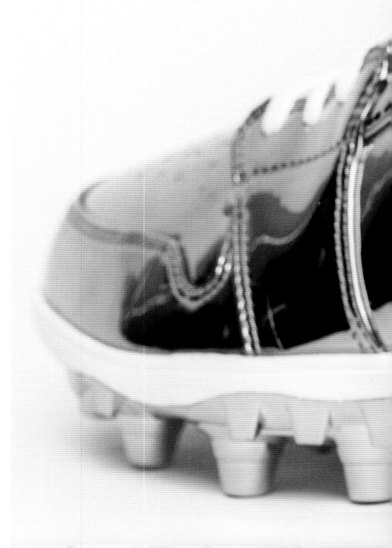

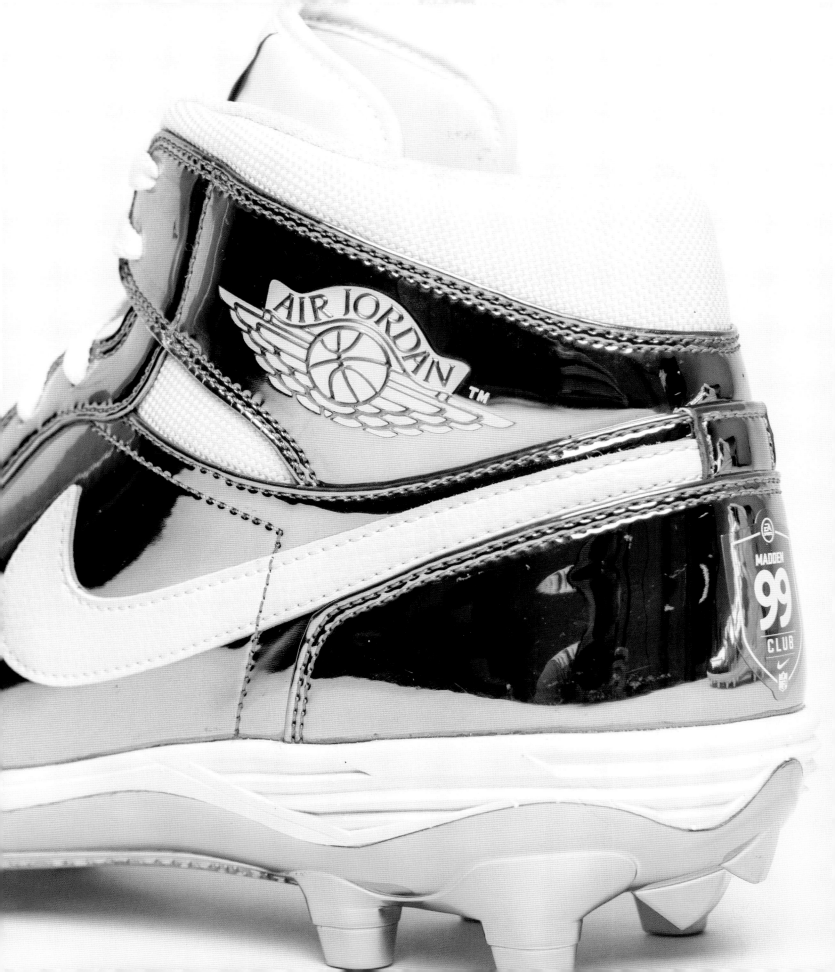

next-generation consoles, like PS5, Xbox Series X, or the latest PCs and their video cards, you're getting into this real-time rendering world where it's so close to real life it seems like you can touch it.

When it comes to the footwear, the advancements we've made in terms of acquiring the content and then re-creating it in our games have changed a lot. When I first started in the industry as an artist, I would visit Nike, Adidas, and other brands that were our partners at the time. I would be the one photographing the shoe from multiple angles, taking digital photographs with these lo-res digital cameras. Then I had to try to stitch all those images back together and wrap it around a pretty low polygonal model—low fidelity, very faceted. The graphics back then were pretty boxy looking.

But today, our art team is leveraging the latest techniques to scan 3D objects. We apply the most current scanning technology to footwear, players' faces, apparel—anything we can get our hands on to scan, we scan. It basically removes subjectivity from the creation side of things. It provides more scientific and empirical data so that what we make is one-to-one with the original design of the sneakers. We translate this information into a lower poly model, but it's still very, very hi-res. We take the information from a scan and create the 3D mesh, and the texture, through photogrammetry. It really is at a point now where you can zoom right in a millimeter away from the shoe and see the material properties, the texture, how it reacts to light—it's so much closer to real life than it ever has been.

ES: How much time do you have from the moment you hear that a player is coming out with a new signature shoe?

RS: Sometimes the hardest part is getting a sample of the footwear itself. Once we acquire that, the scanning doesn't take very long. We could typically scan something in less than thirty minutes, depending on how much detail we need to get. But re-creating it and getting it through the game and into the pipeline takes a few days. It goes through multiple people to be able to process that data, re-create it in our game engine, and push it through the pipeline. Then there are people in charge of assigning it to the right characters and players. In our Madden NFL game, we pay close attention to what cleats they're wearing and what colorways. If there are certain athletes who have more flair and have specific collaborations with Nike, like an OBJ [Odell Beckham Jr.], as an example, we will have those shoes in the game, and we'll attach them to unique experiences that can be unlocked for your character, so you can imitate your favorite players. There's this dichotomy between what we see on these players and how gamers want to be as virtual players in our games. Living out their fantasies through their sports avatars by having them wear the cleats, or sneakers, they see on their favorite real-life players is a strong motivation.

ES: How important are the sneakers to the gamers?

RS: I think it depends on the sport. Obviously in basketball they are so important. But even in sports like American

football, where a player is covered head to toe in a uniform and all the players look the same from a distance—one thing that can differentiate them is their cleats. I think sneakers are a form of self-expression for these players. It is really important for us to nail them.

Sneakers are no longer a subculture. They're pop culture. They're mainstream. Our gamers pay attention to that stuff. Some of our gamers are around the same age as the young players entering the league. What's important to them is that self-expression, that idea of being able to look different from everybody else, because, again, they look the same from a distance, but when you see them up close, they definitely have their own style. I think it's really important to these players.

ES: What is the interplay between reality and virtual? I know that the in-real-life signatures are worn in games, but has there been any movement the other way? Have you created sneakers in the metaverse that go on to have an impact on a real-life design?

RS: I think it's always been a goal of ours working with these companies, but for whatever reason, we haven't gotten there yet. That's still something that's to come. With the advent of NFTs, the idea of owning something virtual, those are the types of talks happening now. We already have the platform, which is our own mini-metaverses. You could argue that every season when you play our sports games, you're living in that sports metaverse with millions of other players, especially in our big titles, like FIFA and Madden.

I remember having a lot of talks early on with designers at companies like Jordan Brand, I remember talking to D'Wayne Edwards and his design team about these concepts back in the early 2000s. "Hey, what if we could work together on designing a virtual sneaker, and launch it in a video game, and then see how it does and depending on the reaction, bring it to life?" We never quite got there, but we definitely talked about it for many, many years. It's just around the corner now, because of the movement around NFTs and the desire to own digital art.

It's been really exciting to be in this space, because we see that every hardware change unlocks more creative capabilities for us. I'm excited about the future. Games have been creating these mini-metaverses for a very long time. It would be interesting if they could all connect so that you could have an avatar, customize it, and retain all of

the things in your collection regardless of what platform you're on. It's going to be a really interesting time if that ever happens.

ES: Do you have any sage advice for somebody who wants to get into making virtual sneakers within games?

RS: User-generated content and even user-generated experiences are the next wave for our gamers, especially younger players. If you talk about Gen Z or even Gen Alpha, there is a strong motivation to create. Everybody's a maker. I think technology and games are unlocking the door for kids, or anybody else, for that matter. We see it all the time in games when people create their avatar. The customization that we afford players in our games turns them all into creators. That's the future of a lot of gaming: we provide the players with a sandbox and they create whatever metaverse they want. That includes designing a character, designing its apparel, the footwear, how they move, how they emote. It's about reducing the barrier to creating whatever virtual world you want.

ES: Do you imagine yourself having a virtual closet of sneakers and other things that you'll wear in the metaverse?

RS: I probably will. I think it'll replace all the crumbling sneakers that I've been holding onto for twenty years. I do think that's going to be pretty commonplace. It is a little niche right now with NFTs. But like I said, if you look at a lot of the games that offer customization for your avatar, people spend a lot of time outfitting their characters and collecting all sorts of things. The intrinsic motivation we have as humans is to express ourselves and be different. I think it's a really interesting intersection of technology and culture and it'll be amazing to see what happens next. I'm all in. I've been creating virtual experiences for a while, so I'm excited to see where it goes. ✱

Madden NFL 99
Club cleats made by
Nike honoring Aaron
Donald, Stephon
Gilmore, Christian
McCaffrey, and
Michael Thomas, 2020

PUMA ACTIVE GAMING FOOTWEAR

AS COMPETITIVE GAMING has grown in importance in the twenty-first century, so has appreciation for what gamers do. Many brands from athletic to luxury fashion have started collaborating with individual players and sponsoring leagues. In 2019, Puma released a shoe specifically designed for console gamers to wear while playing. It featured a knit upper for a socklike fit, a split rubber outsole for flexibility, and traction and a cushioned insole for comfort—all designed to meet the needs of a person gaming in a range of postures. The pre-pandemic release, just months before COVID-19 became a worldwide pandemic, was met with some skepticism, but over the course of the shutdown appreciation grew. The shoes have even become a favored item among barefoot runners. ✱

ACTIVE GAMING FOOTWEAR

Designed for Indoor use.
Conçu pour une utilisation en intérieur.

205

FORTNITE X JORDAN HANGTIME BUNDLE

IN 2017, AFTER YEARS of development, Epic Games released Fortnite, one of the world's largest massively multiplayer online (MMO) games, counting 350 million registered players in 2021 alone. According to TechACake, not only do Fortnite gamers play the game, the vast majority also make in-game purchases. In 2019, Fortnite collaborated with Jordan Brand to offer two limited edition "skins," which are graphics that change the appearance—most frequently the outfits—of a player's in-game character. The Jordan collaboration included two skins—the Get the Grind Outfit and the Clutch Outfit—both under $20. Each outfit came with a choice of Air Jordan Is. The colorways of the sneakers were customizable, and new colorways were unlocked by completing the "challenge packs" associated with each outfit. The popularity of the Fortnite x Jordan skins led to people lamenting that their real-life Air Jordans were increasingly being identified as the sneakers worn in Fortnite, a phenomenon that speaks to the growing porousness between the physical and virtual worlds. ✱

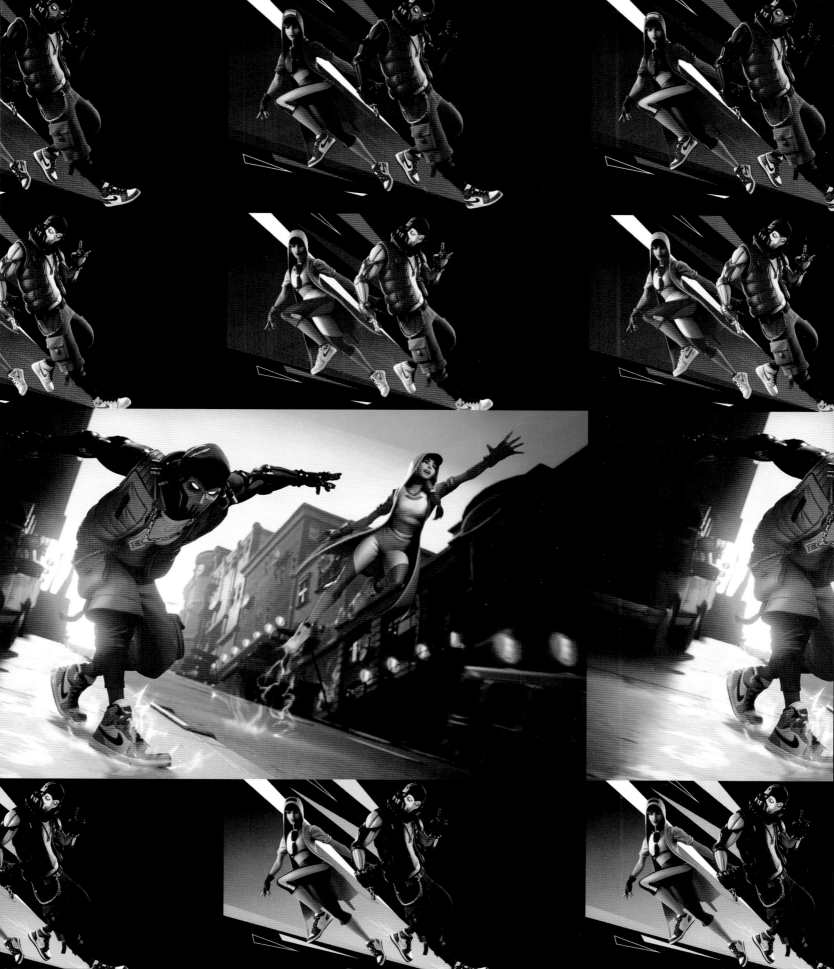

INTERVIEW WITH

ELIZABETH SEMMELHACK: How did this begin?

BENOIT PAGOTTO: It really began when the three of us got together. What I think makes us unique is that only our three brains could have come up with this vision and put together this execution. I'm the one who put the group together because I was at Fnatic, an esports team, as the head of brands and marketing, and I worked with Chris, a very famous Counter-Strike game designer, among many other things.

We worked together on a skin for Counter-Strike and then Chris started to apply skins on sneakers. We began to think about how we could bring sneaker culture and gaming culture together and really make it blow up. We had been noticing that a lot of the Twitch streamers and esports players were increasing in popularity and they were becoming influencers, professional esports players, and professional entertainers using video games.

The first thing we did was we took a Yeezy 700, and we applied the Raven Fortnite skin on it. We posted it on the Fnatic Instagram account, and it became the most engaged post we ever had. It got us thinking that there is definitely something when you put these two cultures together in the right way. My League of Legends team was going to the 2018 World Cup. We felt that there was a very good possibility to make real sneakers because they were going to be in front of millions of viewers online. That's how we got in touch with Steven. I was in the UK at the time, and Steven was in London, too. Steven was the coolest guy. He was very well known because he's the one who pioneered customizing sneakers in a more creative way than just painting on them. He was the first one to do embroidery on Yeezys. We contacted him to make the sneakers for the team going to the World Cup, which was the first time in eleven years that the European team had reached the finals.

Selection of NFT sneakers, 2021. RTFKT

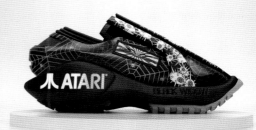

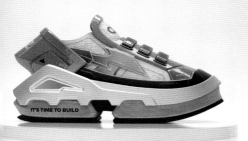

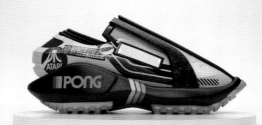

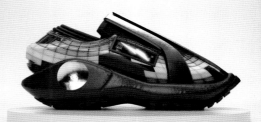

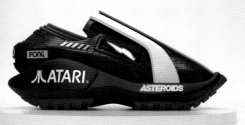

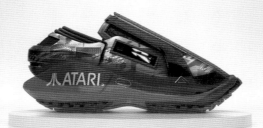

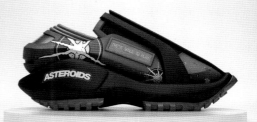

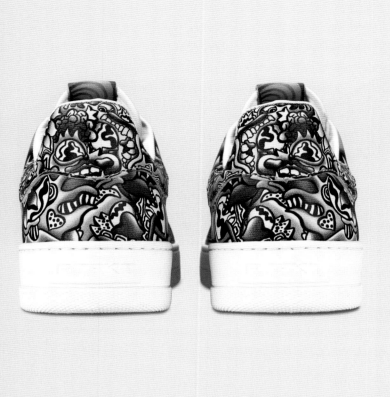

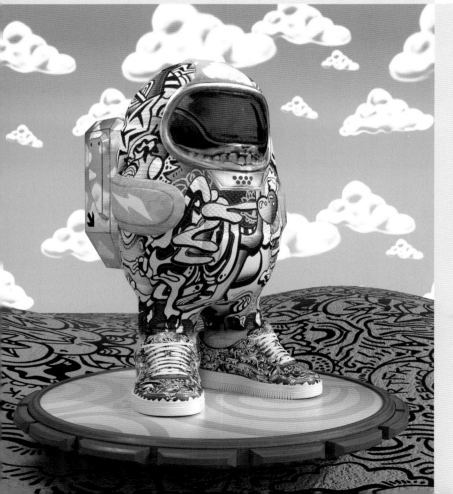

It was a big moment, and everyone wanted the sneakers when they saw them. But in esports, what you can release in terms of products is always dependent on the team's performance. When the team lost, we weren't able to release the final super cool thing, the sneakers.

That's why I thought to do a collector's edition. We did NFTs that were little badges you could collect in the collector's edition. They worked really well. Then we spent more time with Chris talking about his plans in the industry, Steven's plans as well, and my experience.

We realized that everything was in place for us to create the template for the brand of the future, which would be born in gaming, in crypto, and in digital assets. Physical assets were a bonus. We started making our social media account. The more we were bringing to it, the more we were generating interest. Then we decided to dedicate ourselves full-time to it, and we formed a company, RTFKT. We started full-time in January 2020.

ES: Every time I look at Instagram, you guys are blowing up. Are you overwhelmed?

BP: Initially, we got a bit overwhelmed, but to be frank, we made the decision early on not to be defocused by all this attention. The fact that we are remote helps, too. I'm in Paris, Steven now is in Colombia, Chris is in Salt Lake City. We keep cool heads and focus on what we're doing. It's great to have so much mainstream interest, and that so many people want to do stuff with us, and that everyone is writing about NFTs, but we are mainly focused on executing what we want to do.

CHRIS LE: We have experience dealing with this kind of thing because pre-NFTs, we were always dropping crazy viral content. I feel like doing that prepared us for this new era of the NFTs. We have always drawn fake digital sneakers that receive millions and millions of views. There was a learning process when we started with the content, but when NFTs started blowing up and we started reaching a lot of crazy milestones, we were able to tackle it because of our previous experience.

ES: What are NFT sneakers exactly? Does this incredible interest in them dovetail with the already established sneaker collectors' network, or is the NFT phenomenon opening up sneakers to a different group?

STEVEN VASILEV: Sneakers have become trading assets. Kids are buying them, storing them, and then reselling them on sites like StockX. Now technology allows that whole process to take place without tangible goods. You can buy a sneaker after its release in the form of an NFT, and that asset can appreciate without having a physical component. When we introduce using the NFT to redeem a physical sneaker into the mix we create a whole new distribution mechanism, where: 1) you get an authenticated digital sneaker that you can resell or use in some of the games and platforms we work with, and 2) you can use this digital sneaker as an access token to "forge" and redeem physical versions of those designs. It's a game changer. That's why we partnered with Snapchat, because most sneakerheads buy shoes to flex, to show off. They're a status and a culture item. That's why we started RTFKT off making sneakers. They have become cultural assets for Gen Z. This technology can empower. Sneakers are the bridge to understanding the mechanism of NFTs.

CL: We knew the world would shift this way after studying the habits of Gen Z and early millennials. When I was designing skins and selling them on Steam Workshop, too, they attracted a community of kids who collected and traded digital assets. They were making six figures trading these skins. A lot of these kids were also sneaker collectors. They're used to that mindset of digital assets, collecting and trading them. It took a company like RTFKT to introduce kids to what could come after the world of video games with skins, and as Steven said, sneakers were the best starting object.

SV: Just to add to that, that's why we started the company as well—from Benoit's experience in esports, Chris's experience in gaming. We saw these cultures—gaming, sneakers, and fashion—merging. Kids now want to grow up and become streamers or join FaZe Clan. We saw these cultures connecting, and we thought, we can become the first brand to fully merge them.

ES: What can you do with an NFT sneaker if you have one? Can you wear it? If so, how?

SV: As digital wearables they can be worn in blockchain native games, like Decentraland or Cryptovoxels. In addition to that, you get an exclusive Snap filter with our sneakers, where you can create content to show that you own this asset. Most importantly, it's a tradable asset that increases in value that you can always sell and flip. And lastly, you can redeem physicals, and what we've done is multiple physicals from one sneaker NFT. So, it opens new distribution methods, where I can own the NFT, I can claim the physicals, resell the physicals, and then on the next event, get more physicals.

ES: Are most people using them as collectibles?

SV: Yes, but some people do wear our sneakers in places like Decentraland. When we dropped the Atari sneakers there, a lot of people were wearing them. We are also talking to AAA studios to get our sneakers and our objects into their games.

BP: The cool thing is that they're talking to us because we have a lot of contacts in the gaming industry, and they are more attentive now. The sneaker part of character design is not really a place where companies have spent much time or research. So it's going to be very interesting for us to bring attention to that specific part of the outfit in games that so far has not been a priority.

ES: Can you tell me a little bit about the Cyber Sneaker "worn" by Elon Musk?

CL: We knew we wanted to do something in response to his Cybertruck, so I went online and I found a photo of him at the Met Gala that no one knew about. It was an unappealing press photo because it showed him from behind. But this picture looked the dopest because it gave us a canvas to do cool graphics. The photo was just calling for it. I used the same strategy used to do visual effects in movies. We took our Cyber Sneaker and rendered it onto the image with the correct lighting and everything. That's why it looks real. Then we added the whole graffiti thing on top of his outfit. When we released that online, it went viral instantly.

It went number one on a bunch of sites, everybody who is an Elon Musk fan knew about it and we got hit up with DMs. We saw this huge influx of emails coming in. Where do I buy this sneaker? How did we do this? We were even trying to figure out how to make the sneakers. It went number one everywhere. The funny thing is, Elon never mentioned it at all.

SV: Just adding to that, one of Elon Musk's best friends at the time of the Cybertruck drop was trying to make him shoes based on it and when he saw ours, he was really annoyed. But speed forwarding to now, we have spent about eight months R&Ding a physical shoe. It's very difficult to make just because of the sole, the interesting shapes. We are finally close to a prototype, and that prototype is going to Elon Musk himself.

BP: The main thing about this is that when we made the Cyber Sneaker seen by millions of people on the Internet, it became real. A lot of people right now live their lives on the Internet, which is a kind of metaverse, in a sense. Because millions of people saw the sneaker online, who could say it's not true? There were only maybe a thousand people who attended the Met Gala who could attest to the fact that the image wasn't true compared to a million people saying it's true. So, the Internet wins.

CL: Not to mention the Unbox Therapy guy. He did a whole video on it.

BP: Yeah, they thought it was real.

SV: And this was our first ever NFT. It's our genesis piece. Right now [September 2021], the collector has listed it for fourteen million dollars.

BP: We were surprised ourselves during the auction.

CL: It was the highest priced piece of digital fashion at the time.

BP: The actual bid we saw was sixty-five Ethereum but the bidder pulled it because they thought Elon Musk had actually worn them.

ES: Is collaboration central to your work?

Punk forged sneaker, 2021. RTFKT

212

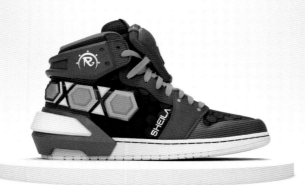

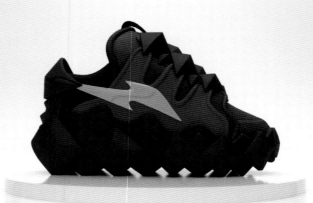

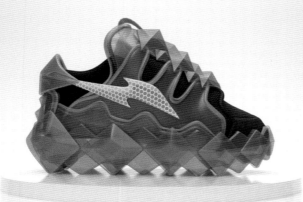

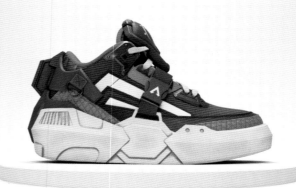

BP: When you do a collaboration, it's about how you merge communities together to create something unique. That's what we really like. We do collabs because the person we collaborate with is making something unique that we would not come up with on our own. We create cultural moments when there's an encounter and something unique gets made from it.

ES: Do you think the virtual world, which, as you said, can be accessed on your cell phone or computer, is allowing for even more collaboration?

BP: Yeah, you're only one DM away from projects right now. One encounter might become a one-off project, or it could become a super long-term creative endeavor. It's so easy today to meet people and exchange ideas. Creation is digital as well, so it is all easier.

ES: How did you start making physical sneakers?

SV: It's native to our process that we always wanted to have sneakers as a canvas for artists because the market's predominantly controlled by big players. The entry to create sneakers is very expensive, with all the mold costs. We hired two former employees of Clarks and we set up an innovation studio in Somerset in the UK and factories in Portugal to mass produce them. We created everything ourselves pretty much. That's why our collab with FEWOCiOUS was so legendary. He always wanted a shoe collab, but no shoe manufacturer wanted to work with him. We made it happen.

CL: We are always trying to innovate with that side because a lot of our designs, especially the video game–inspired ones, were made in 3D with over-the-top design. We're always trying to figure out, how do we do this as a physical shoe? Is it 3D printing? What is it? But eventually I came up with this system. And this is because of the video game background I have. If you're not familiar with how games are done, they use normal maps. These allow video game objects to look high-detail with a normal map that extends the detail. So we connected the dots between crafting games and shoemaking and used this technique to make a unique printed effect on sneakers. No one was doing that. We're really proud of that whole tech process, because we were the first ones to do it.

ES: So, you're skinning an actual shoe?

CL: We're skinning prebaked lighting, in 3D. A good example of this is the collab we did with Apex Legends, which is from EA Games. We created a sneaker in 3D and pre-projected the 3D back onto the sneaker, so it still holds the 3D geometry detail on the sneaker. When you hold the sneaker up, it kind of looks 3D in your hand. Its a technique that they do in video games. I just applied that technique to physical sneakers.

ES: What do you think the future of virtual footwear is?

BP: Sneakers are an asset that makes you part of a community. They also allow you to enter an economy in the community. We aren't limiting ourselves to sneakers, but they are really the meta item for us to start with because they allowed us to merge worlds, to bring the digital and the real together. ✱

Selection of NFT
sneakers, 2021. RTFKT

PUMA LQDCELL ORIGIN AR

IN 2019, PUMA RELEASED the LQDCELL Origin AR, a sneaker whose upper was embellished with a QR code. Using an app created by the digital experience agency INPHANTRY, wearers could use augmented reality to create special effects in photos and videos of the shoes and play interactive games. The most popular was the fire filter, which made the shoes appear to be ignited. As AR grows in importance, having it built into the design of footwear will assuredly be an increasingly important part of design. ✱

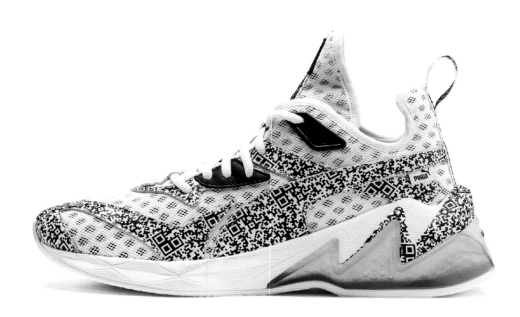

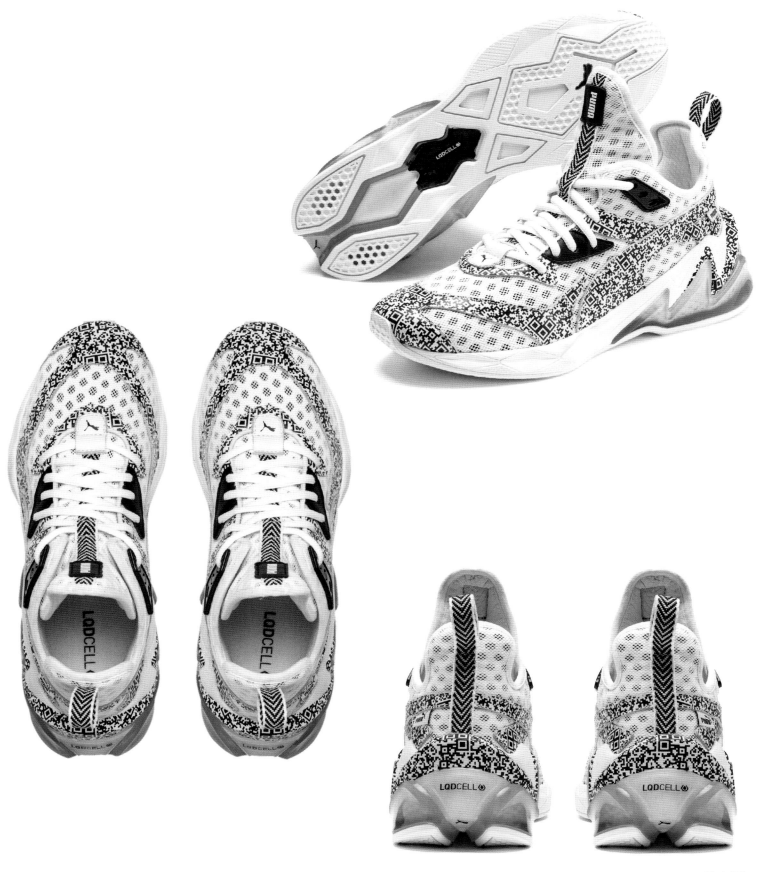

217

INTERVIEW WITH

JEFF STAPLE

ELIZABETH SEMMELHACK: You're known for your groundbreaking work—the 2005 Pigeon is legendary. How did you become interested in the virtual world? What made you try this new space?

JEFF STAPLE: I guess, to put it in one word: FOMO. With new media like NFTs and crypto there's always this determination that people have to make: Is it a fly-by-night trend that's going to die in a second, or in five years is the economy going to be dead and this is going to be *the* thing? Are you going to hop on? People said the same thing about social media. They said the same thing about the Internet. I didn't want to be that person that lagged behind. So out of pretty much pure FOMO, I wanted to learn about it and understand it because it was difficult for me to comprehend the concept coming from the generation that I did, which dealt with real-life things, physical objects. I was used to making real things that had real timelines and paying real dollars for them, so now I've thrown that reality out the window.

ES: I don't think you throw it out. You just move it to the virtual world—dollars to cryptocurrency, physical objects into the metaverse.

JS: Yeah. Crypto and NFT together are two new things that you have to learn simultaneously, so it does require a real shift in how you perceive things, right? If it were one or the other, it might be a little bit more digestible. I took about two months to do my research, listen to podcasts, read articles, etcetera. I'm the type of person who, similar to the way I started my brands, I jump in and I get my hands dirty. How do you figure out if the teakettle is hot? You touch it. Someone could explain it all to you, but for me, the best way to learn is to feel the heat.

Jeff Staple x RTFKT
Meta-Pigeon MK NFT,
2021

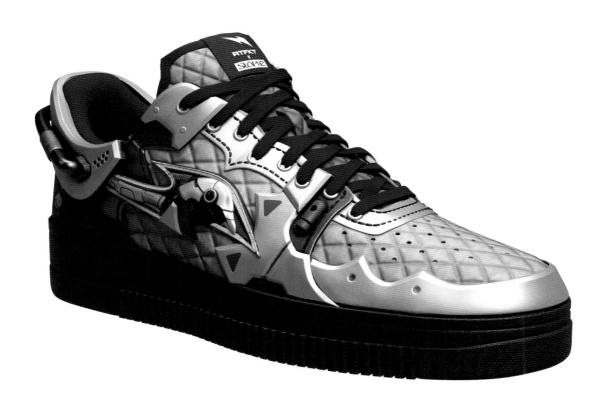

I jumped in around the time that RTFKT released a pretty groundbreaking shoe with artist FEWOCiOUS. I reached out via Instagram to RTFKT and I complimented them. We hadn't been connected before. I said, "I admittedly do not know what's going on, but the energy that I feel with you guys is the same energy that I felt when I released the Pigeon Dunk in 2005." It feels like a movement. There's a movement happening. It's funny because the word *movement*, like a cultural movement, gets thrown around a lot, but when something is a real movement, the ground kind of shakes and the whole earth sort of shakes. It happened with the Pigeon Dunk and I felt like it happened with RTFKT, so I just reached out.

I got a response right away. It just said in all caps, LEGEND, with all these exclamation points after it, and they said, "We need to talk. We're so busy, but we're going to clear our schedule so that we can figure out what we can do." I was super honored that these younger kids, new to the game, recognized what I had done and were willing to potentially merge these two worlds. That was the start of how I decided to jump in. I, a trusted sherpa, if you will, with RTFKT.

ES: I feel that same energy. It's great.

JS: They're the new punk rock. They're the new hip hop. They're the new skateboard. It's just that raw untethered WTF-what's-going-on-here kind of energy. That's what RTFKT is about.

ES: How was the process with them different from real-life collaborations?

JS: It's that hacker mentality. There were some elements of our project that were straight-up frightening for me, like I was scared out of my mind because it just doesn't work that fast in my world. In the metaverse, it just works lightning quick.

The experience was possibly a little different due to the global pandemic, but to be quite honest, even if there was no COVID, I don't think our process would have been very different. There are three main members of RTFKT: Chris was in Utah, Z was in Mexico, Benoit was in Paris, and I was in Los Angeles. Even without COVID it wouldn't have been convenient for us to meet in person. We started a WhatsApp group chat right after that first DM on Instagram. The entire

collaboration happened on WhatsApp: every sample review, photo rendering, and everything else came across the app. It's continuing right now—we still talk all the time. We only had, I think, four or five Zoom calls and that's it. The whole process from the first text message to release was around ninety days.

ES: I guess when you are doing digital you don't have to worry about material sampling or wear testing.

JS: We actually did get a sample.

ES: Oh, right, you forged them in real life.

JS: Yeah. We forged them in real life and customers are going to get the shoes soon. I remember when we were talking about marketing it, I said, "Hey guys, HYPEBEAST is writing an article, and they want to see the actual sample. Guys, I need the sample in my hand. FedEx it to me." And Chris was like, "Jeff, no one cares about physical product anymore." I said, "What are you talking about? How am I going to shoot?" He's like, "Jeff, just send me a picture with your hand out like this. And I'll put the shoe in your hand." Still, I was like, "What are you talking about right now?" Now, if you look at some of the assets where I have the Oculus goggles on and I'm holding a shoe and a Pigeon in my hand, that entire image is virtually manipulated.

I remember those words, "Jeff, no one cares about physical product anymore." I think that was a very overarching statement, but also, maybe in his generation and in the metaverse, it's true that physical products are way less important than digital virtual products now. This blew my mind and quite frankly scared the crap out of me.

ES: Yeah, even if young collectors are collecting physical sneakers, they're still sharing them virtually. Right?

JS: Yeah, exactly.

ES: And so, the divisions between IRL and the metaverse has become so porous.

JS: That's the thing. I think that even OG sneakerheads are starting to wrap their heads around it. If you look at a guy, let's say DJ Clark Kent or someone who's got 10,000 shoes, they are still mostly showing them digitally and virtually now, right? The days of trucking your collection to a flea market

Jeff Staple holding
virtual Meta-Pigeon MK
and Meta-Pigeon, 2021

and showing it to people in person are over—you're not doing that anymore.

ES: I hope people still come to museum exhibitions.

JS: I know. On the one hand, I felt scared. I felt like I was holding on for dear life to these three guys that I had just met on the Internet. It was a very scary proposition. But on the other hand, I felt that there was no better way for me to learn the mindset and the thought process of these young people and what they want out of their collection. I think we touched on something really interesting with our collaboration. I said, "Hey guys, NFTs, kind of get it, and I love it," and they set up my MetaMask. Then I said, "Thank you for that. But I want a real shoe, too." The idea of forging an NFT to become a real shoe was so obvious to me, but to the press and the media, it was such a groundbreaking thing and they really loved it.

ES: I want to talk about the fact that your collaboration resulted in actual sneakers. AR filters that allow people to virtually see what new shoes might look like on their feet seem to be driving sales of physical sneakers, so I don't think that we've completely jumped into the virtual world. Do you think that people are intrigued by this existence in both?

JS: Yes. We released a sticker and two colorways of the shoe, and then a third colorway that was a one-on-one. There was this instant sort of tiering that naturally occurred. And that was pretty experimental for RTFKT and me to see. Another new aspect of what we did was, because we recognized that my audience consists of a lot more of the old-school community that might not have crypto set up yet, we wanted to allow for fiat currency users to buy into this as well. When we dropped this on Bitski, it completely crashed the site. It was totally dismantled. We allowed credit card processing through the company Stripe, which is kind of the de facto credit card merchant. Stripe allows a hundred credit card transactions per second and we blew through that and also crashed the site. So, we created a little virtual riot, if you will, in the metaverse.

opposite top
Jeff Staple x RTFKT
Meta-Pigeon MK
sneakers (left) and Meta-
Pigeon OG (right)

opposite bottom
Meta-Pigeon (left) and
Meta-Pigeon K-Minus
sneakers NFTs, 2021

ES: How do you think this is going to move forward? We've talked about how hard it is to wrap one's mind around things that only exist virtually. Do you think this bridge between real life and virtual will continue for a bit, allowing us to exist in both, or do you think we will get to the point of having only our crypto closets?

JS: I think there's no turning back now. I really believe that this is almost the end of physical. And I say "almost the end." I want to compare it to vinyl records, manual transmission cars, etcetera. They're not dead. There is a community of vinyl-heads. There's a community of people who love to drive stick shift. But it's like 0.1 percent. I really think this is the beginning of that trajectory for footwear and other products. I can totally see this now happening in our lifetime. There are a lot of other factors that involve the real world, whether it's environmentalism, disease, famine, viruses, but aside from whatever happens on earth, I think I could see a universe where people in real life just have one T-shirt, one pair of pants, and one white shoe. And then they flex on their devices.

ES: I have thought about this exact thing for so long. I was looking at images of cluttered Victorian interiors. There were so many things. Images on the walls, plants from exotic places, trophy animals, textiles, the wealthy were completely surrounded by stuff. But they also had space to show it. I understand today that the mega-wealthy are a different story, but most people are finding themselves in smaller and smaller spaces. When you look at Gen Z, they've got no space at all. My kid's room in our home is a small space that is minimally furnished, but their space in VR is like one of these Victorian interiors.

JS: Wow. Everything was in there.

ES: Everything was in there, everything you could ever want. I thought to myself, why would you ever come out of there into real life?

JS: Did you tell them to clean their room? Their VR room?

ES: No, it was—unexpectedly—perfectly organized!

JS: For our generation growing up, when you went to your friend's house, you'd see their CD collection or their vinyl collection, and say, "Oh, I get what you're into now." Now,

because of this digital world, you don't get to walk into someone's house and know what music they're into, but they might have a poster of their favorite concert or maybe some merch from their latest tour, right? That's the representation now. So, if you think about that, the idea of a thousand shoeboxes in a room, quite frankly, even if you owned a big house, doesn't make all that much sense. Shoes take up space really fast.

ES: So much space.

JS: I could see where even the staunchest, diehard, OG sneakerhead could be like, "Hmm, this could be it where, like, I just want my collection living on my phone and maybe at the end of all of this the Chuck Taylor wins out. Everyone just wears white Chucks."

ES: Right? Possibly.

JS: I honestly believe that. And there are other factors, right? There's the creator economy. If you look at the original Pigeon Dunk that I did with Nike and how much it resells for over and over again, I only saw the original 2005 check for that release. I don't make money off these resales, but the one-on-one that we did with RTFKT that auctioned for more than the OG Pigeon Dunk was very telling for me. The OG Pigeon Dunk goes for $35,000 to $75,000. The one-on-one that we did with RTFKT went for $90,000. But now, whenever that gets flipped, RTFKT and I are getting compensated for that.

If you're Ronnie [Fieg], if you're any of these guys that have been giving assets to sneaker companies and getting a onetime check, why wouldn't you do it this way?

ES: I've got one last question.

JS: Before you ask your question, I've got one more observation I want to make.

ES: Please, make as many observations as you want.

JS: When I had Reed Space and when I also worked with Extra Butter, the retail store—both brick-and-mortar—I noticed a lot of people coming in, looking around, and then grabbing a bunch of clothes. Then they'd be like, let me get a dressing room.

ES: To take pictures?

JS: They would do a complete photo shoot in the dressing room, right? Then they'd say, "No, thank you," and leave. But if you checked out their Instagram, they'd be flexing on everything. You could argue that on Instagram, in today's form, that kid is getting social currency out of that experience, right? He's getting likes, he's getting comments. A brand might now look at this style and say, "Oh, we want to give you money to promote our products, right?"

It's not even about owning the shoes anymore. It's about representing what you are into, it's about expressing yourself. His Instagram feed is essentially an NFT wallet in a very crude form. You could see how that could translate to, "Oh, this is what I'm into, and that's it. That's what represents me now." So when I saw that at Extra Butter and Reed Space, I thought, we are falling behind here because we can't stop this. We can't tell kids that you can't try anything on, that's not what a retail store does. So how do we stop this? I went to a bookstore this weekend, and I spent quite a bit of money, and the bookstore clerk was so appreciative because you could see so many people walking into the bookstore, browsing, and then taking a picture of the cover so they could buy it on Amazon where it's half the price and it gets delivered to their house. You can't stop that.

ES: I think that the transition needs to be that stores become showrooms. A place where people can come in, see the product, feel the product, look at the product, but ultimately purchase it online.

JS: Well, going back to footwear, I do think innovations in knitting and 3D printing will allow someone to come into a physical store and look at a sample, and then, say, get measured up and come back in an hour to pick up their shoes or have them delivered. I think it will happen in the same day. Like, we'll just knit this up for you right now. Put your name on the side of it. Like, everything. Whatever you want.

ES: One of the impetuses for this book was that I was thinking about the fact that before industrialization, shoemaking was very much this bespoke experience; you had shoes made exactly to fit your feet. I can see that we are now popping out the other side of this. I wonder if two hundred years from now, people will look back on industrialization and say, wait, what? You had to go into a store and fit into a size that wasn't made for your foot? People will find that so curious.

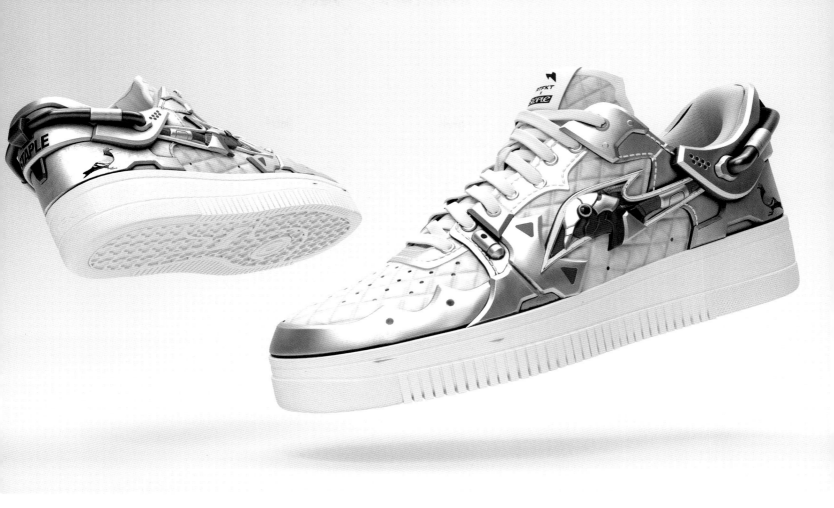

JS: Right. And you know, one's own feet are always different sizes.

ES: Absolutely.

JS: I can imagine them thinking, you had to put both your feet into the same size? And then they'd be like, "So if you were a store, you had to stock every possible size, not knowing whether they would sell?" That will seem totally archaic.

ES: Do you have a virtual closet? Are you putting on your Meta-Pigeons and going into Decentraland?

JS: No, I'm not there yet. I have a MetaMask. I have my creations in there. We also did a collaboration with Gary Vaynerchuk on an NFT. That's all I have in my wallet. I've played around with the AR of putting shoes on my feet. It's still too 1.0; it's not quite right. So no, I'm not living in Decentraland. I don't own any decentralized real estate. I'm still pretty old school, but I'm really glad that I learned

what I did. I realize that this is still a new medium. When I started my brands, I had to take my catalogs to Kinko's to get them printed, and I had to hand deliver them. And then there was Myspace, and then a blog, and then a tweet, and then a Facebook post, an Instagram post, and Snapchat. It just keeps evolving. The way I look at it is that NFTs and the metaverse are just another way of expressing your vision. But if you don't have a solid voice and a foundation to speak on, it's not a guaranteed win. Very big people have failed on an NFT launch because they thought it was a quick money grab. It's not. If you don't have a good message with substance to it, you will lose. If you can innovate and continue to innovate on your voice and message, then I think NFT is just another platform for you. ✱

Jeff Staple x RTFKT
Meta-Pigeon K-Minus
NFT, 2021

225

NINJA X ADIDAS ZX 2K 2.0 TIME IN

IN 2018, TYLER "NINJA" BLEVINS emerged as one of the fore-most gamers in Fortnite. By 2019 he had inked a deal with Adidas to collaborate on merchandise that would be both real and virtual. His Time In collection, released in 2021, included the ZX 2K 2.0 Time In, which features his signature blue and yellow colorway and his Time In catchphrase—a nod to the time he and other creators put into perfecting their craft. Adidas was the first athletic footwear company to collabo-rate with musicians when it signed Run-DMC in 1986. It was ahead of the curve in its collaborations with high-end fashion designers, creating Y-3 with Yohji Yamamoto in 2003, and its collaboration with a video gamer marks another first. ✽

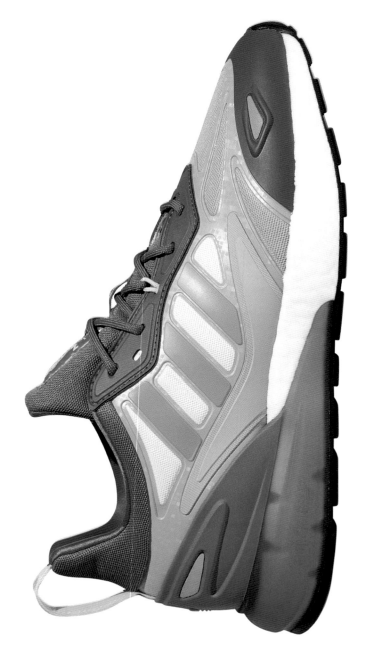

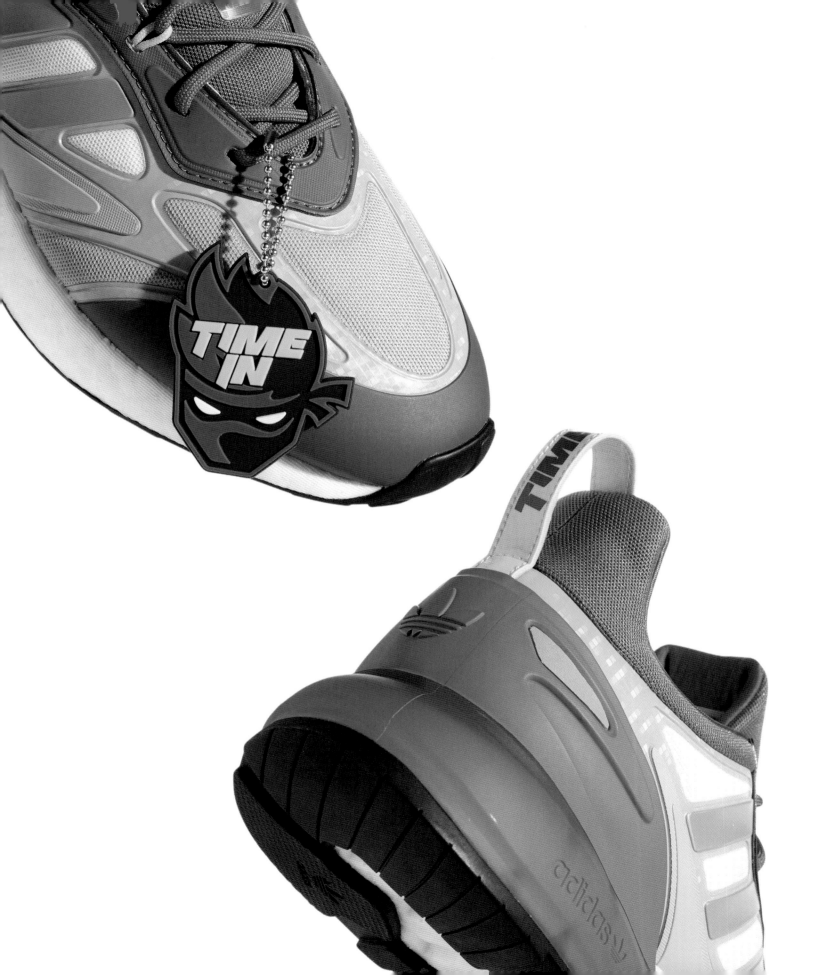

CRYPTOKICKERS

CRYPTOKICKERS WAS STARTED by William Flynn and Thomas Dimson in 2021 to make "custom heat for your metaverse feet." One of the early offerings was the metaverse's first signature shoe, the Wilson Chandler 1. Professional basketball player Chandler had gotten into cryptocurrency via friends he met playing Fortnite, and it was a natural progression for him to create a limited edition collab sneaker with CryptoKickers. The twenty-one pairs of NFT Chandler 1s were released on April 21, 2021. However, in addition to minting rare NFT sneakers of its own design, Cryptokickers has also built the Sole Selector tool that allows anyone to build, customize, and mint their own NFT sneakers directly on the Solana blockchain. If the makers choose, their creations can then be auctioned off on the CryptoKickers marketplace. ✱

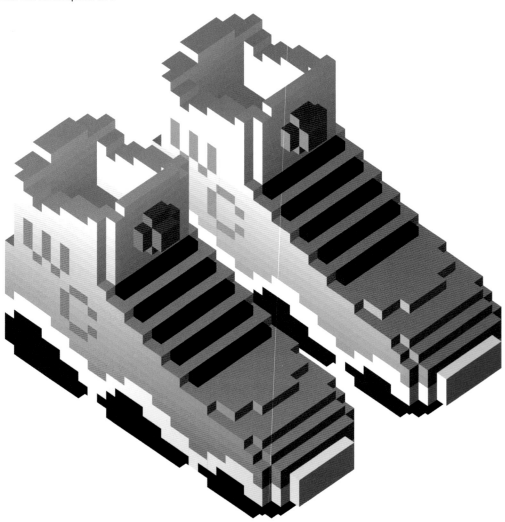

SERGEY ARKHANGELSKIY / WANNA

ELIZABETH SEMMELHACK: When did WANNA start and why?

SERGEY ARKHANGELSKIY: We started building WANNA at the end of 2017, quite a long time ago already.

ES: It's not that long ago!

SA: In terms of lifetime, no. In terms of density of events, it's quite a long time ago. The founding team is like most technical teams; we are skilled in computer vision, machine learning, that kind of stuff. The initial idea was to make online shopping more engaging, more interactive, and easier and better than what we are used to when using AR. This is the why.

ES: Were sneakers the first thing that you tried?

SA: No, the first thing was nail polish. Sneakers were the second.

ES: Why sneakers?

SA: Because they were hyped back then, in 2018. It was an interesting category with rich culture and a big following. There is a lot of interest in sneakers, sneakers represent a large market and we have young people in the company, so sneakers were also very relevant to the internal team. Everyone was excited about building the AR for trying on sneakers.

ES: Since Gen Z is the future, what makes them a natural audience for this type of technology?

SA: The major difference here is that Gen Z's are born with mobile phones in their hands. They're digitally mobile-native. They speak the language of engagement, be

WANNA
KICKS

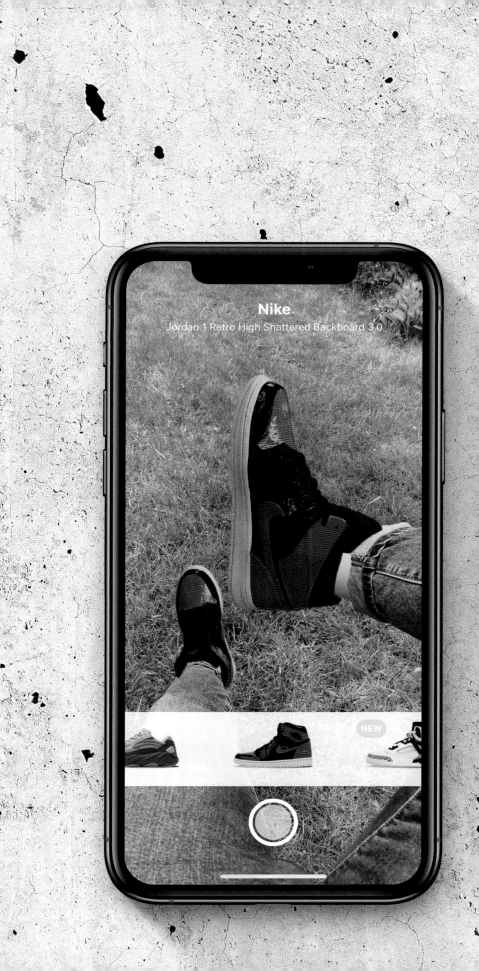

WANNA app, 2021

it Snapchat or TikTok, or any other services. This is why AR is popular within the brands that want to connect with a Gen Z audience. AR gives this audience something interactive, something they understand, something they can share with each other, something they like—I think this is the main difference. AR is an experience Gen Z can relate to.

ES: Is there any risk that sharing the AR experience would be enough for the intended audience? Do these interactions result in people wanting to go and buy the physical objects? What is the link between the real and virtual world?

SA: I'm not skeptical, but I am saying the virtual thing is still years in the future. Many people don't believe that the virtual market will ever be larger than the physical world, but it will

be large. We still have to have clothes. We will always have to have something to wear; shoes to keep our feet warm and clean. We need to still see friends and family offline. We still want to hang out, we still want real things.

ES: AR seems to allow for interactive storytelling.

SA: I think it's adding additional dimensions to the narrative, the stories you can tell. It is how brands can connect with their audience. It is a very emotional, very interactive way to connect and to tell the stories of the new collections, to tell the stories from your shoes. I think that Gen Z wants more than just looking for images; they want something interactive and immersive. Our oldest customer drops each new shoe collection in AR first, to get it into the hands of customers and to tell their story about it in the virtual space.

ES: One of the things that strikes me about the use of AR to try on shoes is that AR provides a very visual experience, but of course, when you go to get the shoes, that's a very physical experience. I know that this is many, many years in the future, but could haptics ever be incorporated into this experience to give you a preview of how the shoes actually feel to wear?

SA: The simple answer is potentially yes. The long answer is let's wait. In three to five years we will have powerful VR glasses for us to wear. The other thing is that with all of the virtual and digital technology, maybe we won't need the haptics. The mind is very good at fooling itself. So even if you are only wearing something virtually, you might start feeling it.

ES: What do you think the role of NFTs will be in future fashion? Do you think that ownership and being able to

have a virtual closet and to wear things that are exclusively digital within the metaverse will be a huge part of fashion consumption moving forward?

SA: I would decouple it: NFTs are just technology. I really believe in the future of digital, including the digital ownership of things. I also believe in the communicative function of fashion. You tell stories about yourself with what you wear, including sneakers. These things are important in real life as well as virtual life.

This is why we need digital fashion, to actually solve the same problems that customers have in their real lives. They want to tell stories about themselves in the metaverse. Because of this, I think we will see the very same mechanics in the virtual world as we have in the physical. But in the digital space, you can afford more. You can afford things such as dynamic clothes that change color, texture, whatever, depending on your mood—I'm dreaming, but you can imagine.

People also want to wear branded things in both digital space and physical space. Potentially we will see changes to business models as well. Currently, in the physical space, you go to the store or you go online and buy things. In the digital space, I might imagine in the future that we'll have some kind of subscription like with Spotify. I might have a subscription for an hour to Gucci for all the new Gucci things. Gucci sells a subscription to me, or maybe an aggregator sells me a subscription to all the top brands. This might happen in the digital world because the transaction costs are much lower and the margins for brands are much higher. Honestly, I feel that it could be something big. It will become big, but we don't know how it's going to play out yet.

ES: One of the things that I find thrilling about the virtual world is that you don't need to be tethered to physical world concepts or realities. I wonder if brands will become more experimental or be willing to create things that are wildly outside what could ever be made in real life. It's completely speculative.

SA: I think they will. Once you have new abilities and technology, combined with the imagination of creators and audience desires, I think brands will build cool stuff for the metaverse. ✱

WANNA app, 2021

DANIEL + DAVID CH/ LEGIT

ELIZABETH SEMMELHACK: My first question: who are you guys?

DANIEL CH: I'm Daniel Ch. This is my brother, David Ch. We're two brothers who started making a couple of guides on how to authenticate stuff because we needed them ourselves. And what happened is, in the meantime, it became a business because we kept getting traction without even setting out to make a business. And this is where we are today. We've got the world's largest library of authentication guides for everything from sneakers and clothing to collectibles, and we've authenticated "weird" stuff like EPs, think discs, as in albums, any kind of collectible. We've got watches, bags, etcetera. We've written and edited and published online more than a million words on how to authenticate stuff. We've got tens of thousands of customers and about, I think, six million all-time users. Dave, am I correct here? We just hit six?

DAVID CH: Yeah, recently.

ES: When did you launch?

DANIEL: We launched in November 2017, but that's before we set out to make a business. I can get into the story, but if we're limited on time . . .

ES: Please, tell the story.

DANIEL: Okay, so the story starts with me. I was learning how to code an app, and I found out I hate coding, but I wanted to finish the app I was working on because our parents taught us to finish what you start. The short of it is the following: I first released this app with a couple of guides, I think five to ten guides. And I thought, okay, it's just a one-off project. I put it on the side. But then I would get into this

Legit website, 2021

234

cycle of checking for milestones, as in the number of users. Our first thousand users, I said, "Yay, congrats!" to myself and shared the news with Dave and then back to other work, because we were both doing our thing. I repeated this at 5,000 users. Three seconds of celebration, back to work, because we weren't treating it as a business or even a project. It was just a one-off. Then there were 10,000, 20,000, 50,000 users, and then we hit around 100,000 users, still going through this roller coaster of "yay" and back to work. At about 300,000 all-time users, we got to a point where we were getting three to ten emails a day and we couldn't face that. It sucked to not reply to people. We thought, something has to take priority. That's when we made the app into a business, in May 2019, when Dave was sixteen and I was twenty-one.

ES: Why is authentication so important right now?

DANIEL: On one side, you have this wave of fake manufacturers who are doing a better and better job of perfecting the fakes. And on the other side is this huge group of people getting into what we call asset production. People need help not only with general-release sneakers but also the limited edition sneakers that can resell for thousands and tens of thousands. The highest value sneakers that we've authenticated have been the Eminem Jordans and the Back to the Future Air Mags.

When you are buying something and you're paying $300 or $3,000 or $30,000, whatever it is, you don't want a fake. If you wanted a fake, you could just go straight to the fake reseller. Getting the real thing is important to many people and it's getting more and more important.

ES: One thing about sneakers is that they don't last, and I wonder how that's going to impact their value as investments.

DANIEL: NFTs could be the next stage in the evolution of sneaker collecting. But wouldn't you agree, Elizabeth, that the fragility of sneakers is also part of the game? We talk about asset products—it's part of the quirkiness of the game that sneakers can turn to dust.

ES: Like wine, it can get corked?

DANIEL: Exactly. A game is defined by constraints. You play Monopoly, you have to play within the rules. You can break

the rules, but it's the rules that define the game. In this case, one of the constraints is that the shoes can be destroyed. But maybe I just want to bet on Jordans. I think that they're going to increase in value because it's 2019 and I have an inkling that Netflix might do a documentary about them, and all the Air Jordans Is are going to skyrocket in price. I should be rewarded for that in the same way that I can bet on a public company like Netflix. I can bet on Chevron or another big company, but why not on something that's closer to me, such as this pair of Air Jordan Is or that Givenchy item, which means something to me.

ES: I wanted to ask you about the fact that you offer both self-education and white-glove service. Let's talk about the educational part first. Why do you want to allow people to gain an education? Also, the amount of content is incredible. Do you get any sleep at all?

DANIEL: We get the help of other people. We get the help of writers. We get the help of people when we write these guides, but credit goes to Dave. Dave is the brain. He's the lead editor, so to speak. He's got other functions as well, but Dave is the brain behind all the curation that happens behind the million-plus words' worth of free guides. I think the reason we made all of these guides rather than having our customers go directly to the authentication service is in part because it offers credibility. The guides prove that we know what we're saying. When somebody is placing an authentication order, the reasons why we believe their sneakers are authentic or fake are based on our words that we write in the guides. We show them that we know this, and we encourage them to compare their sneakers to our guide.

Credibility is key. We could have set up shop one day and had a big banner, WE KNOW HOW TO AUTHENTICATE. But the thing is, we do not have the audacity to claim we know something until we've proved that we know it for free. That's a fair deal. If you've got time and you don't want to spend money because maybe you saved up your whole summer for this pair of shoes, then you can use the library. If you want us to authenticate, then we charge.

When somebody is paying us, we tell them, if you don't want to pay us in the future, you can use the guides. We're kind of shooting ourselves in the foot from a business

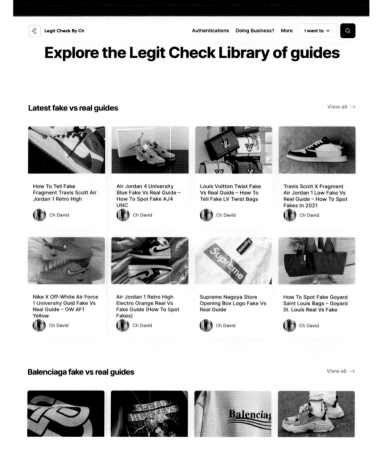

perspective, but we're more focused on educating the market and having a greater mission. We'll make our money because we know how much value we provide, but we'd rather leave some on the table.

ES: When somebody does use the white-glove service, how does that work?

DAVID: You just go on our website and you place an order. You just submit your information, the pictures, the amount of money you paid for the item, where you got it from. Our authenticators look at this carefully because basically every detail matters. If something's unclear, more experts are brought into the conversation, until we all agree on the same conclusion and then we inform you of our findings.

ES: How long does it take? Because that sounds to me very labor intensive, so I'm assuming this is not an instantaneous response.

DANIEL: We have a stated time frame of up to forty-eight hours, but it's purposefully a lot because it's, again, part of our philosophy. The stakes are too high and we want to give the evaluation the time it needs. Forty-eight hours is enough time for two teams to send in their verdicts. If there's a disagreement, a third team has to come in. We allow up to forty-eight hours but we haven't ever taken more than twenty-four hours.

ES: Do you think NFTs are going to be a part of this desire for authenticity and authentication?

DANIEL: I think we're definitely going in that direction where there's going to be a bridge between the real world and the metaverse. Am I excited about it? Yes. Am I 100 percent confident that I can see how it's going to look in the future? No. Because I see a lot of uncertainty.

ES: What do you think the future of footwear is?

DANIEL: Sustainability is going to become increasingly important. We will need to move beyond the practice of shoes being worn once or by one person then going in the garbage and ending up in the ocean.

The secondhand market is projected to become bigger than the retail market in terms of clothing and fashion by, what, 2025? 2026? We're looking forward to that, and we're trying to do our part in encouraging that simply because it's the evolution of humanity. The next phase is where we become more of a conscious customer. Part of being conscious is getting the authentic item and not supporting the fake manufacturers. Dave's generation is okay wearing thrift shop clothing or secondhand. Now it's fully normalized. That is the future. ✻

Legit website, 2021

BRAD FACTOR/ EKTO VR

ELIZABETH SEMMELHACK: How did you even get into this?

BRAD FACTOR: It was definitely a bit of a long road. I started working at Honeywell Aerospace as a flight control systems engineer in 2008, and then in 2013, VR was having its resurgence, so I started thinking—let's say that all those headsets you put on really work this time. Let's say that VR really is a given this time around. What's going to be the next big challenge? Haptics and locomotion, the mobility aspect— those will be the challenges. In 2013 there were a number of players already in the haptic space and not as many in the locomotion space, so I decided to focus on that.

I left Honeywell to get a master of science in the robotic systems development program at Carnegie Mellon University, where I began working on the concept of the EKTO One. It was actually nicknamed "stepping stones," because it was more like Roombas on steroids that you would walk on. There were lots of challenges—the weight of the shoe, issues related to safety and control, as well as user experience aspects. It was also still a uni- or bidirectional design. I wasn't entirely convinced. From a technical perspective, it seemed like everything was lining up, but I still had to figure out, did anybody actually care? Was there a market for this, or were we trying to solve something that wasn't a real problem?

I looked at who the potential consumer was and it did seem like it was a problem that enough people cared about, but I was still on the fence about whether to have my own startup or join one. I was lucky enough to be interviewed by Palmer Luckey, at the time at Anduril, and the founder of Oculus. It was a really interesting chat, we talked almost entirely about VR and what he had seen and tried in that space. He was really excited about what we were working on, and I was thinking, "Okay, I'm excited about this. This guy's excited. I'm in." So I decided to create the company

EKTO One Robotic VR
boots, 2021

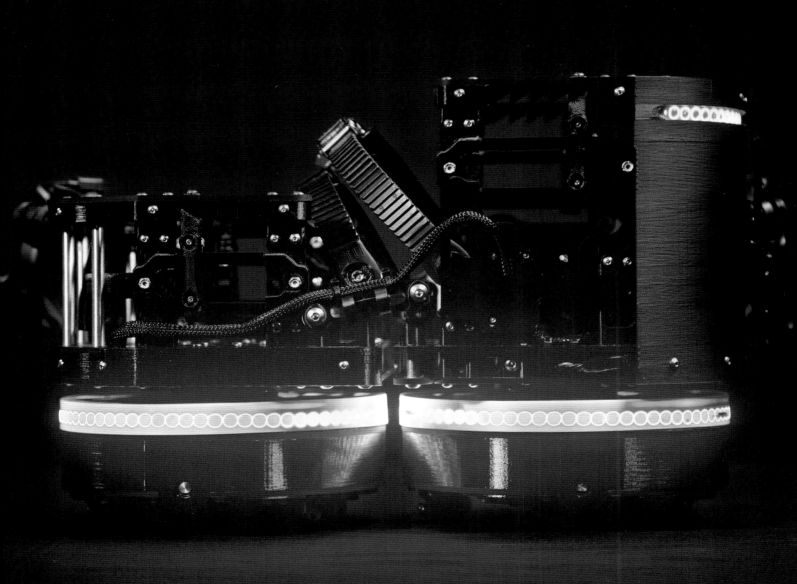

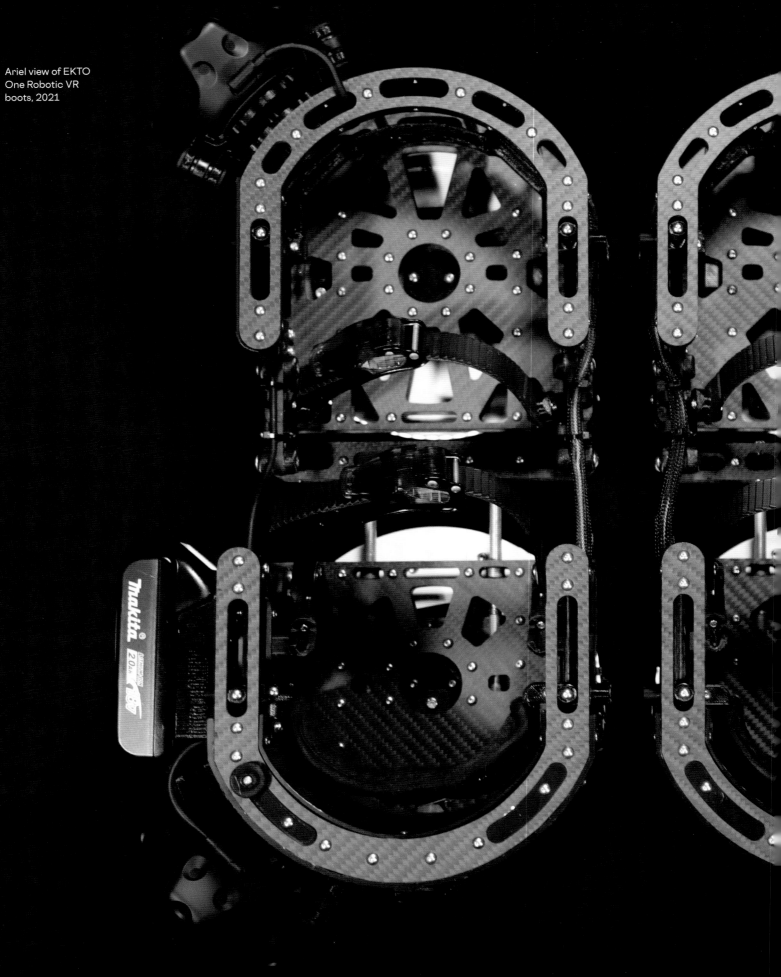

Ariel view of EKTO
One Robotic VR
boots, 2021

EKTO VR in January of 2018, and we incorporated in May of that year.

ES: For those who have not had the opportunity to try VR, let's talk about the challenges with locomotion when using VR.

BF: Typically, when you're trying out VR, you are in a physical room, 10 by 10 feet (or 3 by 3 meters) of space, and that is perfectly fine for a number of VR experiences. In fact, there are a lot of experiences that are tailored for just that, especially in gaming where that's all the space you need in order to walk around, but for anything that's even slightly larger scale—say you're talking about two rooms in a virtual environment rather than just one, or you're talking about an entire industrial facility like a factory or an offshore oil platform—anything that's beyond 10 by 10 feet of space is hard to deal with.

The most common solution is teleporting where you aim your controller, you click, and suddenly you have moved to a new VR space. This is used in gaming a lot but tends to be fairly challenging for people who aren't as familiar with gaming. It is the least intuitive way to move but it also causes the least amount of motion sickness.

The gliding solutions, where you use a controller, a joystick, or more commonly a touchpad, and float around in any given direction is a lot more intuitive because you can see where you're going, but it tends to make people very motion sick. Upwards of 80 percent of people get motion sickness from the VR experience.

There's also the free-roam solution, which is let's either give you headsets that can handle larger spaces or give you a backpack PC, so you can walk around, but even then, there will be space limitations. There was one particular application that was used in mine-rescue training, and the people are being trained do it with backpack PC VR, and they do it in a gymnasium, but they can only render about one-eighth of the entire facility, the entire coal mine, at any given time.

So really, we're focusing on a few different things here. How do you make something that's intuitive? How do you make something that's natural and feels immersive? How do you prevent motion sickness, so people can enjoy their experience?

241

ES: You are focused on making VR for industry training purposes more practical. Can you walk me through how I, as a new employee, might use your footwear in VR?

BF: First, there would be somebody to help you put the boots on. It's certainly possible to do on your own and with enough experience, very practical, but given the scenario we're talking about, you'd have a training operator there. You'd sit down on a chair or a stool. They would ask you your shoe size, and they would make adjustments to the EKTO One boots to adjust the fit. Then they'd guide you to slip your feet into each one. We have ratcheting straps similar to those for ski boots or snowboarding boots, although ours have the flexibility to bend with your feet. These would be fastened down on top of your feet and ratcheted closed for a secure fit. All of this would be happening while the boots are powered on so that when you stood up you would have firm footing.

ES: I was going to ask about stability because there are wheels or a roller system underneath, correct?

BF: There are motorized wheels on an assembly that actually rotates to face the direction that you're walking in. They even take into account the angle of your feet because people don't walk with their feet perfectly straight. This allows you to walk naturally with them on. When you are walking, the wheels match your pace, so you always feel like you have firm footing, like walking on a treadmill. But rather than the treadmill setting the pace, you do.

ES: Is the foot bed stationary? What I mean is, does it pivot at all or is it just a solid surface? I'm imagining I might want to go on my tippy-toes to reach something.

BF: It is a multipart design; the toe and heel are decoupled, so you can flex up on your toes.

ES: So, now that I have the boots on, am I ready to start moving? How do I activate the wheels?

BF: We would first get you into the VR headset. We have tried both techniques—having people try the boots on outside of VR to get comfortable in them, and try them inside of VR to get comfortable. People are different in terms of preferences, but let's assume that we're putting you in VR. We put the headset on. You've got the

EKTO One Robotic VR boots, 2021

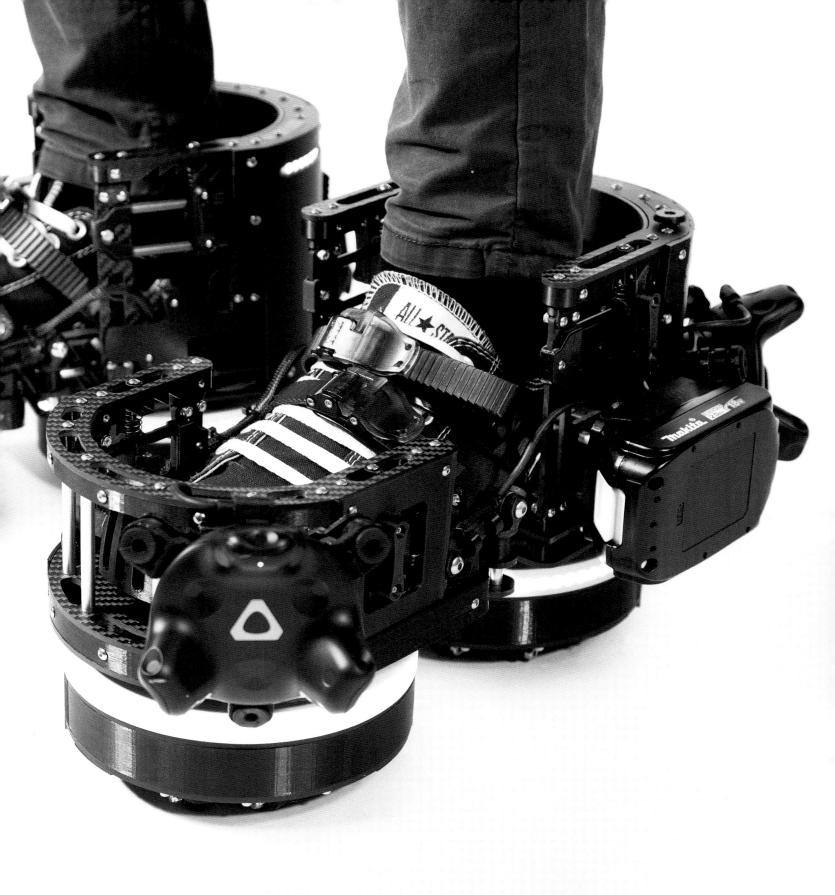

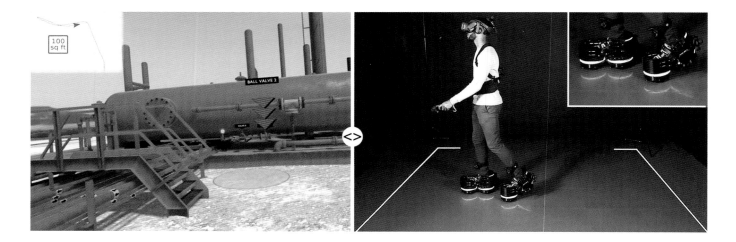

battery pack because we do a wireless VR headset with ours, and we hand you the controllers. Now you're in the environment. You're ready to go.

Currently, it's a click of one of the touchpads that arms the system, and then you can start walking. Nothing happens for the first step or two, so if you're taking small steps around or fidgeting in the center of the room, it's not trying to move you, but once you move out of that space, then the wheels will start moving like the treadmill, starting to speed up to match your pace until it matches your speed. As you walk you won't make any further progress outside of the center of the room as the boots will start to gradually pull you back toward the center of the room. But in the virtual environment, you will see and feel like you're actually walking forward.

ES: Is that what helps with the potential motion sickness? You are physically moving backward, but visually you feel like you're moving forward—you have a physical sensation of movement and a visual sensation of movement, so your mind accepts the movement?

BF: Actually, one of the reasons the boots don't start matching your walking motion initially is so that your inner ear gets a sense that you're starting to walk. You see that with your eyes. You feel that with your inner ear and your legs feel like they are walking so this, to use a simulator term, washes out that movement. You get all the cues that you need when

EKTO One Robotic VR
boots being worn in
VR, 2021

you start walking and then when you get to that steady state of "I'm walking at a constant pace," that's when the boots ensure that you're staying centered in the space.

ES: Are you focused on the boots' application within industry?

BF: That's correct. When we started out, before the company even existed, the focus was predominantly on entertainment, but we had seen a number of companies try to go straight to consumer, and they all faced challenges that didn't make that route very practical. Our original target was more VR arcades and location-based entertainment where it is a business-to-business relationship rather than a direct-to-consumer one. A lot of VR arcades were small or medium businesses, which makes them very approachable and easy to work with, but unfortunately the pandemic, as you might expect, really damaged the location-based entertainment.

The pandemic put our initial pilot projects on hold, and we were forced to pivot our focus. The idea is to first work on industrial applications, bridging over into tactical applications—think first responders. With the hope of eventually getting to the lower price point, higher volume, more uncontrolled space of a consumer product.

The industrial side of things has to do with various forms of safety training or equipment familiarization. For instance, with offshore oil platforms, one of the requirements is that you know before you go there how the facility is laid out, what your muster points are in case of evacuation, where is the different equipment, where are the living quarters, where is all the safety equipment in case they have, say, a

fire on board. A lot of this pre-boarding training used to be done by video or PowerPoint. Now, they have started transitioning that over to VR without any locomotion solution. They are actually pushing a lot of this training to workers' homes and people doing it from their living rooms or on their couches using VR headsets. I think this is part of what's been opening people's eyes to the utility of, to your point, VR and the metaverse.

But it's not just asset familiarization. There's health, safety, and environmental training, slips and falls, scaffolding, protective equipment, those sorts of aspects, and then equipment training for very large equipment. You're a manufacturer, and you've got this enormous, million-dollar piece of equipment that you can't afford to just be shipping around. In the real world, you have to send workers to locations that have this equipment and train them onsite, which is tying up the equipment; it's tying up the personnel; it's tying up the trainees. You've got the travel expense versus being able to virtually represent this equipment and just train them on the spot, so that's part of what we've been seeing.

ES: What about haptics? When I look at haptic solutions for hands it's like you're just tethered to an octopus with twenty-five different tentacles and it seems so onerous. One, do you think the haptics will be solved, and two, will this be of benefit, of interest to the consumer?

BF: Haptics is a really interesting field. From an engineering perspective, I can appreciate why all of this research is going on, but I think until a bunch of brilliant engineers figures it all out and puts the solution into a nice package that you don't need to worry about, haptics won't be a central feature of VR. But I think we will get there. I don't know exactly what it's going to take to really crack the nut on the challenge of providing enough fidelity, while also making it easy enough and compact enough and lightweight enough to use. I see it all as part of the effort to make the user feel like they are having a fully immersive experience. How do I pick up an object and feel like I'm picking it up? If there's a sea breeze, how do I feel the sea breeze? Just engaging all of your senses in a way that makes your mind and body believe that you are in that virtual space, that you're experiencing it as if you're really there. It's not

something that we are prioritizing at the moment, but we definitely have plans to incorporate so that users can feel different textures: I'm walking over gravel; I'm walking on concrete; I'm walking on grass. I think an even bigger challenge will be providing additional haptic feedback when you are going up and down stairs or down a ramp or up a ramp and ladders. Your mind fills in a lot of the details. You see it. You make the motions. You do the thing, and you're where you needed to be, but it would definitely add to the immersiveness to be able to fully sense that experience.

ES: Now for the last question: What is EKTO's application in VR for either gaming or just wandering in different VR spaces? Do you think footwear and walking have the potential to become more important in VR? Will every household have a pair of your VR boots in the closet?

BF: The short answer is yes, there's absolutely application to gaming. Honestly, quite a bit of our passion is for people to be able to have this experience in their homes, but we want to make sure that they're able to get the experience that they deserve, where it's easy to set up, easy to use, integrates with their favorite content. They're getting an advantage from using our boots in VR that maybe those who don't have them aren't able to compete with.

The earliest demo before EKTO even existed was Robo Recall and we have more recently done one with Half-Life: Alyx. I walked through the whole first chapter of Half-Life: Alyx. The real aha moment for me was getting on the boots and walking through that first chapter, because so many of our demos are actually pretty wide-open spaces, and you're able to walk. You get a really good sense of where you're going. It helps with building mental models and all of the really helpful stuff in the industrial space, but in the mixed spaces of Half-Life: Alyx, where you have small rooms, corridors, stairways, but then also courtyards, balconies with vistas, walking across rooftops, it's just a really cool experience—that mix of environment, and being able to walk through it like you're actually there. Even in their current development, being able to walk through it with the boots was just such a different experience from teleporting or gliding through it. ✳

INTERVIEW WITH

ANTONIO AROCHO HERNÁNDEZ

ELIZABETH SEMMELHACK: How did you become interested in footwear?

ANTONIO AROCHO HERNÁNDEZ: Footwear, for me, started back in my first year of industrial design at the School of Plastic Arts and Design [Escuela de Artes Plásticas y Diseño] in Puerto Rico, where I was getting my bachelor's degree. I was doing research on the construction of furniture and came across a book of illustrations. I remember it vividly because it had a Manolo Blahnik pump on the cover. It was green. I knew in the back of my head that I was always very interested in fashion, but I was mostly in the construction and industrial side of design, working with wood, metal, cork, all of these materials that you use to create an object. Footwear was that perfect bridge between the two. Throughout my industrial design studies, starting in my first year, I was heavily influenced by 3D—3D modeling and 3D printing. This all guided me toward getting my master's in footwear at the London College of Fashion, where I pursued 3D and virtual footwear in the virtual space. It was the perfect balance between my industrial background, my love for footwear, and my passion for 3D that led me to the path that I am on now.

ES: Let's talk about footwear in the virtual space. Freed from real-life responsibilities—protecting the foot, keeping us warm and dry—what can a shoe be in VR? The possibilities seem endless. What's possible in terms of the design of virtual footwear? What challenges do you face in attempting to bring these new virtual realities forward?

AH: For me, the beauty of a virtual space, or the metaverse, is that we have no restrictions in the physical and construction worlds. All of those bounds are lifted when you're looking into creating a pair of shoes. Theoretically, anything that can be

Fiona, 2021

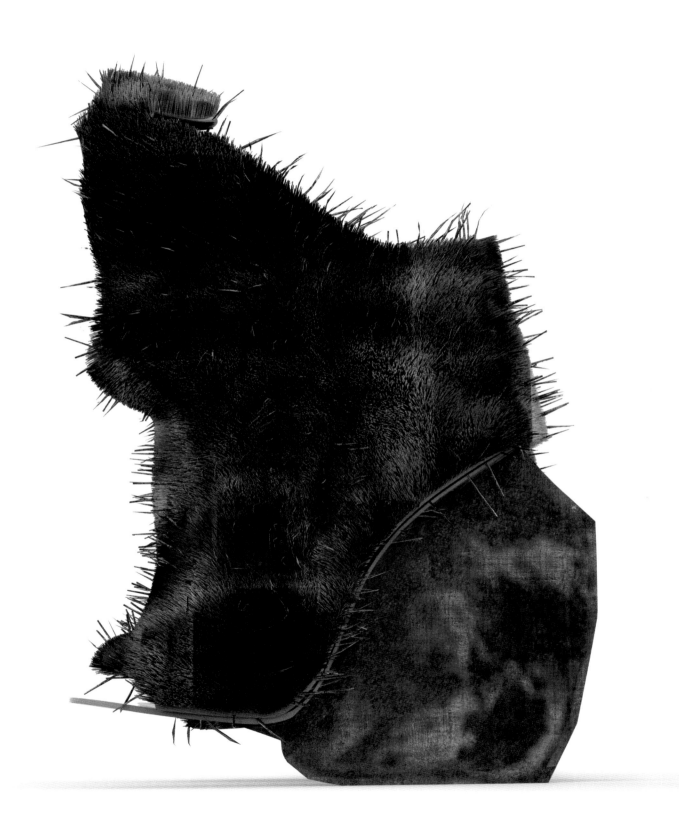

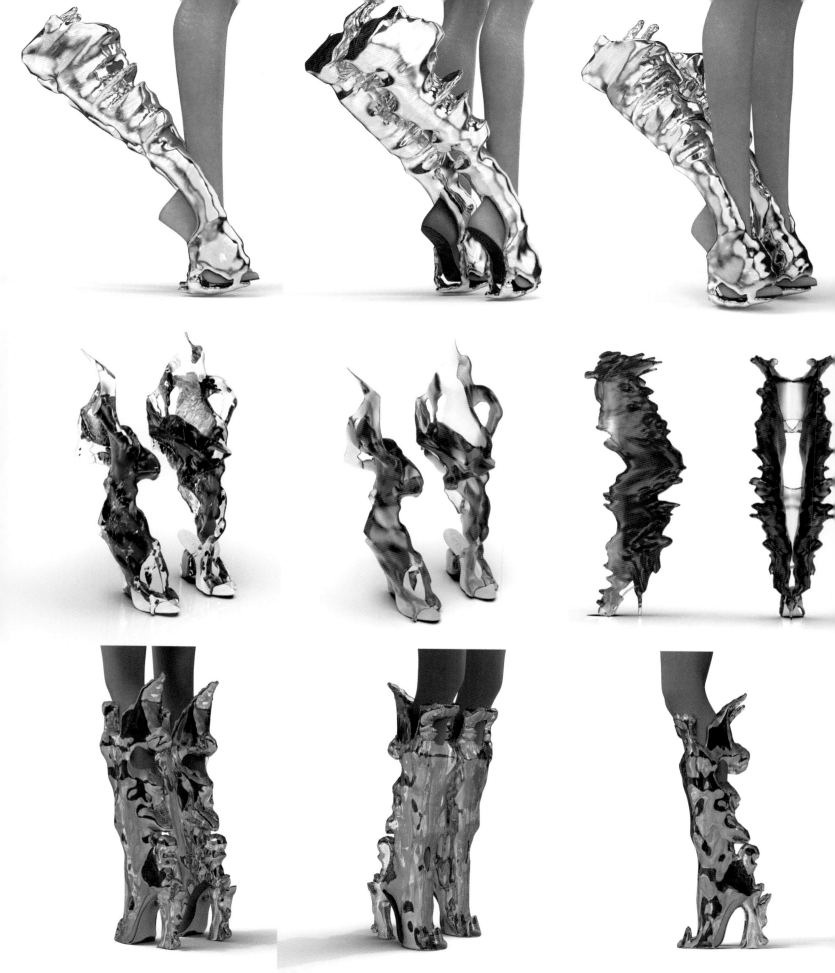

wrapped around your foot can become a shoe. This links back to the 2000s, when Second Life had shoe galleries. They had huge success and big designers. I found some of these boutiques in Second Life fascinating. Now, the metaverse, or the virtual space, has expanded and we can, especially now with crypto and the NFTs, create and own anything in the 3D dimension. It's an exciting time to be creating and exploring what an actual shoe could be.

It's now being adopted commercially. For example, you can go to Snapchat and "try on" Gucci shoes and buy them on the spot. It's compelling because it is making the augmented reality experience much more accessible. It re-creates that Cinderella moment when you try them on. You feel like you are actually wearing the shoes, even though they're digital. You are taking them out of the website from a 2D platform and putting them on in 3D, bringing the store to you.

In a more a conceptual way, the possibilities are endless. We get to redefine what a shoe is. What does it represent? What form will it take? And we don't need to think about things like glue, or molding, or lasting. We can challenge what the paradigm of a shoe is.

ES: One of the things that I love about what you've been doing is the fact that you often make your virtual footwear look like it is made out of water, a material that you could never harness in real life. How did you arrive at those ideas?

AH: My inspiration came from asking myself, how can I take time, movement, and space and hold it for a minute so I can see it? It came from looking at water and understanding how it interacts with the space, force, and gravity. Saying, "Oh, that's beautiful," but then it's gone in half a second. Taking water into the 3D space I thought, oh, I actually go in and create a fluid that will resolve itself. I can control time and explore that split second for a longer period. See what happens between those seconds. I still have that little bit of control as I tell the computer or the renderer what to do, but I don't know what the end result will be. I give the fluid the tools to find a solution and leave the shoe or entity to live by itself in the digital space.

Akvo, 2021; F02-
Green, 2020; F02,
2019; F01, 2019;
Hanada, 2021

ES: It's so interesting because you are allowing the fluid to respond to the space in a way that mirrors water in the natural world.

AH: Yes and no. When we think about the metaverse and virtual/augmented reality, we all talk about polygons, geometry, and optimization. Here organic, complex shapes rarely survive, but I want to safeguard the organic curves and keep their sense of organic nature, the forms, and represent that yes moment: these can also live in the virtual space. It lives! I also like to play with direction, the sense of gravity, and where the fluid begins and ends. That's why a few of the recent projects that I've been working on are animations and experimentations with fluids. It's that constant dance of a shoe that shape-shifts or breathes within itself. And for me, a good source of inspiration is water, because water changes. Shape-shifters can change form but will always come back. It's a cycle that I start, but that the machine creates.

ES: It seems to me that virtual footwear, and virtual fashion more generally, can be worn on virtual bodies that have no gender. Is there an opportunity here?

AH: Absolutely. We are finally addressing the binary paradigm.

ES: Do you think about this when you are making your shoes?

AH: All the time. I did a collaboration with a brilliant designer, Romain Portier. They are based in London, and I created a collection of shoes for their fashion graduate collection. The footwear collection, called Alice, speaks to the deconstruction of gender in the digital space. Alice is one shoe that changes form into seven different shoes. In the virtual space there are no rules, so gender doesn't exist. These paradigms that we have as a society are not real here, and you can truly be yourself. That is incredibly exciting because a shoe is like a piece of clothing. It doesn't have any gender. It doesn't have any of these social constructs by itself. It's just a shoe. It's just up to the user to define what it is.

ES: Another thing that's so exciting about clothing or fashion in the virtual space is that it's now completely free of a practical job to do, which means that it reveals more clearly the work that fashion always has done: construct, challenge, or reaffirm cultural constructs. We're at

the brink of this new world where we can change those conversations and those constructs, right?

AH: Definitely, these conversations fuel the deconstruction of paradigms, helping with the creation of the metaverse and its inclusivity. It's for everyone. We see now that the fashion lines are starting to do one inclusive show with all representing bodies walking in the same space. The clothing starts to be for everyone: female, male, trans experience, or in between.

ES: What are you currently working on?

AH: We talked a little bit about shape-shifting and virtual shoes. I think it's important for me to continue on that route, because we don't really know how the shoes will turn out. It's not about the dance that I have with the machine; it's the dance the shoe has within itself. I like the circles of this dance as I work with the organic and liquid parts in these shoes. That is intriguing. It's the balance for me, and practice to have a little bit of control with the computer, but then turn it over and see how it solves itself. The latest collection of virtual shoes that I've been working on, The Blue Collection, explores this in depth.

I want to present it in a virtual space and have the user walk in and experience and feel the shoes. I have also tiptoed around the idea of 3D printing them and making them real physical shoes. But I would love to have them more as sculpture

pieces because these shoes live in a virtual space. They don't live with us but they can be tokens of another dimension that we have the privilege to visit in order to see them.

ES: To try these shoes on in VR, you have to wear real footwear with trackers that can track the wearer's movements, right?

AH: Yes, I did boots with a tracker, the Janus boots, that let you walk in the VR footwear. It's fascinating to watch. I know that you'll be very interested in the sense of the ceremony there is when putting on the shoes. They have very high heels, like five to six inches high. The way users change how they walk while they're wearing them is very interesting because you see people strutting even when they don't normally wear heels. You see them walking around and they're excited and they're comfortable. There's a disconnect between the footwear they are actually wearing and the ones they have put on in VR. That is really the beauty of virtual reality—it takes you somewhere else.

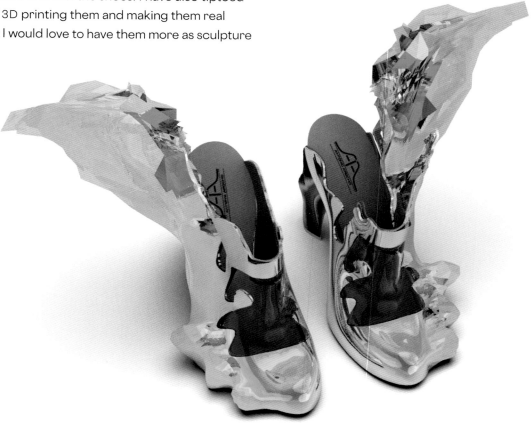

ES: It is very interesting that you have to get dressed in one type of footwear in order to experience this completely alternative form of footwear in the virtual space. You're still tethered to this reality but you don't feel it.

AH: You don't see the VR tracker boots when you are in virtual reality. This was the technical challenge for the Hyperreal collection. Making sure that when you do that step forward, the virtual shoe follows with you, making sure that it's strapped to your foot or on your leg and that the connection between the two of them coexists. That was the real challenge for me. The magic of it is you don't see yourself, but you walk with it. You feel the physical shoe, but you're wearing the virtual shoes, creating the connection between reality and virtual.

ES: I wonder what it means for museums. We're object-based, like brick-and-mortar stores, but you can't touch anything yet. I think that potential for virtual reality and museums is exciting.

AH: It is really interesting that you mention that because I remember some of the feedback that I received when I did my first show in London was that when the attendees were in VR, they felt like the shoe that was in the space for them to put on, you shouldn't touch it. Some of the digital shoes are really big and were displayed on a podium, waiting for wearers to put them on, but people felt a bit guilty. When you pick up the shoe, the controller vibrates to create the illusion that you picked it. You experience that gratification of picking up an art object and wearing it, something we haven't experienced before. It felt mischievous.

ES: Another line blurred, right? I guess we have been discussing this all along, but what do you think is next?

AH: What really excites me is to continue to work on that shape-shifting dance, but also to see how we can add more to the physicality of it, that sense of feeling. How can we incorporate into the physical shoe worn for tracking the experience of wearing the virtual shoes? How can we connect these two together even further so that you can experience the VR shoes evolving with you, breathing and changing? How can we create a way for you to feel the movement of the digital shoes when they wrap around your legs?

ES: That would be incredible.

AH: That's what I have been dedicating most of my time to: thinking of ways to solve this and push the design forward. It is an electrifying time. ✱

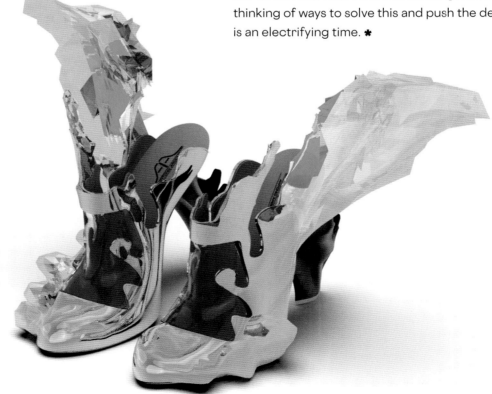

Nada, 2021

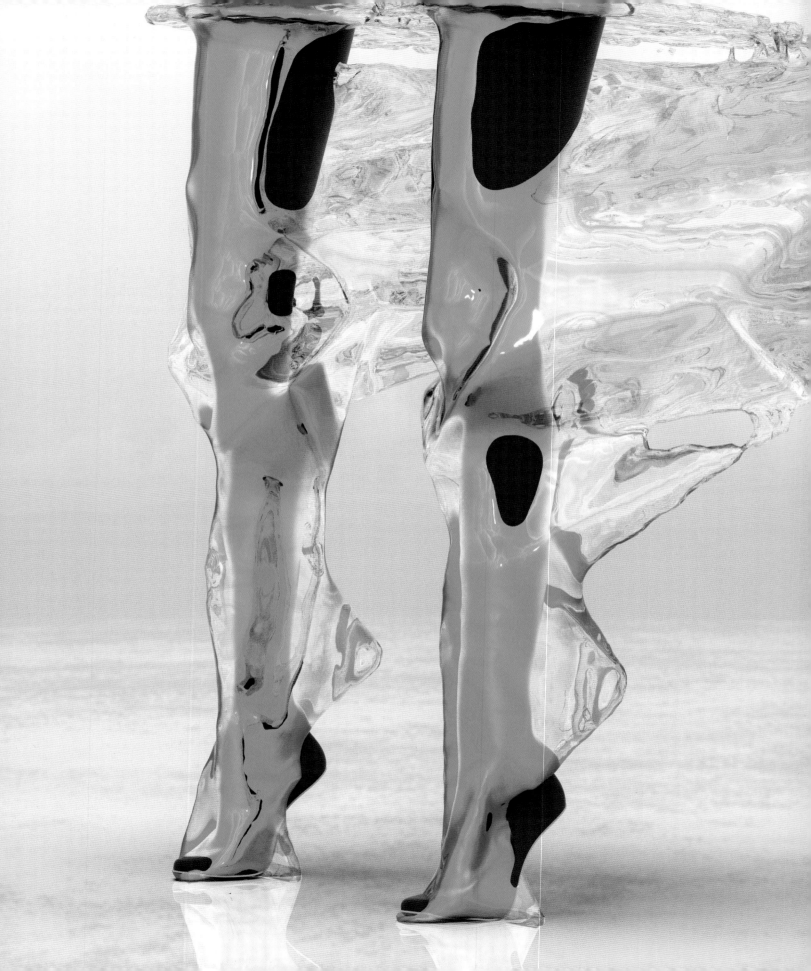

Marina, 2021

PHOTO CREDITS

ACKNOWLEDGMENTS

THIS BOOK WOULD NOT HAVE BEEN POSSIBLE without the help of many, many individuals. The board of the Bata Shoe Museum Foundation and I extend our sincerest thanks to everyone who contributed to its success.

First, we would like to thank Charles Miers for seeing the potential of this idea and agreeing to publish it. We would like to thank Margaret Chace, who has been a champion of many of our projects at Rizzoli. We also owe great thanks to Andrea Danese, our editor at Rizzoli, whose commitment to this book was immediate and whose work ethic, enthusiasm, and good humor made creating it a pleasure. We also thank Sarah Gifford for her incredible design for the book.

We extend our deepest gratitude to all of the inspiring people who so generously gave of their time and resources. We are extremely grateful to Steven Smith, Benoit Méléard, Darryl Matthews, Shamees Aden, Rem D. Koolhaas, Alexander Taylor, Tim Brown, Zixiong Wei, Allyson Felix, Salehe Bembury, Daniel Bailey, D'Wayne Edwards, Ryan Santos, Benoit Pagotto, Steven Vasilev, Chris Le, Jeff Staple, Sergey Arkhangelskiy, Daniel Ch, David Ch, Brad Factor, and Antonio Arocho Hernández for their insightful and lively interviews. We also extend our warmest thanks to Iris van Herpen, Tom Sachs, Julian Zach, Safa Şahin, Thomas Dimson, and Joey Flynn at Cryptokickers.

This book would not have been possible without the generosity of Nicholas Schonberger at Nike, Marta Rodriguez Sainz and Benedetta Rovardi at Puma, Stuart Gower and Hailey Albright at Adidas, Lauren Waters at Hill+Knowlton Strategies, Shuxin Cheng at Scry, Tamara Yvette Day at Skai Blue Media, Kim Caban at Staple Design, Minna Axford at Alexander Taylor Studio, Nate Hinton and Omari Williams at Pyer Moss, Anna Pozniak at WANNA, Eugenia Hermo at Rick Owens, Lili Dreyer at VÆR, and Erin Narloch and Stephanie Schaff at Reebok Archive.

Heartfelt thanks also goes out to the entire team at the Bata Shoe Museum with special thanks to Amy Prilika, deputy director of administration; Ada Hopkins, conservator; Suzanne Petersen, collections manager; and Nishi Bassi, manager of exhibitions and assistant curator. We also wish to thank photographers Ron Wood and Kailee Mandel for their many beautiful images.

Elizabeth Semmelhack
December 2021

First published in the United States of America in 2022 by
Rizzoli Electa, A Division of
Rizzoli International Publications, Inc.
300 Park Avenue South
New York, NY 10010
www.rizzoliusa.com

Publisher: Charles Miers
Associate Publisher: Margaret Rennolds Chace
Senior Editor: Andrea Danese
Design: Sarah Gifford
Production Manager: Alyn Evans

Printed in China

2022 2023 2024 2025 / 10 9 8 7 6 5 4 3 2 1

ISBN: 978-0-8478-7122-3
Library of Congress Control Number: 2021953306

Visit us online:
Facebook.com/RizzoliNewYork
Twitter: @Rizzoli_Books
Instagram.com/RizzoliBooks
Pinterest.com/RizzoliBooks
Youtube.com/user/RizzoliNY
Issuu.com/Rizzoli

Fig. 9

Fig. 16

Fig. 20